FRENCH PAINTINGS FROM THE CHRYSLER MUSEUM

FRENCH PAINTINGS
from The Chrysler Museum

Jefferson C. Harrison

THE CHRYSLER MUSEUM
NORFOLK, VIRGINIA

North Carolina Museum of Art
May 31—September 14, 1986
Birmingham Museum of Art
November 6, 1986—January 18, 1987

Copyright 1986 The Chrysler Museum
Olney Road and Mowbray Arch
Norfolk, Virginia 23510
(804) 622-1211

LCCN 86-70826
ISBN 0-940744-54-6

Edited by Joanne Jaffe
Designed by the North Carolina Museum of Art Design Department
Typeset in Garamond 3 by Marathon Typography Service, Inc., Durham, North Carolina
Printed by Balding + Mansell, Wisbech, Cambs., England

Cover:
François Boucher (1703–1770)
PASTORALE: THE VEGETABLE VENDOR (detail)
Plate no. 12

FOREWORD

In 1922, at the age of thirteen, Walter P. Chrysler, Jr., purchased his first painting. His choice was a small Renoir landscape sketch. This auspicious beginning was continued in the 1930s with major purchases of contemporary French art, particularly works by Picasso, Braque, and Matisse, and by a few of their immediate predecessors, including the monumental Degas DANCER WITH BOUQUETS. In the 1950s Mr. Chrysler began to collect nineteenth-century academic painting, including works by Gérôme and Gleyre. It was in the 1960s and 1970s that most of the seventeenth- and eighteenth-century paintings were added to the collection. Thus, in the main, the works in this exhibition were brought together in reverse chronological order.

Under ordinary circumstances The Chrysler Museum would not lend so many of its most important paintings at one time. The year 1986 is not, however, an ordinary one for the Museum. It is, in fact, a year of physical expansion as a new wing is added to the building. When the new wing is completed and opens in the late fall of this year, the original building and the first addition of 1967 will be closed for major renovations. The entire project will be completed in the fall of 1988.

The firm of Hartman-Cox in Washington, D.C., is architect for the project. When completed, the four separate elements—the 1933 building, and the 1960s, 1970s, and 1980s additions—will look and function as one building. The exterior will be a continuation of the original limestone, as will the architectural details. Among the most dramatic changes will be a return to the original entrance, which faces the canal known as The Hague, and the creation of an interior sky-lighted court.

At no time during the construction will the Museum be closed to the public. The tradition of being open six days a week, which began with the Museum's inauguration in 1933, will remain uninterrupted. When the Norfolk Museum of Arts and Sciences originally opened fifty-three years ago, it was the first art museum in the Commonwealth of Virginia. In 1971 Mr. Chrysler donated a large portion of his collection to the Museum, and the name was changed to The Chrysler Museum.

It is with great pleasure that the Museum is able to share some of its finest paintings with two other Southern museums. We all hope that the citizens of North Carolina and Alabama will enjoy these wonderful works as much as we do in Virginia. They are among the true treasures of the South.

DAVID W. STEADMAN
Director, The Chrysler Museum

The rebirth and growth of Southern museums during the last decade has been extensively reported in the popular press and in a variety of art and architecture journals. These articles have especially focused on the often dramatic and variously successful new museum buildings which have been erected in such cities as Dallas, Atlanta and Raleigh, or the many new additions to older museum structures, as at The Virginia Museum of Fine Arts in Richmond, the J.B. Speed Museum in Louisville, or The Chrysler Museum in Norfolk. By comparison, little has been written about the important public art collections which have been assembled in the South, collections which figure prominently in any serious survey of American art museums, particularly those at the North Carolina Museum of Art; The John and Mable Ringling Museum of Art in Sarasota, Florida; The Bob Jones University Collection in Greenville, South Carolina; and The Chrysler Museum in Norfolk. In the area of Old Master paintings, these four museums are clearly preeminent in their region of the country, and of great significance on the national scene as well.

Just as it has been the goal of the staff at the North Carolina Museum of Art to make our own collection better known, it has also been our desire to increase the public's knowledge of these other treasures in the South through the medium of exhibitions. Thus my goal in proposing this exhibition to The Chrysler Museum was quite simply to bring to our public in North Carolina and to the Alabama audience a greater awareness of one of the very best public art collections in the South, one that also deserves to be much better known. The exhibition program of this museum has, in fact, placed a particular emphasis on important collections which often, and for a variety of reasons, have not received their due recognition or which would otherwise be difficult for our public to see. A special effort has been made to feature Southern collections, beginning with the Museum's very first major loan exhibition in its new building: *French Salon Paintings from Southern Collections,* which demonstrated an unknown area of strength in the area of French nineteenth-century paintings within the South. This exhibition has been followed over the last few years by *Baroque Paintings from The Bob Jones University Collection; An American Perspective: Paintings from The Maier Museum of Art, Randolph-Macon Woman's College*; and now, *French Paintings from The Chrysler Museum.* Each of these exhibitions has allowed us the opportunity to see a strong and focused collection in depth. Through the generous cooperation of The Chrysler Museum, our public has the opportunity to study and enjoy this remarkably comprehensive collection of French paintings over an extended period of time.

Beginning with the early seventeenth century, the Chrysler's collection of French paintings covers a period of over 300 years, extending well into the twentieth century. Although The Chrysler Museum's seventeenth-and eighteenth- century French paintings are vastly outnumbered by the museum's nineteenth-century holdings, there is an enviable variety and remarkable level of quality to these earlier groups. Among the greatest and rarest prizes is Georges de La Tour's painting of SAINT PHILIP. This work clearly shows the influence of the style of Caravaggio in its realism and strong *chiaroscuro,* ably demonstrating why La Tour was one of the great masters of the early seventeenth century in France. The more austere and classical style characteristic of the French Baroque is equally well represented in the exhibition by the works of Le Sueur, de La Hyre, and Patel, each a superb example of the artist's work. This concentration

of French Biblical or religious painting of the Baroque and Rococo, usually under-represented in American museums, is carried into the mid-eighteenth century in a pair of magnificent canvases by Jean-François de Troy, CHRIST AND THE CANAANITE WOMAN and CHRIST IN THE HOUSE OF SIMON, and up to the end of the eighteenth century in Greuze's SAINT MARY OF EGYPT.

The heights of Baroque and Rococo portraiture are also well represented in works by the great rival portraitists of the late seventeenth and early eighteenth century, Rigaud and Largillierre. Largillierre's group portrait, THE ARTIST IN HIS STUDIO, is a remarkable document of the symbiotic relationship which existed between artist, engraver and patron during this era. It is the essence of the grand Baroque portrait and a masterpiece of Largillierre's early career.

The essence of the Rococo is similarly embodied in The Chrysler Museum's magnificent François Boucher, PASTORALE: THE VEGETABLE VENDOR. This painting is a great joy to have in the exhibition and quite appropriately graces the cover of its catalogue. An early work by Boucher, painted shortly after his youthful trip to Italy, it beautifully conveys the fecundity of nature in brushwork of a richness and fluidity that few have ever rivaled.

The range of the Chrysler's nineteenth-century French paintings is extraordinary and one can only touch upon a few of the highlights here. The first group begins with the painting tradition established during the Neoclassical period and continues on through the academic followers of the late nineteenth century. One of the most remarkable early pictures of this group is Boilly's THE BILLIARD PLAYERS, a brilliant genre scene of contemporary Parisian life. Boilly's meticulous painting style reflects his admiration for the Dutch seventeenth-century genre pictures which he collected. Among the later academic masterworks, one should particularly note here Jean-Léon Gérôme's THE EXCURSION OF THE HAREM, which is an exceptionally fine example of the artist's work both for its refinement of drawing and for its beautiful rendering of light and atmosphere—all the more apparent now as the painting was cleaned especially for this exhibition.

There is also a remarkable series of landscape paintings in the collection, from the proto-Romantic grand LANDSCAPE WITH AQUEDUCT by Théodore Géricault, whose works are so rare in this country, through a group of Barbizon open-air landscapes of a scale and importance seldom seen outside France, to a delightful array of Impressionist views. Notable for both their size and impact are Daubigny's BEACH AT VILLERVILLE-SUR-MER AT SUNSET, an expansive and dramatic landscape and an important example of Daubigny's freely painted late style; and Jacque's SHEPHERD AND HIS FLOCK, his major late Salon painting, which powerfully conveys the interrelationship between man, animal and the earth through the artist's powerful silhouetting of the striding shepherd and his roaming flock against a vast landscape and brooding sky.

The Chrysler collection is also rich in the works of artists who sought a stylistic middle road or more individual style, artists such as Corot, Couture, Millet and Fantin-Latour. Couture's PIERROT THE POLITICIAN and Fantin-Latour's PORTRAIT OF LÉON MAÎTRE are both particularly distinguished representatives of that blend of conservative and avant-garde style called the *Juste Milieu*. In both paintings, academically correct drawing is wedded to strong color and richly textured, scumbled brushwork which shows the inspiration of that

genius of eighteenth-century painting, Chardin.

Probably the most important Impressionist painting in the collection is Renoir's lovely double portrait of THE DAUGHTERS OF DURAND-RUEL. It is a delightfully intimate painting, representing the daughters of Renoir's dealer Paul Durand-Ruel, who did so much to further the careers of the Impressionists during their early struggles. It is both a historical document and a fine example of Renoir's full Impressionist style. Although the Post-Impressionist painters and the art movements of the early twentieth century are not as fully represented in the Chrysler collection as are their nineteenth-century predecessors, there is no lack of individual works of distinction to complete our view of three centuries of French painting. Undoubtedly, the rarest painting in this last portion of the exhibition is Gauguin's THE LOSS OF VIRGINITY, an early masterpiece of the artist, painted before his famous journey to Tahiti. Works such as Matisse's BOWL OF APPLES ON A TABLE and Braque's THE PINK TABLECLOTH bring us fully into the mainstream of twentieth-century painting. Both still-life subjects, they provide a wonderful opportunity to compare two very different but similarly colorful and lyrical strains of abstraction in the wake of the Fauve and Cubist experiments earlier in the century.

The North Carolina Museum of Art is very grateful to The Chrysler Museum for the generous loan of these forty-five prime paintings from its French collection. I would especially like to thank David Steadman, Director of The Chrysler Museum, and Roger D. Clisby, Deputy Director/Chief Curator, for their cooperation in the organization of the exhibition, and Jeff Harrison, Researcher, for the thorough and informative catalogue he has written. At the North Carolina Museum of Art, I would like to thank our Registrar, Mrs. Peggy Jo D. Kirby, and her staff for their excellent organizational work, and Chief Designer Lida Lowrey and her staff for the fine design of this catalogue. Lastly, I would like to thank Douglas Hyland, Director of The Birmingham Museum of Art, for his participation in the exhibition tour, which has made this project a much more feasible one for both our institutions. For our audiences both in Raleigh and in Birmingham, this is a rare opportunity to gain a new understanding and appreciation of a long and glorious chapter in French art.

WILLIAM J. CHIEGO
Chief Curator, North Carolina Museum of Art

ACKNOWLEDGEMENTS

Many individuals have helped to make this catalogue possible. I am particularly grateful to David W. Steadman, Director of The Chrysler Museum, and to Roger D. Clisby, its Deputy Director and Chief Curator, whose enthusiastic support and unfaltering encouragement sustained me during my months of research and writing. I am equally indebted to William J. Chiego, Chief Curator of the North Carolina Museum of Art, who worked with David Steadman and Roger Clisby to organize the exhibition and who was instrumental in selecting and arranging the paintings to be shown. I appreciate, too, the important contributions of Peggy Jo D. Kirby, Registrar of the North Carolina Museum of Art, and Lida Lowrey, its Chief Designer, who designed the catalogue.

Among the scholars who gave so generously of their opinions and advice, I offer special thanks to Pierre Rosenberg, Robert Rosenblum, and Eric Zafran, and to Juliet Bareau, Philip Conisbee, Alden Gordon, John S. Hallam, William Hauptman, Lee Johnson, Georges de Lastic, Mary O'Neill, Joseph Rishel, Myra Nan Rosenfeld, and Christopher Sells.

Amy Ciccone, Chief Librarian of The Chrysler Museum, and Anne Lobe, Library Cataloguer, also deserve special praise for their kind assistance with countless reference requests. My work with the curatorial files of The Chrysler Museum was greatly facilitated by the Museum Registrar, Catherine Jordan, and Assistant Registrar Irene Roughton, and I warmly acknowledge the crucial efforts and exemplary patience of the Museum's Chief Conservator, Foy C. Casper, Jr., who performed conservation treatments on most of the paintings in the exhibition; Karen Twiddy, who photographed the paintings for the catalogue; and Joanne Jaffe, who edited the catalogue text. I am grateful, too, to Shirley S. Woodward, Assistant to Director for Administration, who graciously served on more than one occasion as troubleshooter for the project. Finally, I salute the unfailing good humor and peerless computer skills of The Chrysler Museum's Curatorial Secretary, Georgia Lasko, who readied the catalogue text for the designer.

JEFFERSON C. HARRISON
Researcher, The Chrysler Museum

INSTRUCTIONS FOR THE CATALOGUE

The title of each painting has been given in English. If an historic French title for a painting is known, it appears in parentheses after the English title.

The catalogue entries and color plates have been arranged in the same order. Thus, catalogue numbers and plate numbers correspond.

Unless otherwise noted in the "Collections" sections of the catalogue entries, paintings exhibited from the permanent collection of The Chrysler Museum are the gifts solely of Walter P. Chrysler, Jr. Those paintings exhibited from Mr. Chrysler's collection are on loan to The Chrysler Museum.

Paintings in the permanent collection of The Chrysler Museum are occasionally referred to in the catalogue texts as "Norfolk paintings"—i.e., paintings in Norfolk—to distinguish them from those in the collection of Walter P. Chrysler, Jr., which are consistently referred to as "Chrysler paintings" in the catalogue texts.

The following bibliographical abbreviations have been used in the catalogue:

Apollo, 1978
 Mario Amaya, "Contrasts and Comparisons in French Nineteenth-Century Painting," *Apollo,* 107(April 1978), pp. 16–25.

Atlanta, 1983
 French Salon Paintings from Southern Collections, High Museum of Art, Atlanta; Chrysler Museum, Norfolk; North Carolina Museum of Art, Raleigh; and John and Mable Ringling Museum of Art, Sarasota, Jan. 21—Oct. 23, 1983 (catalogue by Eric M. Zafran).

Chicago, 1937
 Exhibition of the Walter P. Chrysler, Jr. Collection, Arts Club of Chicago, Jan. 8–13, 1937.

Dayton, 1960
 French Paintings 1789–1929 from the Collection of Walter P. Chrysler, Jr., Dayton Art Institute, March 25—May 22, 1960.

Detroit, 1937
 Selected Exhibition of the Walter P. Chrysler, Jr. Collection, Detroit Institute of Arts, Oct. 5–31, 1937.

Finch College, 1963
 French Masters of the Eighteenth Century, Finch College Museum of Art, New York, Feb. 27—April 7, 1963.

Finch College, 1965–66
 French Landscape Painters from Four Centuries, Finch College Museum of Art, New York, Oct. 20, 1965—Jan. 9, 1966.

Finch College, 1967
 Vouet to Rigaud. French Masters of the Seventeenth Century, Finch College Museum of Art, New York, April 20—June 18, 1967.

Fort Worth, 1962–63
 1550–1650 A Century of Masters from the Collection of Walter P. Chrysler, Jr., Fort Worth Art Center, Philbrook Art Center, Tulsa, and University of Texas, Austin, Sept. 7, 1962—March 31, 1963 (catalogue by Bertina S. Manning).

Hofstra, 1974
 Art Pompier: Anti-Impressionism, Emily Lowe Gallery, Hofstra University, Hempstead, New York, Oct. 22—Dec. 15, 1974.

Nashville, 1977
 Treasures from the Chrysler Museum at Norfolk and Walter P. Chrysler, Jr., Tennessee Fine Arts Center at Cheekwood, Nashville, June 12—Sept. 5, 1977 (catalogue by Mario Amaya and Eric M. Zafran).

Palm Beach, 1936
 Twentieth Century Painting, Society of the Four Arts, Palm Beach, Feb. 20—March 25, 1936.

Palm Beach, 1962
 Paintings of the Barbizon School, Society of the Four Arts, Palm Beach, Jan. 6–29, 1962.

Portland, 1956–57
 Paintings from the Collection of Walter P. Chrysler, Jr., Portland Art Museum, Portland, Oregon; Seattle Art Museum; California Palace of the Legion of Honor, San Francisco; Los Angeles County Museum of Art; Minneapolis Art Institute; St. Louis City Art Museum; William Rockhill Nelson Gallery of Art, Kansas City; Detroit Institute of Arts; and Museum of Fine Arts, Boston, March 2, 1956—April 14, 1957 (catalogue by Bertina S. Manning).

Provincetown, 1958
 Chrysler Art Museum of Provincetown Inaugural Exhibition, Provincetown, Massachusetts, 1958 (catalogue by Bertina S. Manning).

Provincetown–Ottawa, 1962
 The Controversial Century 1850–1950, Chrysler Art Museum of Provincetown, Massachusetts, and National Gallery of Canada, Ottawa, 1962, no pagination and no catalogue numbers.

Richmond, 1941

Collection of Walter P. Chrysler, Jr., Virginia Museum of Fine Arts, Richmond, and Philadelphia Museum of Art, Jan. 16—May 11, 1941.

Rosenberg, Paris, 1982

Pierre Rosenberg, *France in the Golden Age. Seventeenth-Century French Paintings in American Collections,* Grand Palais, Paris, Metropolitan Museum of Art, New York, and Art Institute of Chicago, Jan. 29—Nov. 28, 1982.

Weisberg, Tokyo, 1985

Gabriel P. Weisberg, *Millet and his Barbizon Contemporaries,* Keio Department Store, Tokyo; Hanshin Department Store, Osaka; Miyazaki Prefectural Institution; Fukushima Prefectural Museum of Art; and Yamanashi Prefectural Museum of Art, Kofu, April 5—Sept. 8, 1985.

Wildenstein, 1978

Veronese to Franz Kline. Masterworks from the Chrysler Museum at Norfolk, Wildenstein and Co., New York, April 13—May 13, 1978 (catalogue by Mario Amaya and Eric M. Zafran).

Additional abbreviations that may appear in the footnotes of a catalogue entry refer to books, periodical articles or exhibitions cited fully at the outset of that entry.

EUSTACHE LE SUEUR

1. VIRGIN AND CHILD WITH ST. JOSEPH

Oil on canvas, 35″ diameter

COLLECTIONS:
Painted by the artist ca. 1651 for a Monsieur Foucaut; Earl of Harcourt, Nuneham, England, by 1797; sale, Viscount Harcourt, Christie's, London, June 11, 1948, no. 181; David Koetser, New York, 1953; Walter P. Chrysler, Jr., 1953; Chrysler Museum, Norfolk, 1971.

EXHIBITIONS:
British Institution, London, 1823, no. 137; Portland, 1956–57, no. 60; Provincetown, 1958, no. 37; Fort Worth, 1962–63, p. 40; Finch College, 1967, no. 40; Rosenberg, Paris, 1982, no. 54.

REFERENCES:
F. Le Comte, *Cabinet des singularités d'architecture, peinture, sculpture et gravure*, Brussels, 1702, III, p. 81; E. W. Harcourt, *The Harcourt Papers*, Oxford, n.d., III, p. 39; L. Dussieux, "Nouvelles recherches sur la vie et les ouvrages de Le Sueur," *Archives de l'art français*, 2 (1852–53), p. 116; A. Graves, *A Century of Loan Exhibitions 1813–1912*, London, 1913–15, II, p. 694; H. Brigstocke, "France in the Golden Age," *Apollo*, 116 (July 1982), p. 14, fig. 11; R. Weil, "Seventeenth-Century French Paintings," *Art Journal*, 42 (1982), p. 331.

Le Sueur spent the whole of his brief life in Paris. Like the older La Hyre (cat. no. 4), he gained his knowledge of Italian art largely through a study of prints, drawings, and the Italian paintings then in private French collections. Le Sueur was an artist of immense promise and increasing influence in mid-seventeenth-century Paris, and he might well have become Charles Le Brun's chief artistic rival had his life not been cut short by a slow "wasting fever" at the age of thirty-eight.[1]

The son of a Paris lathe worker, Le Sueur entered, around 1630, the studio of Simon Vouet, who had only recently returned from Italy and had quickly established himself as the most important French artist then working on native soil. Vouet's decorative Baroque style attracted the young painter for a time. The surviving remains of one of Le Sueur's first commissions—the eight designs he made ca. 1636 for a set of tapestries illustrating the HYPNEROTOMACHIA POLIPHILI—clearly show his master's manner. So, too, does his early Caravaggist group portrait found today in the Louvre, the RÉUNION D'ARTISTES. From the outset, however, Le Sueur's art was quieter and more lyrical than Vouet's, and by the early 1640s he had begun to work in an altogether different and more personal, classical style. This conversion was prompted by his study of Raphael and his encounter with the art of Nicolas Poussin, who sojourned in Paris in 1640–42.

Le Sueur first achieved fame around 1645 with his twenty-two paintings of the LIFE OF ST. BRUNO for the cloister of the Chartreux in Paris. Soon after, in 1646–47, he supervised the decoration of the celebrated Cabinet de l'Amour in the Hôtel Lambert, a rich suite of mythological paintings that coordinated the talents of a number of gifted artists, among them Pierre Patel (cat. no. 3).[2] The Hôtel Lambert was located on the newly fashionable île Saint-Louis, where the now-wealthy Le Sueur built his own townhouse.

The artist worked passionately throughout the last decade of his life. He provided numerous altarpieces and scenes from the lives of the saints for the churches and convents of Paris, as well as larger decorative ensembles of mythological and historical content for the royal family and their courtiers. During the later 1640s he painted the Cabinet des Muses and other rooms in the Hôtel Lambert, working alongside Le Brun. In the early 1650s he worked in the Louvre, decorating the Chambre du Roi with political allegories celebrating the triumph of the French monarchy and providing the apartments of the Queen Mother, Anne of Austria, with an opulent mythological series featuring the goddess Juno. In 1648 he helped found the Académie Royale and in the same period served as *peintre du Roi*. At the time of his death in 1655, he was at the height of his fame and artistic power.

In his final decade Le Sueur evolved a kind of lyric classicism, a style in which the rigors of structural order and emotional restraint were softened by a sweetly human feeling and a palette of precious and powdery tints. This blend of classical control and poetic *tendresse* is splendidly revealed in the VIRGIN AND CHILD WITH ST. JOSEPH of ca. 1651, a charming vision of domestic harmony in the Holy Family. The instability inherent in the

painting's circular, tondo shape[3] is counter-acted beautifully by the powerful, anchoring verticals of the columns, palm tree, and distant buildings. The flowers that Joseph offers the Child—difficult to identify—may be white violets, traditional symbols of the Virgin's and Christ's humility.[4] Drawing its inspiration particularly from Raphael, the painting "renews, without imitating, the Renaissance ideal of perfection."[5]

The picture was first mentioned in 1702, in the brief biography of Le Sueur included in Florent Le Comte's *Cabinet des singularités*. There Le Comte presents a chronological list of the paintings Le Sueur produced between 1645 and '53, a list that, he reports, was taken directly from "a manuscript journal of [the artist's] works . . . given to me by a member of the family."[6] The VIRGIN AND CHILD WITH ST. JOSEPH is mentioned in the paragraph devoted to the year 1651: "for Monsieur Foucaut, a round painting of a Virgin, the infant Jesus, and Saint Joseph."[7]

The identity of the mysterious Monsieur Foucaut who commissioned the painting is not yet known, though Pierre Rosenberg has suggested several likely candidates, including Louis de Foucault (d. 1659), then maréchal de France, and Claude Foucauld, who served as counselor to the Paris Parliament in the years after 1627.[8] Whoever commissioned the piece, its modest size and devotional content clearly suggest that it was intended for private meditation.[9]

NOTES:

1. G. Rouchès, *Eustache Le Sueur,* Paris, 1923, p. 11.
2. For an account of Le Sueur's works in the Cabinet de l'Amour, most of which are located today in the Louvre, see J.-P. Babelon *et al., Le Cabinet de l'Amour de l'Hôtel de Lambert*, Paris, 1972.
3. The tondo shape had been used regularly for devotional paintings in Italy and France since the fifteenth century. Le Sueur employed circular formats for both his religious and secular paintings, as did other contemporary Frenchmen practicing in an Italianate mode. The circular shape, subject matter and imagery of the Norfolk painting bring to mind, for example, a devotional tondo by Le Sueur's former mentor Vouet, the *Holy Family with Infant St. John,* in the Fine Arts Museums of San Francisco. See T. Lee, "Recently Acquired French Paintings: Reflec-tions on the Past," *Apollo,* 111 (1980), pp. 213–214.
4. R. Koch, "Flower Symbolism in the Portinari Altar," *Art Bulletin,* 46 (1964), p. 77.
5. Rosenberg, Paris, 1982, p. 274.
6. F. Le Comte, 1702, p. 96: "je l'ay tiré sur un manuscrit Journal de ses ouvrages, depuis 1645, jusqu'en 53 lequel m'a été confié par une personne de sa famille . . ."
7. *Ibid.,* p. 99: "pour Monsieur Foucaut un Tableau rond d'une Vierge, le petit Jésus, & saint Joseph."
8. Rosenberg, Paris, 1982, p. 274.
9. *Ibid.*

LUBIN BAUGIN

2. MADONNA AND CHILD

Oil on panel, 13″ × 9¾″
Signed, in monogram, lower left: *L B* (in ligature)

COLLECTIONS:
Private collection, England; sale, Sotheby's, London, July 21, 1954, no. 99; David M. Koetser, New York, 1954; Walter P. Chrysler, Jr.

EXHIBITIONS:
Portland, 1956–57, no. 58; Finch College, 1967, no. 32; Rosenberg, Paris, 1982, no. 1.

REFERENCES:
J. Thuillier, "Lubin Baugin," *L'Oeil*, 102 (June 1963), pp. 27, 67, fig. 26.

Baugin was one of the most productive painters working in Paris during the first half of the seventeenth century. Most of his major works—the many altarpieces and devotional pictures of Virgin and Child that he produced during the 1640s and '50s for Notre-Dame and other Paris churches—have, however, disappeared since the French Revolution. His paintings are extremely rare today, with fewer than forty known to exist.

The details of Baugin's life are largely lost to us,[1] though he seems to have been born around 1612 into a prosperous family of notaries and lawyers in the village of Pithiviers, near Fontainebleau. He probably received his first training at Fontainebleau, where the Mannerist paintings of Rosso Fiorentino and Francesco Primaticcio exerted a formative influence on his art. In 1629, at the precocious age of seventeen, he joined the painters' guild of Saint-Germain-des-Prés, on the outskirts of Paris, and there began to produce a series of still lifes—exquisitely spare and geometrically precise arrangements—that are hailed today as early masterpieces of that genre in France.[2] During the 1630s he must have visited Italy—his first wife was Roman by birth—and studied the works of Parmigianino, Correggio, and Guido Reni. So clear was Guido's imprint on Baugin's mature art that the painter soon came to be known among his countrymen as *le petit Guide*.

Returning to Paris by 1641, Baugin quickly established himself as a major painter, a worthy colleague of La Hyre and Le Sueur (cat. nos. 4, 1). In 1645 he enrolled in the Paris painters' guild, the Académie de Saint-Luc, and six years later was invited to join the fledgling, but more prestigious, Académie Royale. Under Simon Vouet's direction, he took part in designing several tapestries in Paris. He even attracted the attention of the crown, for in 1657 he was ranked among the royal *peintres ordinaires*.

From his early experiences at Fontainebleau and his later years of study in Italy, Baugin distilled an art of tender nuances and elegant attenuations, a sweet and fragile poetry that shares much with the contemporary works of Le Sueur, La Hyre, and other painters of the mid-seventeenth-century School of Paris. The Chrysler Virgin and Child—frail and refined, with delicate, boneless hands, tapering fingers and elongated necks—bring to mind particularly the figures of Parmigianino and Primaticcio. Yet the compositional complexities of these earlier Mannerists are held in check here by a noble simplicity of design and economy of detail. Baugin appears to have produced a number of similarly small-scale, meditative images of the Madonna and Child over the course of his career, most of them intended for private devotion. The Chrysler painting[3] may well have hung originally above the altar of a private Paris chapel, its pure, clear colors gleaming magically in the candlelight of the sanctuary.

NOTES:
1. For the most complete survey of the documents relating to Baugin's life, see Thuillier, 1963, pp. 16ff.
2. These few surviving still-life paintings—one in the Galerie Spada in Rome, two in the Louvre, and one more in the Musée des Beaux-Arts, Rennes—display a style markedly different from that of Baugin's mature figurative pieces, and in the past scholars believed that the still lifes were the work of a different master. In 1955, however, M. Faré analyzed the signatures and inscriptions on these pictures and argued quite convincingly that both sets of paintings were indeed produced by Lubin Baugin. Faré's conclusions have since been endorsed by most writers. See M. Faré, "Baugin, peintre de natures mortes," *Bulletin de la Société de l'histoire de l'art français*, 1955, pp. 15–26; P.-M. Auzas, "Lubin Baugin à Notre-Dame de Paris," *Gazette des Beaux-Arts*, 51 (1958), p. 129; Rosenberg, Paris, 1982, p.

PIERRE PATEL THE ELDER

3. LANDSCAPE WITH JOURNEY TO
 EMMAUS

221; and P. Rosenberg, N. Reynaud, and I. Compin, *Musée du Louvre, Catalogue illustré des Peintures. Ecole française XVIIe et XVIIIe siècles,* Paris, 1974, I, p. 255.
3. A version of the Chrysler picture, comparable in size but less finely painted, was lent in 1966 to the Erzbischöfliches Dom- und Diözesanmuseum in Vienna and appeared in the same year on the Vienna art market (Dorotheum, Nov. 29—Dec. 2, 1966, p. 4, no. 10, pl. 2). See Rosenberg, Paris, 1982, p. 221.

Oil on canvas, 27⅜″ × 36½″
Signed and dated lower right: *P. PATEL INVE. 1652*

COLLECTIONS:
Private collection, Great Britain; sale, Christie's, London, May 29, 1952, no. 39; David M. Koetser, New York; Walter P. Chrysler, Jr.; Chrysler Museum, Norfolk, 1971.

EXHIBITIONS:
Finch College, 1967, no. 28; Rosenberg, Paris, 1982, no. 78.

REFERENCES:
J. Mahey, *Master Drawings from Sacramento,* exhib. cat., E. B. Crocker Art Gallery, Sacramento, 1971, p. 27, under no. 66; P. Rosenberg, *French Master Drawings of the 17th & 18th centuries in North American collections,* exhib. cat., Art Gallery of Ontario, Toronto, etc., 1972–73, p. 192.

France produced an extraordinary group of landscape painters in the seventeenth century. Indeed, the romanticized landscapes of Claude Lorrain and the heroic vistas of Poussin transformed the genre in France, enhancing its stature there immeasurably and attracting the attention not only of middle-class buyers, but of the most exacting connoisseurs. Inspired by the Roman works of Claude and Poussin and the growing enthusiasm for landscapes among wealthy patrons, scores of artists in Paris devoted themselves largely or wholly to landscape painting in the years around 1650. Many of these specialists, like Jacques Fouquières, had come from Flanders, where the tradition of landscape was well established. Among French masters, La Hyre (cat. no. 4) enjoyed an exceptional reputation as a landscape painter toward the end of his life, and his fame was shared in Paris by such talented native specialists as Henri Mauperché and Pierre Patel.

Originally from Picardie, Patel was already established in Paris by 1635, when he was made a master painter in the city's guild of St. Luke. As were many other landscape specialists then working in Paris, Patel was regularly called upon to produce pictures for large decorative projects. After 1646, for example, he collaborated with Le Sueur (cat. no. 1) in the Hôtel Lambert,

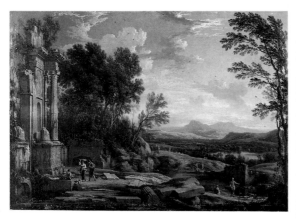 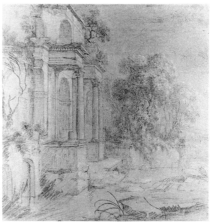

Fig. 1. Pierre Patel the Elder, LANDSCAPE WITH ANTIQUE RUINS, Offentliche Kunstsammlung, Basel.

Fig. 2. Pierre Patel the Elder, CLASSICAL RUINS IN A LANDSCAPE, The Chrysler Museum, Norfolk, Museum Purchase.

painting several landscapes for the Cabinet de l'Amour and landscape backgrounds for the Cabinet des Muses.[1] He also worked in 1660 in the apartments of Anne of Austria in the Louvre. Though he seems to have played an active role in the 1651 merger of the Paris painters' guild and the Académie Royale, he was not asked to join the newly founded Académie.

Unlike so many French landscapists of the day, Patel did not study in Italy. His classically constructed vistas embellished with nostalgic temple ruins owe an obvious debt nonetheless to the Roman works of Claude and Poussin. The tranquil, Attic landscapes of La Hyre made an impression, too, on his mature work. Patel's style was closely followed by his son, Pierre-Antoine (1646–1707), who like his father worked solely as a landscapist.

On the day of his resurrection, the newly risen Savior joined two of his disciples on the road to Emmaus and traveled with them unrecognized (Luke 24: 14ff.). Produced by Patel during his period of activity in the Hôtel Lambert, the Norfolk painting of 1652 recounts the gospel story of the Journey to Emmaus in the lower right foreground, where Christ and the two disciples appear as tiny, "staffage" figures. As is often the case in Patel's work, the biblical narrative in this instance is little more than a footnote to the landscape

itself, a mere pretext for a sweeping vista of idyllic, open countryside and crumbling, vine-covered ruins, all minutely crafted and suffused with the pink, pearly light of dusk.

The basic composition of this landscape—its broad, gently rolling expanses framed at one side by a foreground tree and closed on the other by an architectural structure placed diagonally in depth—was one of Patel's favorites.[2] In fact, a slightly earlier painting on copper by the master —the 1650 LANDSCAPE WITH ANTIQUE RUINS in the Kunstmuseum, Basel[3] — directly foreshadows the composition and imagery of the Norfolk picture (fig. 1). Patel's preliminary drawing for the left half of the LANDSCAPE WITH JOURNEY TO EMMAUS is also in the collection of The Chrysler Museum (fig. 2).[4]

NOTES:
1. The Cabinet de l'Amour originally contained thirteen landscape pictures that were ranged along the walls at eye level, just below the larger figure paintings. Of the eight landscapes that still exist, two were produced by Herman Swanevelt, three by Jan Asselin, one by Mauperché, and two by Patel. Both of Patel's surviving landscapes are found today in the Louvre. See J.-P. Babelon et al., Le Cabinet de l'Amour de l'Hôtel de Lambert. Paris, 1972, pp. 35ff., esp. pp. 37–38, nos. 54, 58, and P. Rosenberg, N. Reynaud, and I. Compin, Musée du Louvre, Catalogue illustré des Peintures. Ecole française XVIIe et XVIIIe siècles, Paris, 1974, II, p. 33, nos. 617–618.

LAURENT DE LA HYRE

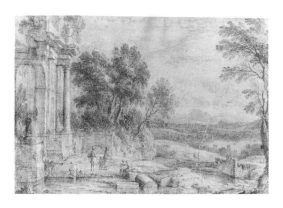

Fig. 3. Pierre Patel the Elder, LANDSCAPE WITH FIGURES, Crocker Collection, Crocker Art Museum, Sacramento, California.

2. Two comparably composed Italianate landscape paintings by Patel are in the Louvre, both of them designed in 1646 for the Cabinet de l'Amour in the Hôtel Lambert. See Rosenberg, Reynaud, and Compin (note 1), p. 33, nos. 617–618. Another similarly constructed landscape is in the Musée des Beaux-Arts, Orléans (see *The Splendid Century. French Art: 1600–1715*, exhib. cat., National Gallery of Art, Washington, D.C., etc., 1960–61, no. 88, fig. 88), and yet another is found in Great Britain, in the Birmingham Museum and Art Gallery (see *French Paintings and Sculptures of the 17th Century —Part I*, exhib. cat., Heim Gallery, London, 1968, p. 11, no. 17). A closely related pen drawing, its landscape composition reversed, is in the collection Lugt in Paris. See *Acquisitions récentes de toutes époques. Fondation Custodia Collection Frits Lugt*, exhib. cat., Institut Néerlandais, Paris, 1974, p. 23, no. 57, fig. 57.

3. Inv. no. 1181, signed and dated 1650. Oil on copper, 31 × 44.5 cm. See Rosenberg, 1972, p. 192. Patel's drawing of an architectural landscape in Sacramento's E.B. Crocker Art Museum (inv. no. 394, black chalk heightened with white on grey paper, 150 × 227 mm.) is probably a preliminary study for the Basel painting (fig. 3). See Rosenberg, 1972, p. 192, and Mahey, 1971, p. 27, no. 66.

4. Inv. no. 84.180. Black and white chalk on brown paper, 228 × 228 mm. See *Important Old Master Drawings*, Christie's, London, July 4, 1984, no. 100.

4. JOB RESTORED TO PROSPERITY

Oil on canvas, 51¾" × 39¾"
Signed and dated lower left: *L. De La Hire. in. & F. 1648.*

COLLECTIONS:
Sir Samson Gideon, Belvedere House, 1766; Sir Culling Eardley, Belvedere House, 1857; Eardley sale, Christie's, London, June 30, 1860, no. 5; Lord Forester, 1862; probably Marquis of Cholmondeley, Houghton Hall; sale, Christie's, London, March 16, 1945, no. 115; sale, Sotheby's, London, March 23, 1949, no. 137; private collection, France; sale, Hôtel Drouot, Paris, May 21, 1952, no. 39; Julius Weitzner, New York, 1953; Walter P. Chrysler, Jr., 1953; Chrysler Museum, Norfolk, 1971.

EXHIBITIONS:
British Institution, London, 1862, no. 30; Portland, 1956–57, no. 56; Provincetown, 1958, no. 34; Fort Worth, 1962–63, p. 40; Finch College, 1967, no. 29; Nashville, 1977, no. 11; Rosenberg, Paris, 1982, no. 32.

REFERENCES:
R. and J. Dodsley, *London and its Environs Described*, London, 1761, I, p. 273; T. Martyn, *The English Connoisseur*, London, 1766, I, p. 13; G.F. Waagen, *Treasures of Art in Great Britain*, London, 1854, IV-supp., p. 282; A. Graves, *A Century of Loan Exhibitions 1813–1912*, London, 1913–15, I, p. 271; A. Blunt, *Art and Architecture in France, 1500 to 1700*, Baltimore, 1954, p. 215; P. Rosenberg and J. Thuillier, "Laurent de La Hyre: The Kiss of Peace and Justice," *Bulletin of the Cleveland Museum of Art*, 61 (1974), p. 308, note 6; E. Zafran, "French Masterpieces," *Chrysler Museum Bulletin*, 5 (June 1976), p. 3; J.-P. Cuzin, "French seventeenth-century paintings from American collections," *Burlington Magazine*, 124 (1982), p. 530; A(nthony) B(lunt), *Burlington Magazine*, 124 (1982), p. 530, no. 32; P. Rosenberg, "*France in the Golden Age*: A Postscript," *Metropolitan Museum Journal*, 17 (1982), p. 28.

Together with his younger colleague Eustache Le Sueur (cat. no. 1), Laurent de La Hyre led a small group of seventeenth-century French painters who developed a flawlessly classical, Italianate aesthetic without the benefit of the customary visit to Italy. The group, whose classicizing style dominated much of the Parisian art world in the years around 1650, has come to be known as the First School of Paris.

After studying with his painter-father Etienne, La Hyre continued his artistic education at Fontainebleau and in the Paris atelier of Georges Lallemant. The Mannerist art of Fontainebleau determined his

early style of the 1630s, but by the first years of the following decade he had begun to embrace instead the coolly classical Roman manner of Nicolas Poussin, who visited the French capital in 1640–42. This decorous, classical style is very much in evidence in La Hyre's Job Restored to Prosperity.

During the 1630s and '40s La Hyre worked primarily as a painter of religious and allegorical themes. In 1635 and '37, for example, he painted two of his most important altarpieces—his two *Mays*—for the cathedral of Notre-Dame: St. Peter Healing the Sick with his Shadow and The Conversion of St. Paul.[1] In 1652 he completed a series of grisaille saints for the refectory of the Paris convent of the Minims.[2] As his career progressed, however, he became more interested in landscape painting and, according to his son Philippe, devoted his final few years to "small landscapes ornamented with architecture,"[3] which were more highly prized than his figurative works. In 1648, the year he painted the Norfolk canvas, La Hyre was made one of the twelve *Anciens*, or founding members, of the Académie Royale de Peinture et de Sculpture.[4]

An amateur musician, passionate huntsman, and capable mathematician, La Hyre also knew the Bible well. His surviving oeuvre of religious paintings contains a sizable number of Old Testament themes that had seldom or never been illustrated in earlier French art and whose rarity must have delighted the artist's private patrons.[5] Among the loveliest of these Old Testament pictures is Job Restored to Prosperity. Here La Hyre presents the rarely depicted moment from the Book of Job (42:1–12)[6] when the Lord finally ends the suffering and restores the wealth of this "perfect and upright man":

> Then Job answered the Lord, and said, I know that thou canst do everything, and that no thought can be withholden from thee . . . The Lord said to Eliphaz the Temanite . . . take unto you now seven bullocks and seven rams, and go to my servant Job . . . And the Lord turned the captivity of Job . . . also the Lord

gave Job twice as much as he had before. Then came there unto him all his brethren, and all his sisters, and all they that had been his acquaintance before . . . [and] every man also gave him a piece of money, and every one an earring of gold. So the Lord blessed the latter end of Job more than his beginning.

His trials over, a weary Job receives the tribute of his family and friends. In true Poussinesque fashion, La Hyre envisions this Old Testament account of divine restitution as a grave, high-minded drama, a moment of decorous and noble action.

One of La Hyre's early biographers, Dezallier d'Argenville, marveled at the "skillful handling of architecture and perspective" in the master's paintings.[7] The setting of the Norfolk picture—an antique temple ruin with crumbling columns—was a favorite of La Hyre and reveals his mastery in depicting classical architectural forms.[8] The colors of the temple and landscape—a delicate bouquet of lilac, green, blue, and light brown—and the clear light that informs them are superbly characteristic as well of La Hyre's gently understated art.

Notes:
1. Between 1630 and 1707, the Paris goldsmiths' guild and the royal confraternity of SS. Anne and Marcel donated annually to Notre-Dame a painting depicting an act of the apostles. These donations, presented to the church on the first of May, came to be known as *les grands Mays*, and they were painted by some of the finest French artists of the time. For the history of the *Mays* of Notre-Dame and La Hyre's two *Mays*, see P.-M. Auzas, "Les Grands 'Mays' de Notre-Dame de Paris," *Gazette des Beaux-Arts*, 36 (1949), pp. 172–200, and *idem*, "A propos de Laurent de la Hire," *Revue du Louvre*, 17 (1968), pp. 3–6.
2. M. Pinault, "Laurent de la Hyre et le couvent des Minimes de la Place Royale à Paris," *Revue du Louvre*, 31 (1982), pp. 89–98.
3. ". . . paysages en petit ornés d'architecture." See Ph. de Chennevières and A. de Montaiglon, *Abecedario de P.J. Mariette et autres notes inédites de cet amateur sur les arts et les artistes*, Paris, 1858–59, III, p. 46. For discussions of La Hyre's landscape art, see especially Pinault (note 2), pp. 91ff., and Rosenberg and Thuillier, 1974, pp. 302–308.
4. Rosenberg, Paris, 1982, p. 250.
5. Rosenberg and Thuillier, 1974, p. 305.
6. Indeed, the theme of Job restored to prosperity is so seldom depicted in art that the painting's sub-

GEORGES DE LA TOUR

5. SAINT PHILIP

ject was misidentified for nearly 200 years. The earliest known reference to the picture is found in R. and J. Dodsley's *London and its Environs Described* of 1761, where it is titled "Rebecca bringing presents to Laban." In 1857, G.F. Waagen offered another opinion, interpreting the theme as that of "Belisarius receiving alms." Not until 1949, when the picture was on the London art market (Sotheby's, March 23, 1949, no. 137), was its subject correctly identified. There are, perhaps, two later copies of the Norfolk picture, one formerly in the London collection of Curt Benedict and the other sold in Paris in 1964 (Palais Galliera, June 23, 1964, no. 31). For details, see Rosenberg, Paris, 1982, pp. 249–250.
7. ". . . habile en architecture et perspective." See Dezallier d'Argenville, *Abrégé de la vie des plus fameux peintres,* Paris, 1745, II, pp. 271ff.
8. A similar architectural setting was used by La Hyre, for example, in his *Allegory of the Peace of Westphalia* (Louvre), also of 1648. See Rosenberg and Thuillier, 1974, p. 304.

Oil on canvas, 25″ × 21″

COLLECTIONS:
Hôtel Drouot, Paris, 1941; Nicolas Czynober, Paris, 1941–73; private collection, Switzerland, 1973; Walter P. Chrysler, Jr., 1975; Chrysler Museum, Norfolk, 1977.

EXHIBITIONS:
P. Rosenberg and J. Thuillier, *Georges de La Tour,* Orangerie des Tuileries, Paris, May 10 — Sept. 25, 1972, no. 6; Nashville, 1977, no. 9.

REFERENCES:
V. Bloch, "Georges de La Tour, twee nieuwe werken," *Nederlands kunsthistorisch jaarboek,* 1 (1947), p. 140, fig. 5; F.-G. Pariset, *Georges de La Tour,* Paris, 1948, pp. 234–235, pl. 32; V. Bloch, *Georges de La Tour,* Amsterdam, 1950, p. 52, no. 6; C. Sterling, "Observations sur Georges de La Tour à propos d'un livre récent," *La Revue des Arts,* Sept. 1951, p. 155; A.-M. Bouvier, *Georges de La Tour, Peintre du roy,* Paris, 1963, p. 95; F.-G. Pariset, "Y a-t-il affinité entre l'art espagnol et Georges de La Tour?", *Vélasquez, son temps, son influence,* Paris, 1963, p. 60; *idem,* "La Tour," *Enciclopedia Universale dell'Arte,* Venice and Rome, 1963, VIII, col. 543; A. Szigethi, *Georges de La Tour,* Budapest, 1971, fig. 14; P. Rosenberg and F.M. de L'Epinay, *Georges de La Tour. Vie et Oeuvre,* Fribourg, 1973, pp. 92–96, fig. 6; F. Solesmes, *Georges de La Tour,* Lausanne, 1973, pp. 42–45, 157, no. 43, pl. 43; B. Nicolson and C. Wright, *Georges de La Tour,* London, 1974, pp. 21–24, 181–182, no. 40, pl. 30; B. Nicolson, *The International Caravaggesque Movement,* Oxford, 1979, p. 65; Rosenberg, Paris, 1982, pp. 253, 355, no. 3, ill.

La Tour and his art were forgotten soon after his death and were not rediscovered until the early twentieth century, when scholars first began to research his life and oeuvre. A mere thirty-nine of his paintings —most of them religious images of saints or genre pictures of peasants, pickpockets and cardsharps—have been recovered to date. Eleven of them are in American collections. Despite centuries of obscurity and the scarcity of his extant work, he is ranked today among the premier geniuses of seventeenth-century French painting.

La Tour was raised within a family of bakers and shoemakers in the village of Vic-sur-Seille in Lorraine, which was then a duchy independent of the French crown. It is no longer known where or from whom he learned his craft. Both the stark naturalism of his "daylight" paintings and the

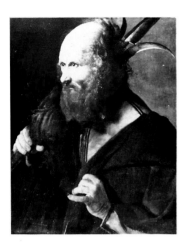 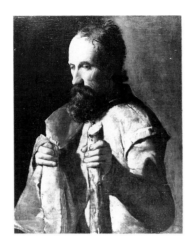

Fig. 4. Georges de La Tour, SAINT JUDE, Musée Toulouse-Lautrec, Albi.

Fig. 5. Georges de La Tour, SAINT JAMES THE LESS, Musée Toulouse-Lautrec, Albi.

magical chiaroscuro of his candlelit nocturnals betray the influence of Caravaggio and his followers, leading scholars to speculate that La Tour studied before 1616 in Rome or among the Netherlandish Caravaggisti in Utrecht.

His 1617 marriage to Diane Le Nerf —the daughter of the finance minister to the Duc de Lorraine—brought La Tour wealth and social position. After he moved his family from Vic to nearby Lunéville in 1620, he seems to have lived the life of a gentleman-painter, a country squire with a taste for hounds and hunting. He also appears to have assumed the hauteur and impatience of a *grand seigneur*, for the citizens of Lunéville complained more than once about his fiery temper and the arrogant neglect of his hunting dogs.[1]

The bloody struggle between France and Lorraine brought on by the Thirty Years War turned Lunéville into a battleground in the later 1630s and almost certainly resulted in the destruction of many of La Tour's early pictures. It may also have encouraged the artist to seek refuge and work temporarily in Paris. In any event, he was present in the French capital in 1639 and was described that year as *peintre ordinaire* to Louis XIII.[2] By 1642 the artist had returned permanently to Lunéville, where during the next decade he worked steadily for the town fathers, supplying them with six paintings for the

French governor of Lorraine, La Ferté-Senneterre. In 1652, at the age of fifty-nine, La Tour was struck down by the plague.

La Tour spent most of his career working in provincial isolation, far from the highly competitive Paris art world. His humble, often brutally realistic style of painting displays none of the urban refinements of a Vouet or Le Sueur (cat. no. 1). Indeed, his Caravaggist manner was never fashionable in Paris and had already become outmoded in much of the rest of Europe by the mid-1630s.[3] His paintings were collected nonetheless by some of the most discriminating patrons of his era—the Duc de Lorraine, Cardinal Richelieu, and Louis XIII—who may well have seen in his simple depictions of faith and suffering the same timeless truths that captivate us still today.

SAINT PHILIP, one of the earliest of La Tour's surviving works, was painted by the master around 1620 as part of a set of half-length images of Christ and the twelve apostles. The set was first mentioned in 1698, when it hung in the chapel of St. John in the cathedral of Albi, far to the south of Lunéville:

> The sixth [chapel] is dedicated to St. John . . . [in which there are] thirteen paintings representing Our Lord and the twelve apostles in gilded frames . . .[4]

The paintings were apparently donated by one of the canons of the church, Jean-Baptiste Nualard, who decorated the chapel of St. John at his own expense and was buried there in 1694.[5] How Nualard acquired the paintings is no longer known. They remained in the cathedral at least until 1795, when they were described once again as part of the decor of the chapel of St. John:

> . . . twelve small paintings the size of portraits representing the twelve apostles [executed] in a vigorous style and [painted] dark in the manner of Caravaggio.[6]

Soon after the paintings were moved to the Albi museum in the early nineteenth century, most of them were replaced by mediocre copies.[7] Of the original thirteen, only three survive—SAINT PHILIP, and the paintings of SAINT JUDE and SAINT JAMES THE LESS in the Musée Toulouse-Lautrec, Albi (figs. 4, 5).[8]

As were the other figures in La Tour's series, Philip is portrayed as a rugged man of the people. Such rustic peasant types occur throughout La Tour's art. His head bowed in prayer, Philip holds a plain wooden cross-staff tied with a cord, an attribute that surely alludes to his martyrdom, for Philip was crucified upside down, bound to the cross not with nails, but with rope. Though the painting was produced at the start of La Tour's career, its hushed stillness, broadly massed forms and carefully crafted details—for example, the saint's crystal buttons and their exquisite, light-filled shadows—forecast the reverential tone and poetic realism of his mature religious art.

NOTES:
1. Rosenberg and L'Epinay, 1973, pp. 68, 71, 76.
2. M. Antoine, "Un séjour en France de Georges de La Tour en 1639," *Annales de l'Est,* 1 (1979), pp. 17–26.
3. Rosenberg, Paris, 1982, p. 76.
4. "La sixième est dédiée à saint Jean . . . Il y a . . . treize tableaux représentant Nostre-Seigneur et les douze apôtres, dans les bordures dorées . . ." See Rosenberg and Thuillier, 1972, p. 127.
5. *Ibid.,* p. 128.
6. ". . . douze petits tableaux grandeur de portraits représentant les douze Apôtres d'une touche forte et rembrunie comme celle de Michel-Ange Caravage." *Ibid.,* p. 127.
7. These copies, nine of which survive, are found today in the Musée Toulouse-Lautrec, Albi. Among them is a copy of *Saint Philip.* See Rosenberg and L'Epinay, 1973, pp. 96–99, esp. p. 98, ill. 11.
8. Both oil on canvas, 62 × 51 cm. and 66 × 54 cm., respectively. See Rosenberg and L'Epinay, 1973, pp. 92–94.

HYACINTHE RIGAUD

6. PORTRAIT OF A GENTLEMAN

Oil on canvas, 53¼″ × 41¼″
Signed and dated lower left: *fait par hyacinthe Rigaud 1696*

COLLECTIONS:
Walter P. Chrysler, Jr.; Chrysler Museum, Norfolk, 1977.

Rigaud was descended from a family of craftsmen—painters and tailors—who had lived for generations in provincial Perpignan.[1] The penchant for precise, nearly hallucinatory realism evident in his later Paris portraits may well have been formed during his early years of study in southern France. The young Rigaud displayed a precocious talent for painting, and in 1671, at the age of twelve, he was sent by his widowed mother to Montpellier to continue his training. He remained until 1676, working under the painter Antoine Ranc, who seems to have introduced him to the Flemish portrait styles of Peter Paul Rubens and Anthony Van Dyck. From them Rigaud distilled much of the grandeur and stately elegance of his own mature portraiture.

After further study in Lyon, he arrived in Paris in 1681 to perfect his art at the Académie Royale. At first he worked to make himself known primarily as a painter of historical subjects; he won the *Prix de Rome* in 1682 with his CAIN BUILDING THE CITY OF ENOCH and was *reçu* as both a history and portrait painter in 1700.[2] By the mid 1680s his genius as a portraitist had already attracted a large and increasingly influential clientele, and at the urging of Charles Le Brun, Rigaud renounced his plans to study in Italy and concentrated instead on building his portrait practice. By the turn of the century he had consolidated his reputation as the principal portraitist of the Parisian upper classes and French crown. Louis XIV sat for Rigaud in 1694, 1701 and '15, and Louis XV, in 1716 and '30. The artist was also beseiged with portrait requests from provincial nobles and clergy and from the titled heads of other European nations. Rigaud was himself ennobled in 1727, when he was named *chevalier* of the *Ordre*

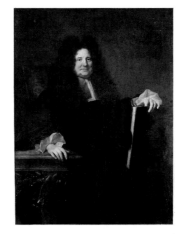

Fig. 6. Hyacinthe Rigaud, PORTRAIT OF DENIS-FRANÇOIS SECOUSSE, Musée des Beaux-Arts, Lyon.

de Saint-Michel. He rose steadily within the hierarchy of the Académie and was named *directeur* in 1733.

Rigaud painted the PORTRAIT OF A GENTLEMAN in 1696. By then the thirty-seven-year-old artist had already established an immensely successful portrait practice that drew its patrons from the aristocracy, from Parliament and the government ministries, and from the royal family as well. The three-quarter-length presentation of the sitter and his commanding, seated pose owe much to the art of Van Dyck and were compositional elements favored by Rigaud throughout his career. Indeed, an identical version of the composition is found in Rigaud's undated PORTRAIT OF DENIS-FRANÇOIS SECOUSSE in the Musée des Beaux-Arts, Lyon (fig. 6).[3] Though the identity of the Norfolk sitter is unknown, his official black robes and the weighty tome he balances on his lap suggest that he was a man of considerable position and learning—a lawyer, perhaps, or a member of Parliament.

NOTES:
1. The details of Rigaud's life are exhaustively researched by C. Colomer, *La Famille et le Milieu social du peintre Rigaud*, Perpignan, 1973. Colomer, pp. 12–13, notes that while Rigaud's grandfather was a painter, his father Matias worked as a tailor. Furthermore, he takes issue with the old belief that Rigaud received his first instruction in painting

CHARLES-ANTOINE COYPEL

7. PAINTING EJECTING THALIA
(Thalie Chassée par la Peinture)

from his great-uncle and grandfather.
2. Colomer, 1973 (note 1), p. 20.
3. Inv. no. A2726, oil on canvas, 139 × 106 cm. See *Le Musée de Lyon*, Paris, 1912, p. 52, ill.

Oil on canvas, 26″ × 32″
Signed and dated lower left: *Charles Coypel 1732*
Inscribed on the paper lower right:
> *Muse, je plains votre avanture*
> *Partez, emportez prose et vers;*
> *Pour mettre une tête a l'envers*
> *C'est bien assez de la Peinture.*

COLLECTIONS:
Baron de Linder, Russia; Comte de Canson, Paris; Galerie Jamarin, Paris, 1954; Walter P. Chrysler, Jr.

EXHIBITIONS:
Finch College, 1963, no. 13.

REFERENCES:
Mercure de France, Dec. 1733, pp. 2879–2880; J.B. de Boyer, Marquis d'Argens, *Examen Critique des Différentes Ecoles de Peinture*, Berlin, 1768 (Minkoff reprint, Geneva, 1972), pp. 244–245; F. Ingersoll-Smouse, "Charles-Antoine Coypel," *La Revue de l'Art ancien et moderne*, 37 (1920), p. 146; I. Jamieson, *Charles-Antoine Coypel, Premier Peintre de Louis XV et Auteur Dramatique (1694–1752)*, Paris, 1952, p. 83; A. Schnapper, "A propos de deux nouvelles acquisitions: 'Le chef-d'oeuvre d'un muet' ou la tentative de Charles Coypel," *Revue du Louvre*, 17 (1968), p. 254, note 3; P. Rosenberg, *Chardin 1699–1779*, exhib. cat., Grand Palais, Paris, etc., 1979, pp. 288–289, ill.; E. Zafran, "Charles Antoine Coypel's *Painting Ejecting Thalia*," *Apollo*, 111 (April 1980), pp. 280–287, pl. 1; S. Taylor, "Engravings within Engravings: Symbolic Contrast and Extension in some 18th-century French Prints," *Gazette des Beaux-Arts*, 106 (1985), p. 63.

Charles-Antoine Coypel was the last of a distinguished dynasty of painters that stood for nearly a century at the pinnacle of official French art. His grandfather, Noël Coypel (1628–1707), directed the Académie Royale under Louis XIV. His father Antoine (1661–1722) succeeded Noël as head of the Académie and achieved even greater fame as *premier peintre du Roi*. Charles-Antoine's illustrious lineage surely predetermined his career as a painter. Trained by his father, he dispensed with the customary trip to Italy and moved at once to establish himself in Paris as a painter of exalted historical themes in the tradition of Antoine and Noël Coypel. In 1715, when he was barely twenty-one, he was admitted to the Académie, his *morceau de réception* the rather hastily painted MEDEA PURSUED BY

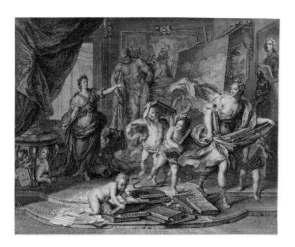

Fig. 7. Bernard Lépicié after Charles-Antoine Coypel, PAINTING EJECTING THALIA, The Metropolitan Museum of Art, New York, Rogers Fund, 1962 (62.602.569).

JASON.[1] Within a year he was at work for the Gobelins tapestry factory, supplying cartoons for the STORY OF DON QUIXOTE. With this highly regarded suite of twenty-eight designs, his career in Paris was launched. When his father died in 1722, Charles-Antoine inherited his place as first painter to the royal regent, Philippe d'Orléans, and soon after Louis XV ascended the throne in 1723, he became the preferred artist of Queen Marie Leszczynska, a position he maintained until his death.[2] His years of faithful service to the Académie and the crown were rewarded in 1747, when he was made both director of the Académie and *premier peintre du Roi*.

While still in his early twenties, the artist had also begun to work as a playwright. Indeed, Coypel made his debut as a dramatic author in 1718, when his play, *Les Amours à la chasse*, was performed at the Comédie Italienne. His subsequent work for the stage, however, was not well received by the critics. Of his many later plays, few were performed, and only one, *Les Folies de Cardenio* of 1720, was published before his death.[3]

Coypel's abiding interest in the theater was reflected directly in the themes and tone of his paintings. Not only were the subjects of several of his pictures and

tapestry designs taken from the stage, but the dramatic tenor of his painted figures —their intense expressions and broad, histrionic gestures— was clearly colored by the conventions of the theater.

These theatrical qualities are readily evident in Coypel's light-hearted allegory of 1732, PAINTING EJECTING THALIA, in which the artist, with characteristic vivacity and charm, reveals the frustrations of simultaneously pursuing two careers —painting and playwriting. Here the female personification of Painting, standing at the right with palette and mahlstick in hand, banishes Thalia, the Muse of Comedy, from the artist's studio. Exiting with a stack of folios cradled in her skirts, Thalia is accompanied in her flight by several *génies*, who hastily collect the rest of the papers and folios that litter the studio floor. The books bear the names of Coypel's plays and, thus, are clearly meant to symbolize the artist's dramaturgical efforts.[4] Attached to the canvas at the lower right is a piece of paper inscribed with a quatrain in French. Most certainly composed by Coypel himself, the verses liken Thalia to a mistress spurned:

> Muse, I have had enough of your affair.
> Leave, and take prose and poetry with you;
> To turn one's head
> Painting is quite enough.

Coypel had already established the mise en scène of the painting five years before, in a 1727 gouache drawing today in the Bibliothèque Nationale, Paris.[5] A year after Coypel completed the painting, Bernard Lépicié made an engraving after it (fig. 7).[6] Exhibited at the 1738 Salon, Lépicié's print also carries an inscription that sheds more light on the meaning of Coypel's work:

> This allegory was conceived upon the subject of a person who has sacrificed to the study of painting the taste that he had had for composing theatrical works.[7]

In the past, scholars have assumed that the painting signaled Coypel's decision to abandon forever his career as a dramatist and to concentrate all of his energy on painting. Actually the artist continued to write plays after 1732. As Eric Zafran

has suggested, the painting and earlier drawing may have been intended instead as somewhat less definitive statements of Coypel's professional priorities, statements prompted by the death of his father and his own increasing prominence as a painter in the years around 1730. Indeed, Coypel was made professor of painting at the Académie in early 1733, and "he may have felt the need at this time to take some public stand showing which of the two arts he considered the more important."[8]

The objects ranged along the walls in the painting reflect the prevailing aesthetic theories of the day and also advertise Coypel's own accomplishments as a painter. The casts of the Farnese Hercules and Belvedere Torso—placed just behind the figure of Painting—allude to the classical regimen followed by all students at the Académie. The picture hanging behind the Hercules is the *modello* for the cartoon of Coypel's SACRIFICE OF IPHIGENIA of 1730, one of the artist's most famous tapestry designs.[9] On the opposite wall, in the extreme upper left corner, is Coypel's own self-portrait. Gazing out brightly at the viewer, he presides over one of the most fascinating and disarmingly personal disquisitions on the profession of painting ever offered by a European artist.

NOTES:
1. Coypel was so displeased with this, his inaugural effort as a master painter, that in 1746 he persuaded the Académie to let him remove the painting and substitute another piece. See Jamieson, 1952, p. 2.
2. Ingersoll-Smouse, 1920, p. 148.
3. Zafran, 1980, p. 280.
4. As Zafran, 1980, p. 284, has noted, some of the folios are inscribed with the names and dates of plays that Coypel wrote only in 1735 and '36, several years after he composed the painting. Zafran rightly concludes from this that the picture must have remained with Coypel after he finished it and, thus, been subject to certain changes, like the addition of the names of his later plays.
5. Jamieson, 1950, pp. 79, 110, and Zafran, 1980, p. 280.
6. Ch. Le Blanc, *Manuel de l'amateur d'estampes,* Paris, 1856–1888, II, p. 537, no. 14A. The Lépicié print was featured in Chardin's 1751 painting of the *Bird-Song Organ*. For details, see Rosenberg, 1979, pp. 288–289.
7. Zafran, 1980, p. 281: "Cette Allegorie a été imaginée au sujet d'une personne, qui a sacrifié à

l'étude de la Peinture, le goût qu'elle avoit à composer des pièces de Théâtre."
8. Zafran, 1980, p. 280.
9. *Ibid.*, p. 281.

8. THE ARTIST IN HIS STUDIO

Oil on canvas, 58½″ × 45½″
Signed lower right: *Peint Par N. de Largillierre*

COLLECTIONS:
Comte de Montreuil, Paris, by 1928; Princesse de
Faucigny-Lucinge, Paris, by 1952, to 1954; Walter P.
Chrysler, Jr.; Chrysler Museum, Norfolk, 1971.

EXHIBITIONS:
N. de Largillierre, Petit Palais, Paris, May-June,
1928, no. 62; *Chefs-d'oeuvre des collections parisiennes*,
Musée Carnavalet, Paris, Nov.-Dec., 1950, no. 34;
Cent portraits d'hommes du XIVe siècle à nos jours,
Galerie Charpentier, Paris, 1952, no. 49a; Portland,
1956–57, no. 61; *Paintings from Private Collections.
Summer Loan Exhibition*, Metropolitan Museum of
Art, New York, 1958; Finch College, 1963, no. 3;
Finch College, 1967, no. 52; *Gods and Heroes,
Baroque Images of Antiquity*, Wildenstein Gallery,
New York, Oct. 30, 1968—Jan. 4, 1969, no. 20;
Nashville, 1977, no. 17; M. N. Rosenfeld, *Lar-
gillierre and the Eighteenth-Century Portrait*, Montreal
Museum of Fine Arts, Sept. 19—Nov. 15, 1981,
no. 45.

REFERENCES:
C. Gronkowski, "L'exposition N. de Largillierre au
Petit Palais," *Gazette des Beaux-Arts*, 17 (1928), pp.
325–326; J. Van Renssalaer Smith, *Nicolas Lar-
gillierre. A Painter of the Régence,* diss. University of
Minnesota, 1964, pp. 117–119; G. de Lastic, "Por-
traits d'artistes de Largillierre," *Connaissance des Arts*,
9 (1979), p. 20; *idem*, "Largillierre et ses modèles.
Problèmes d'iconographie," *L'Oeil*, 323 (1982), p.
27; *idem*, "Largillierre à Montréal," *Gazette des
Beaux-Arts*, 102 (1983), p. 37.

Like his friend and rival Hyacinthe Rigaud
(cat. no. 6), Largillierre was one of the
most celebrated French portrait painters of
the late-seventeenth and early-eighteenth
century. His artistic training was interna-
tional in scope, for though he was Parisian
by birth, he learned his craft among Flem-
ish and Italian painters in Antwerp and
London. His father, a Paris hat merchant,
moved the family to Antwerp when Lar-
gillierre was only three. There, between
1668 and 1673, the youth was apprenticed
to Antoine Goubau, a Flemish painter
who devoted himself to Italianate land-
scapes and genre scenes in the manner of
Pieter van Laer. As one of his early biogra-
phers reports, Largillierre worked as a still-
life specialist in Goubau's shop, adding
fruit, game, and other details to the
master's market pictures.[1]
Largillierre may have visited England

in 1665. He was certainly there in
1675–79, when he assisted the Italian
painter Antonio Verrio in the decoration of
the royal apartments at Windsor Castle.[2]
Largillierre's few, extant paintings from
this English period are all still lifes. He
must, however, have studied Verrio's alle-
gorical portrait schemes and perused with
even greater interest the English court por-
traits of Peter Lely and Anthony Van Dyck,
for upon his return to Paris in 1679, he
abandoned still-life painting and began to
produce full-blown Baroque portraits in
the manner of Lely and Van Dyck. Spon-
sored by Charles Le Brun, the powerful
director of the Académie Royale and first
painter to Louis XIV, Largillierre joined
the Académie in 1686, offering as his
morceau de réception the PORTRAIT OF
LE BRUN found today in the Louvre.
He advanced gradually through the hierar-
chy of the Académie. In 1705 he became a
full professor; in 1722, rector; and in 1738,
director of the Académie.

In 1689 Largillierre completed the
first of five large group portraits for the
provost and aldermen of Paris. These
important municipal commissions estab-
lished his reputation early on as the princi-
pal portraitist of the city's professional
classes. While he enjoyed his share of aris-
tocratic patronage in the years that
followed, he continued to draw his clients
mainly from the Paris *haute bourgeoisie*,
from the ranks of its lawyers, government
officials, financiers, and artists. For these
well-placed sitters he devised a highly
flattering portrait type, one that blended
the grandeur and refinement of French
court portraiture with the penetrating
naturalism of the middle-class portrait.

As Myra Nan Rosenfeld has shown,
Largillierre began to alter his style around
1700. Under the influence of Rubens and
Titian, he renounced the subdued colors
and precise detail of his earlier pieces for a
brighter palette and more summary, atmo-
spheric ambience.[3] His mature work also
reveals a new informality and directness in
the presentation of his sitters,[4] a shimmer-
ing surface lightness that proclaims his
central role in the formation of the Rococo.

Largillierre painted the splendid por-
trait group in The Chrysler Museum rela-

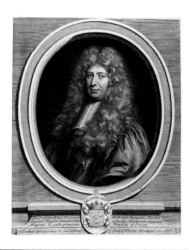

Fig. 8. Gerard Edelinck after Nicolas de Largillierre, PORTRAIT OF THOMAS-ALEXANDRE MORANT, Bibliothèque Nationale, Paris. Photo. Bibl. nat. Paris.

tively early in his Paris career—around 1686–90, about the time he joined the Académie. Scholars have identified at least three of the four men depicted. At the right, seated in a gilded chair with palette and brushes in hand, is Largillierre himself,[5] his youthful features still free of the fullness evident in later self-portraits. Joining him in his studio[6] is the Flemish engraver Gerard Edelinck (1640–1707), who moved from Antwerp to Paris in 1666 and soon became a leading printmaker in the French capital. Edelinck regularly made engravings from Largillierre's portraits, and in the Norfolk picture he and the artist hold one of these portrait prints, his 1685 engraving of the royal magistrate, Thomas-Alexandre Morant (fig. 8). The source for the engraving—Largillierre's painted image of Morant—is displayed on the easel at the left,[7] and though Edelinck points with pride to his print, he also gazes respectfully at the work of art that inspired it. The man standing behind Edelinck has yet to be identified, but he may well be Pierre Bernard, who commissioned Edelinck's engraving of Morant.[8]

Eager to own images of famous contemporaries, many Frenchmen in Largillierre's day collected prints like the one included in this painting. The commercial collaboration of portrait painter and engraver could, therefore, be immensely profitable to both parties, while bringing art images to a mass audience at affordable prices. In the Norfolk picture Largillierre documents the production of Edelinck's engraving from his portrait of Morant. In the process, he celebrates the cooperative enterprise of painter, engraver, and patron, the kind of joint professional effort that enriched his own career and was so vital to the artistic life of seventeenth-century Paris.

The curriculum of the Académie Royale as formulated by Le Brun stressed drawing and the study of classical sculpture as key components of an artist's education. Largillierre endorses these principles in the still life at the lower left of the painting. There we see a portfolio of drawings, a roll of paper, and casts of three antique sculptures: the Belvedere Torso, Vatican "Antinoüs," and a bust of Athena.[9] With these objects the artist pays tribute to the academic practices that, in his time, underlay the art of both painter and engraver and led ultimately to the creation of works like the portrait and print of Morant.

NOTES:
1. A.-J. Dézallier d'Argenville, *Abrégé de la vie des plus fameux peintres,* III, 1752, p. 247; see also Rosenfeld, 1981, pp. 28, 82.
2. Rosenfeld, 1981, p. 30.
3. *Ibid.,* p. 107.
4. *Ibid.,* p. 107.
5. In recent publications (1982, 1983), Georges de Lastic has convincingly identified this figure as Largillierre himself, thus ending years of scholarly debate concerning the sitter's identity. Indeed, Largillierre confirms his identity here with a clever conceit. The colors of the paint daubs on his palette —blue, gold, grey, white, and shades of rust and brown (somber hues typical of his early work)—are precisely those used in the Norfolk piece. Thus the sitter holding the palette reveals himself as the author of the painting in which he appears—i.e., as Largillierre.
6. As Rosenfeld, 1981, p. 230, has observed, the atelier pictured here—with its symbolic still life and back wall opening on to a landscape—is an idealized evocation of the artist's studio.
7. A portrait of Morant by Largillierre is found today at Versailles (inv. no. MV 4410). The Versailles image deviates slightly from the Edelinck engraving, yet could still have served as its principal compositional source. For the Versailles portrait, see A. Gordon, *Masterpieces From Versailles. Three Centuries of French Portraiture,* exhib. cat., National Portrait Gallery, Washington, D.C., 1983, pp. 52–53, no. 9.

JEAN-FRANÇOIS DE TROY

9. CHRIST AND THE CANAANITE WOMAN

Oil on canvas, 76½″ × 57½″
Signed and dated upper right: *De Troy à Rome
1743*

10. CHRIST IN THE HOUSE OF SIMON

8. Rosenfeld, 1981, p. 229.
9. *Ibid.*, p. 230. The extent to which these objects function specifically as endorsements of Le Brun's academic theories can be gauged by studying Largillierre's contemporary *Portrait of Le Brun.* There the same objects—a drawings portfolio and casts of the "Antinoüs," Belvedere Torso, and head of Athena—appear as symbolic references to the aesthetic ideals upheld by the director of the Académie. It is also interesting to note that Largillierre derived his seated, crossed-leg pose from the figure of Le Brun in the 1686 Louvre portrait.

Oil on canvas, 76¾″ × 57½″
Signed and dated lower left: *1743 De Troy à
Rome*

COLLECTIONS:
The artist, 1743–1752; the artist's estate sale, Paris, April 9, 1764, both no. 277; Frances Lady Ashburton; sale, Christie's, London, Dec. 16, 1949, nos. 18–19; Leger Gallery, London; Newhouse Galleries, New York, 1954; Walter P. Chrysler, Jr.; Central Picture Galleries, New York (*Christ and the Canaanite Woman* only); Norfolk Museum of Arts and Sciences, 1969 (*Christ and the Canaanite Woman* only); both, Chrysler Museum, Norfolk, 1971 (*Christ in the House of Simon*, the gift of Walter P. Chrysler, Jr.; *Christ and the Canaanite Woman*, Museum Membership Purchase, 1969).

EXHIBITIONS:
Portland, 1956–57, no. 62 (*Christ in the House of Simon* only); Finch College, 1963, nos. 5–6; E. Zafran, *The Rococo Age*, High Museum of Art, Atlanta, Oct. 5—Dec. 31, 1983, no. 9 (*Christ in the House of Simon* only).

REFERENCES:
G. Brière, "Detroy 1679 à 1752," in L. Dimier, *Les Peintres français du XVIIIe siècle*, Paris, 1930, II, p. 45, nos. 7–8; F. Watson, "A Note on Some Missing Works by De Troy," *Burlington Magazine*, 92 (1950), p. 50; A. Busiri Vici, "Opere Romane di Jean de Troy," *Antichità Viva*, 2 (March-April 1970), no pag., fig. 8; D. Ternois, "En marge du 'Jugement de Salomon' de Jean-François de Troy," *Bulletin des Musées et Monuments Lyonnais*, 6 (1978), pp. 128–130, figs. 6–7; E. Zafran, *The Rococo Age*, exhib. cat., High Museum of Art, Atlanta, 1983, pp. 39–40, fig. I. 7 (*Christ and the Canaanite Woman*); J. Baillol, "French Rococo Painting: A Notable Exhibition in Atlanta," *Apollo*, 119 (1984), p. 17.

Jean-François de Troy received his first instruction in painting from his father, the fashionable Parisian portraitist and director of the Académie Royale, François de Troy (1645–1730). Later the elder de Troy enrolled his son in the Académie schools. If early biographies can be trusted, Jean-François initially proved an indifferent student, a wayward gallant more interested in amorous adventure than in studying art.[1] When he failed to win the *Prix de Rome*—the coveted government

scholarship that allowed the Académie's finest students to complete their training in Italy—the elder de Troy sent him to Rome, in 1699, at his own expense. There his father's influence gained him acceptance as a *pensionnaire* at the Académie de France. Jean-François traveled widely while in Italy, visiting Florence, Pisa, and probably Venice and Naples. He returned to Paris in 1706 and, once again with his father's backing, was admitted to the Académie, entering as a history painter in 1708. He became an adjunct professor at the Académie in 1716, and three years later, a full professor.

De Troy's career took flight in the early 1720s, when he completed the first of several large commissions for the city of Paris—his PLAGUE IN THE CITY OF MARSEILLES of 1722 (Musée des Beaux-Arts, Marseilles)—and made his public debut at the Académie's temporarily revived Salon (1725). There he exhibited four lofty historical subjects drawn from classical legend and the poetry of Tasso (LEDA AND THE SWAN, DIANA AND ENDYMION, THE SACRIFICE OF IPHIGENIA and RINALDO AND ARMIDA) and four of his small-scale genre pictures of aristocratic dalliance, his elegant *tableaux de modes*. Such early displays of virtuoso eclecticism confirmed his standing as a painter of extraordinary range, and over the next decade de Troy was called upon to produce religious paintings, mythologies, portraits, landscapes, and more of his popular *tableaux de modes*.

His fame as a decorator of fashionable Paris townhouses—in 1728–29, for example, he painted scenes from Roman history in the apartments of the financier Samuel Bernard—led to a few royal commissions in the mid-1630s. He collaborated with Charles Joseph Natoire and François Boucher (cat. no. 12) in the decoration of the queen's chamber at Versailles, where he painted an ALLEGORY OF LOUIS XV'S CHILDREN (1734). At Versailles he painted a lion hunt (1736) and, for the dining room at Fontainebleau, a suite of hunting scenes (1737).[2] In all of these works de Troy displayed a charming, yet vigorous painting style, one that blended the delicacies and refinements of

the Rococo with the more robust, Baroque language of Rubens and Jacob Jordaens.

To encourage the nation's history painters, the Duc d'Antin—the royal *Directeur des Bâtiments*—instituted a competition in 1727. Twelve artists entered their works in the famous *Concours*, vying for the king's prize of five thousand *livres* and the prestige that first place would bring. After much deliberation, the prize was awarded jointly to de Troy and François Le Moyne. The resulting rivalry that sprung up between the two painters ended in disappointment for de Troy in 1736, when Le Moyne, and not he, was chosen *premier peintre du Roi*. Soon after, in 1738, de Troy returned to Rome as director of the Académie de France, remaining in Italy for the rest of his life.

By 1736 de Troy had already begun creating tapestry designs for the royal manufactory, the Gobelins. After his return to Rome he continued to supply the Gobelins with even larger cartoons, chief among them his STORY OF ESTHER series, which brought him great acclaim at the Salons of 1740 and '42. Liberated by the monumental scale of these later tapestry designs, de Troy evolved in his second Roman period a dramatic, grand manner, a weighty, classic figure style that owed much to the art of Jean Jouvenet and the Baroque painters of Naples.[3]

De Troy's mature style is splendidly revealed in the Norfolk pendants of 1743, CHRIST AND THE CANAANITE WOMAN and CHRIST IN THE HOUSE OF SIMON.[4] Each depicts Christ blessing an outcast woman,[5] revealing his compassion for the downtrodden victim who, despite everything, remains faithful. The subject of the first painting is taken from Matthew 15:22–28. In these verses a Canaanite woman begs Christ to banish the devil that "grievously vexed" her daughter. Christ observes that because the woman is not a Jew, he cannot help her, cannot "take the children of Israel's bread and cast it to dogs." Turning his metaphor to her own advantage, the woman responds: "Truth, Lord: yet the dogs eat of the crumbs which fall from their master's plate." (The dog in de Troy's painting serves as a traditional allusion to this exchange.) Though his dis-

ciples object, Christ then blesses the woman for her faith and miraculously heals her daughter. The second painting is taken from Luke 7:36–50. While supping with his followers in the house of Simon the Pharisee, Christ is approached by a sinful woman who humbly washes his feet with her tears, dries them with her hair, and covers them with ointment from an alabaster jar. When Simon—the turbaned figure in de Troy's painting—wonders that so lowly a creature should be allowed to touch the Lord, Christ praises the woman for her faith and love, and pardons her sins.[6]

The two paintings were first mentioned in the 1764 sale of de Troy's estate. There they were recorded as " 'the Canaanite Woman'. . . composed of nine figures" and " 'the Meal in the House of the Pharisee'. . . of eight figures."[7] The broad handling and stark monumentality of the CANAANITE WOMAN contrast with the more finely worked and opulent CHRIST IN THE HOUSE OF SIMON, where the figures all but vanish beneath billowing waves of brilliant-hued fabric. Joseph Baillio has aptly described CHRIST IN THE HOUSE OF SIMON as a characteristic example of de Troy's "grandiose religious machines . . . its huge figures literally crammed into the composition, with Christ oddly subordinate . . . to the kneeling adulteress and the pasha-like priest."[8]

NOTES:
1. According to Brière, 1930, p. 2, early accounts of the young de Troy's romantic exploits read like the "memoires of Casanova."
2. Zafran, 1983, p. 39.
3. *Ibid.*
4. *Ibid.*, p. 40, sees Jouvenet's *Christ in the House of Simon* of 1706 (Musée des Beaux-Arts, Lyon) as a major source for the composition and imagery of the Norfolk painting of the same subject.
5. *Ibid.*
6. De Troy's interest in such subjects seems to have been especially strong in the years around 1743. Indeed, in a 1742 set of six large canvases painted for the Cardinal de Tencin of Lyon, de Troy included a *Christ and the Adulterous Woman* and *Christ and the Samaritan Woman*, both lost today. For these six representations of New Testament, Old Testament and classical themes, see Ternois, 1978, pp. 124ff.
7. "Deux tableaux, l'un représentant *la Cananée,* et l'autre *le Repas chez le Pharisien.* Le premier est composé de neuf figures, et le second de 8 . . . Ces deux morceaux tiennent dans la manière des plus grands Maîtres, le coloris vigoureux et l'expression dans les Figures y est porté à un degré éminent." See *Catalogue d'une collection de très beaux tableaux, desseins et estampes . . . partie de ces effets viennent de la succession de feu Mr. J.B. {sic} de Troy,* April 9, 1764, p. 65, no. 277.
8. Baillio, 1984, p. 17.

LOUIS TOCQUÉ

11. PORTRAIT OF CHARLES-FRANÇOIS-PAUL LENORMANT DE TOURNEHEM

Oil on canvas, 54¼″ × 41¾″
Inscribed on the verso lower right: *L. Tocquet. pinxit.*

COLLECTIONS:
Prince Bilosselsky, Leningrad; Bilosselsky-Belozersky sale, Georges Petit, Paris, June 17, 1921, no. 13; Galerie Jamarin, Paris; Walter P. Chrysler, Jr.; Chrysler Museum, Norfolk, 1971 (gift of Mr. and Mrs. Jacob John Gurdus and Walter P. Chrysler, Jr.).

REFERENCES:
A. Doria, *Louis Tocqué*, Paris, 1929, pp. 14, 140, under no. 325.

Louis Tocqué's early training with his painter-father Luc was cut short when the elder Tocqué died in 1710. The youth, having lost his mother as well, was taken in hand by his father's Parisian colleagues, who enrolled him in the Académie schools. After a brief stay with the painter Nicolas Bertin, he entered, ca. 1718, the atelier of the renowned portraitist Jean-Marc Nattier, who kept Tocqué with him for eight years. Under Nattier's direction, Tocqué made copies of the portraits of Van Dyck, Rubens, Titian, Rigaud, Largillierre and thereby laid the foundation for his own portrait art. Tocqué's enduring friendship with Nattier was strengthened in 1747, when he married his daughter.

The painter's earliest recorded work is the 1730 group image of THE FAMILY OF ABRAHAM PEIRENC DE MORAS. (The paterfamilias was Louis XV's Master of Petitions.) As a result of this piece, Tocqué was made an associate member of the Académie Royale, and three years later he was fully admitted as a portrait specialist. His first royal commissions came in 1737–38, when he was summoned to Versailles to paint the young dauphin and his mother, Queen Marie Leszczynska. Like Rigaud earlier in the century (cat. no. 6), Tocqué was now favored with a steady stream of requests from the French aristocracy, who responded enthusiastically to his staid and solid portrait style. By midcentury he ranked among the most famous Parisian painters.

In 1756, at the king's command, Tocqué departed for St. Petersburg to serve as official portraitist to the Czarina Elizabeth I. He remained in Russia for two years, during which time he painted portraits of the Empress and a score of her retainers. From St. Petersburg the artist went on to Copenhagen, where several members of the Danish royal family sat for him and he was enrolled, with great pomp, in the Danish Academy of Painting.

Tocqué returned triumphantly to Paris in the summer of 1759 "laden with riches, gifts, and honors."[1] So profitable had his northern sojourn been that the artist virtually retired from painting. After 1759 he no longer sent his works to the Salon, and after 1763 he seems to have laid down his brush for good. During the final decade of his life he lived "at rest and in silence" in his Louvre apartments, devoting himself to his family and his administrative duties at the Académie.

The subject of the Norfolk portrait, Charles-François-Paul Lenormant, Seigneur de Tournehem (1684–1751), was a wealthy financier and a trusted advisor to the crown. During the 1720s and '30s he served as protector and guardian to the young Mme de Pompadour, who in time would become Louis XV's mistress. In fact, he was rumored to be the natural father of Pompadour and her brother, the future Marquis de Marigny. Early in his career he served the king as ambassador to Switzerland and as farmer-general of the revenues. In 1746 he was named *Surintendant Général des Bâtiments du Roi*, the chief administrator of all artistic projects connected with the crown. As such, he supervised the business of the Académie, dispensing royal commissions to its members and making recommendations to the king regarding such matters as the appointment of *premier peintre du Roi*. Tournehem maintained his position as *surintendant* until his death, when he was succeeded by Marigny.

In 1750, the year before he died, Tournehem commissioned Tocqué to paint his portrait. The piece, which was shown at the 1750 Salon,[2] was immensely popular among the artist's colleagues. An autograph replica of the portrait was gratefully received by the Académie later in the same

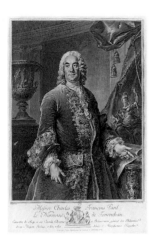

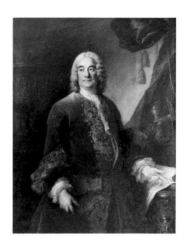

Fig. 9. Nicolas-Gabriel Dupuis after Louis Tocqué, PORTRAIT OF LENORMANT DE TOURNEHEM, Louvre, Paris. Phot. Bibl. nat. Paris.

Fig. 10. Louis Tocqué, PORTRAIT OF LENORMANT DE TOURNEHEM, Musée national du château de Versailles.

year,[3] and in the spring of 1751 the academicians ordered Nicolas-Gabriel Dupuis to make an engraving of it. Dupuis offered the engraving as his reception piece in 1754 and exhibited it at the Salon the following year (fig. 9).[4] Two more replicas of the portrait—"entirely retouched" by Tocqué[5]—were painted in 1751. One of these, commanded again by the Académie, is found today at Versailles (fig. 10).[6] The second was made for Marigny, who secured yet another replica from Tocqué in 1752 for Pompadour's husband and Tournehem's nephew, Le Normant d'Etioles.[7] It is not known for certain if the Norfolk painting is Tocqué's prototype—the portrait he displayed at the 1750 Salon—or, like the Versailles example, one of the replicas he painted in 1751–52. As Arnauld Doria noted in 1920, however, the condition of the Norfolk portrait is far better than that of the Versailles version, "its tonality clearer and fresher."[8]

The painting shows Tournehem in his role as royal *surintendant*. Lavishly attired in a embroidered doublet of apricot velvet and holding a black *tricorne*—a three-cornered hat—under his arm, he stands before his worktable and with his left hand points to the architectural plan resting upon it, as though busy with one of the king's buildings. Also on the table is a bronze statuette of Minerva, who as goddess of wisdom and patroness of the arts inspires and watches over his work.

NOTES:
1. "Chargé de richesses, de présents et d'honneur," as the engraver Wille wrote after visiting with Tocqué in July of 1759. See Doria, 1920, p. 24.
2. *Ibid.*, pp. 139–140, no. 324. Doria did not know of its whereabouts, nor are they known today.
3. *Ibid.*, p. 140, no. 325. Doria reports that this replica was presented to the Académie on October 31, 1750, by the king's *premier peintre*, Charles-Antoine Coypel.
4. Ch. Le Blanc, *Manuel de l'amateur d'estampes*, Paris, 1856–1888, II, pp. 97, 98, 102.
5. "Entièrement retouchées par l'auteur," Tocqué himself wrote in his personal records of December 1, 1751. See Doria, 1920, p. 140.
6. Inv. no. 3774, oil on canvas, 134 × 104 cm. In the past the Versailles version has sometimes been described as the replica presented to the Académie in 1750. However, Roland Bossard of the Musée National de Versailles recently reported (in a letter of February 28, 1985) that the painting is currently viewed as the 1751 replica destined for the Académie. Contrary to what is sometimes reported in the literature, the Musée des Beaux-Arts in Dijon does not possess the other replica of 1751.
7. Doria, 1920, p. 140, under no. 325.
8. *Ibid.*

FRANÇOIS BOUCHER

12. PASTORALE: THE VEGETABLE VENDOR

Oil on canvas, 95″ × 67″
Signed lower right: *f. Boucher.*

COLLECTIONS:
Hôtel of the Duc de Richelieu, Paris, until 1852; sale, Paris, May 18, 1952, no. 2; Baron de Rothschild; Alphonse de Rothschild, Paris, 1954; Robert Lebel, Paris, 1954; Walter P. Chrysler, Jr.; Chrysler Museum, Norfolk, 1971.

EXHIBITIONS:
Portland, 1956–57, no. 65; *The Age of Elegance: The Rococo and its Effect*, Baltimore Museum of Art, April 25—June 14, 1959, no. 6; Finch College, 1963, no. 22; Nashville, 1977, no. 22; *François Boucher,* Tokyo Metropolitan Art Museum and Kumamoto Prefectural Museum of Art, April 24—August 22, 1982, no. 6.

REFERENCES:
H. Macfall, *Boucher,* London, 1908, p. 149; R. Slatkin, *François Boucher in North American Collections,* exhib. cat., National Gallery of Art, Washington, D.C., etc., 1974, p. 41; W. Hovey, *Treasures of the Frick Art Museum,* Pittsburgh, 1975, p. 108; A. Ananoff, *François Boucher,* Geneva, 1976, I, pp. 214–217, no. 83, II, pp. 279–281; D. Posner, "Alexandre Ananoff, *François Boucher,*" *Art Bulletin,* 60 (1978), p. 561; A. Ananoff and D. Wildenstein, *L'opera completa di Boucher,* Milan, 1980, p. 91, no. 82; A. Laing *et al., François Boucher 1703–1770,* exhib. cat., Metropolitan Museum of Art, New York, etc., 1986–87, pp. 163–168, fig. 119.

Boucher was the principal painter during Louis XV's reign and the quintessential exponent of French Rococo style. Taught first by his father, an obscure Parisian painter and embroidery designer named Nicholas Boucher, he trained briefly thereafter with the great François Le Moyne. By the tender age of twenty Boucher had already distinguished himself as a history painter of great promise, winning first prize at the Académie Royale with a seldom depicted Old Testament subject, EVILMERODACH FREEING JEHOIACHIN FROM PRISON.[1] His boundless energy and creative range were also revealed early. Indeed, between 1721 and 1726 he lent his hand to several large artistic enterprises in Paris, including Jean-Baptiste Massé's project to engrave the paintings in the Grande Galerie and Salons de la Guerre et de la Paix at Versailles.

In 1727 Boucher departed for Italy, where he responded warmly to the Baroque art of Luca Giordano, Pietro da Cortona and Giovanni Benedetto Castiglione. Returning home four year later, he rapidly came to the fore in Paris. In 1734 he was admitted to the Académie Royale—his presentation piece was the seductive RINALDO AND ARMIDA now in the Louvre—and the next year completed his first royal commission, painting four grisaille virtues on the ceiling of the queen's chamber at Versailles.

Though besieged with requests for historical, mythological, and pastoral genre pictures, Boucher launched a second career as a designer of tapestries. From 1736 to 1755 he created cartoons for the tapestry works at Beauvais, and in such immensely popular suites as his CHINESE HANGINGS (1742) and THE NOBLE PASTORAL (1755) he gave full rein to his decorative genius. By 1755 he had become director of the royal tapestry factory, the Gobelins, a position he held until 1764. Boucher also worked for the theater—after 1737 he regularly supplied the Opéra with designs for stage sets—and he faithfully met his duties as professor at the Académie. Among his students was the painter Jean-Honoré Fragonard.

From 1746 Boucher enjoyed the enthusiastic patronage of Mme de Pompadour, Louis's *maîtresse en titre,* and through her sponsorship became the most favored artist at court. His career reached a triumphant climax in 1765, when he was named both director of the Académie and first painter to the king.

Despite the many official accolades, Boucher was subjected to criticism toward the end of his life. An increasing number of artistic reformers—chief among them, Denis Diderot—had grown impatient with the Rococo, denouncing it as artificial and immoral and calling for a revival of more serious, edifying subjects based upon sterner, classical precepts. As a leader of the Rococo, Boucher was singled out for harsh attacks by these critics during the 1760s. Diderot was particularly offended by Boucher's pastorals. In these bucolic genre scenes the artist had fashioned an idyllic realm of perfect, unfettered love, an arcadian dream world where comely young

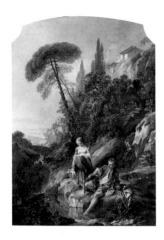

Fig. 11. François Boucher, PASTORALE: A PEASANT BOY FISHING, collection of the Frick Art Museum, Pittsburgh, Pennsylvania.

Fig. 12. François Boucher, YOUNG PEASANT GIRL, Nationalmuseum, Stockholm. Photo: Statens Konstmuseer.

shepherdesses and peasant girls were courted by their handsome swains under an eternally blue sky.[2] These paintings were a response to the escapist fantasies of the French aristocracy, who found in them a momentary refuge from the pressures of life at court. Diderot, however, viewed such joyfully amoral pictures as dire symptoms of aristocratic decadence, and in his commentaries on the 1765 Salon, he roundly condemned both Boucher and his pastorals:

> I don't know what to say of this man. The degradation of taste . . . of composition, of characters, of expression, of design has followed step by step the corruption of morality . . . My friend, is there no policing of the Académie? In the absence of any commissioner . . . is it not then permitted to kick him out of the Salon, down the staircase, into the courtyard, until the shepherd, shepherdess, flock, ass . . . the entire pastoral would be out in the street? . . . Ah, how I hate this false genre![3]

But even Diderot could not deny the sheer visual brilliance of Boucher's art, the allure of his colors and luscious, buttery brushwork:

> What colors, what variety, what a wealth of forms and ideas! The man has every-

thing, excepting truth . . . It's such an agreeable vice, it's an extravagance so inimitable and so rare! It has such imagination, effect, magic, and facility![4]

Produced by the artist around 1732, THE VEGETABLE VENDOR is one of Boucher's first post-Italian paintings in the pastoral mode. Here a young boy displays his produce to an aristocratic lady while her bashful maid looks on. As in all of Boucher's pastorals, the encounter brims with amorous intent. Much of the landscape imagery and the splendid array of vegetables, animals, buckets and jugs in the foreground were derived from the bucolic paintings and prints of Castiglione, who exerted a formative influence on Boucher's pastoral art.

THE VEGETABLE VENDOR served originally as a pendant to another of Boucher's pastorals, his PEASANT BOY FISHING, now in the Frick Art Museum, Pittsburgh (fig. 11).[5] The two paintings were commissioned by the Duc de Richelieu (1696–1788) for the reception hall of his Paris hôtel. Richelieu—the grand nephew of Louis XIII's chief minister, Cardinal Richelieu—may well have had a special fondness for such subject matter, for his own life was marked by a succession of amorous affairs and an extraordinary romantic longevity. Among his many mis-

Fig. 13. Charles-Nicolas Cochin after François Boucher, TRIUMPH OF POMONA, Louvre, Paris, collection Edmond de Rothschild. Photo: Musées Nationaux.

tresses was the Duchesse de Berry, the eldest daughter of the Royal Regent Philippe d'Orléans. And in 1780, at the age of eighty-four, he wed his third wife.[6]

Among Boucher's preparatory drawings for THE VEGETABLE VENDOR is a sketch in red chalk for the lady's maid, found today in the Nationalmuseum, Stockholm (fig. 12).[7] A sheet of preliminary studies for the farm boy, also in red chalk, was formerly in the Michel-Lévy collection in Paris,[8] and the same boy reappears in Boucher's 1738 pastel drawing in the Art Institute of Chicago.[9] All of the painting's figurative imagery and much of its landscape detail appear again in THE TRIUMPH OF POMONA, an etching executed by Charles-Nicolas Cochin after Boucher's design (fig. 13).[10]

NOTES:
1. For this painting, found today in the Columbia Museums of Art and Science, Columbia, South Carolina, see E. Zafran, *The Rococo Age*, exhib. cat., High Museum of Art, Atlanta, 1983, p. 34, no. 3.
2. For discussions of the pastoral in Boucher's art and eighteenth-century France in general, see J.-L. Bordeaux, "The Epitome of the Pastoral Genre in Boucher's Oeuvre," *J. Paul Getty Museum Journal*, 3 (1976), pp. 75–101, and H. Goldfarb, "Boucher's *Pastoral Scene with Family at Rest*," *Bulletin of the Cleveland Museum of Art*, March 1984, pp. 82–89.
3. See J. Seznec, *Diderot Salons*, Oxford, 1979, II,

pp. 75, 79, 81, and Goldfarb (note 2), p. 82, whose translation is followed here.
4. Seznec (note 3), I, p. 112, and Goldfarb (note 2), p. 82.
5. Oil on canvas, 95″ × 67″. See Hovey, 1975, p. 108. Curiously, Ananoff, 1976, II, p. 279, contends that two considerably later pastoral paintings in the Metropolitan Museum composed a suite with the Norfolk and Pittsburgh pictures. Posner, 1978, p. 561, correctly disputes this claim.
6. *François Boucher*, 1982, p. 224. The traditional assumption that *The Vegetable Vendor* and *Peasant Boy Fishing* were painted by Boucher for the Duc de Richelieu has been challenged recently by Laing *et al.*, 1986–87, pp. 163–167. Laing *et al.* also contend that the Norfolk and Pittsburgh pictures were part of a larger decorative ensemble by Boucher that included another pair of pendant paintings of different dimensions, *Le bonheur de village* and *Le halte à la fontaine*, both on loan to the Alte Pinakothek, Munich.
7. Red chalk, heightened with white on brownish grey paper, 35.3 × 22.4 cm. See Ananoff, 1976, I, pp. 214, 216.
8. Red chalk, heightened with white on buff colored paper, 26 × 36 cm. See Ananoff, 1976, I, p. 216.
9. 30.6 × 24.1 cm. See Slatkin, 1974, pp. 41–42, and Posner, 1978, p. 561. Slatkin dates *The Vegetable Vendor* ca. 1738 on the basis of its presumed connection with the Chicago pastel. This is unconvincing.
10. Ananoff, 1976, I, pp. 214–215.

JEAN-BAPTISTE-SIMÉON CHARDIN

13. BASKET OF PLUMS *(Panier de prunes)*

Oil on canvas, 12¾″ × 16½″
Signed lower left: *chardin*

COLLECTIONS:
Emil Leroux, Paris; Georges Hoardt, New York, 1939; Newhouse Galleries, New York, 1939; Walter P. Chrysler, Jr.; Chrysler Museum, Norfolk, 1971.

EXHIBITIONS:
Exposition de l'art français au XVIIIe siècle, Charlottenberg Palace, Copenhagen, Aug. 25—Oct. 6, 1935, no. 33; *Chefs-d'oeuvre de l'art français*, Palais National des Arts, Paris, 1937, no. 144; *Origins of Modern Art*, Arts Club of Chicago, April 1940, no. 20; Richmond, 1941, no. 34; Portland, 1956–57, no. 64; Provincetown, 1958, no. ll; Finch College, 1963, no. 17; *Still Life Painters: Pieter Aertsen 1508–1575 to Georges Braque 1882–1963*, Finch College Museum of Art, New York, opened Feb. 2, 1965, no. 25; Nashville, 1977, no. 21.

REFERENCES:
L. Gillet, "Masterpieces of French Art at the Paris Exhibition," *Connoisseur*, Jan. 1938, p. 6, pl. 67; M. Florisoone, *Chardin*, Paris, 1938, ill.; J. Mouton, *Suite à la Peinture*, Paris, 1952, p. 167; P. Rosenberg, *Chardin 1699–1779*, exhib. cat., Grand Palais, Paris, etc., 1979, pp. 333–334, under no. 121, ill.; E. Bukdahl, *Diderot, critique d'art*, Copenhagen, 1982, p. 231, fig. 35; P. Rosenberg, *Tout l'oeuvre peint de Chardin*, Paris, 1983, p. 109, no. 173A.

Born in Paris to a master cabinetmaker, Chardin became one of the most revered still-life and genre painters in mid-eighteenth-century France. Though little is known of his artistic training, early biographical accounts indicate that he received some instruction in drawing and still-life painting from Pierre-Jacques Cazes and Noël-Nicolas Coypel. In 1724 he joined the Paris painters' guild—the less-exalted rival of the Académie Royale—and made his debut in 1728 at the city's outdoor fair, the Exposition de la Jeunesse, where he showed several of his earliest still lifes. These immediately caught the attention of the Académie Royale, and through the enthusiastic patronage of Nicolas de Largillierre (cat. no. 8), Chardin was elected to that body in the same year. He was enrolled as a painter "skilled in animals and fruit," the lowest ranking in the Académie's rigidly hierarchical classification of subjects. In spite of his humble position, his steady professionalism and the extraordinary quality of his work

impressed his colleagues, and in time he was selected to fill several of the Académie's more prestigious administrative posts. In 1743 he was named counsellor of the Académie. In 1755 he became its treasurer and was chosen to organize and hang the Salon, tasks he performed regularly after 1761. He himself exhibited faithfully at the Salon from the time of its revival in 1737 until his death in 1779.

Chardin's first prominent patron was the Comte de Rothenbourg, Louis XV's ambassador to Madrid, for whom he painted sets of overdoors with allegorical still lifes in 1730–31.[1] In 1740 Chardin was introduced to the king who, between 1752 and 1766, purchased several of his pictures.[2] The painter was granted a royal pension in 1752 and five years later was given lodgings in the Louvre, a favor accorded only the most eminent artists of the realm. In his later years his still-life and genre pieces were avidly collected by other European monarchs, chief among them Frederick of Prussia and Catherine the Great.

Despite the acclaim that his paintings won him, Chardin keenly sensed the disparity between his own modest works and the grander and more highly regarded productions of the Académie's history painters. He regretted the limits of his early training—that he had not been "properly" educated at the Académie. To ease his disappointment he resolved to make his reluctant and untalented son Jean-Pierre the history painter he himself had never become. The experiment ended in disaster in the late 1760s when Jean-Pierre committed suicide.

Chardin began his career as a painter of still life, producing humble images of fruit and dead game and equally spare and modest ensembles of household utensils.[3] After 1733 he turned to domestic genre scenes of bourgeois and lower-class life, which drew their inspiration largely from the paintings of Gerard Dou, Gabriel Metsu and other seventeenth-century Dutch "little masters."[4] These simple and timeless visions of kitchen maids and diligent mothers—which Chardin began to paint no doubt to improve his status at the Académie—dominated his art until 1748.

Fig. 14. Jean-Baptiste-Siméon Chardin,
BASKET OF PLUMS, private collection, Paris.

Thereafter he resumed his work as a still-
life painter, reviving the repertoire of
objects previously used in his art: fruit,
kettles, glasses and jars, tureens, baskets
and coffeepots. In these later still lifes,
however, Chardin abandoned his earlier
commitment to the meticulous delinea-
tion of texture and detail and concentrated
on more profound visual truths. Color and
volume, half-light and highlight, the
broader compositional interplay of solid
and void—these became the underlying
concerns of such mature still lifes as the
masterful BASKET OF PLUMS of 1765.[5]

According to the *livret* accompany-
ing the 1765 Salon, Chardin exhibited,
under entry number 49, "several paint-
ings . . . one of which represents a basket
of grapes."[6] More specific information was
provided by one of Chardin's most ardent
supporters, the famous encyclopedist,
philosopher, and art critic Denis Diderot
(1713–1784). Among his observations of
the 1765 exhibition, Diderot recorded that
no. 49 comprised two still lifes by
Chardin, one depicting a "Basket of grapes,
a macaroon, a pear, and two or three lady-
apples"[7] and the other a "Basket of Plums"
that he described thus:

> Placed on a stone bench, a wicker basket
> full of plums, for which a paltry string
> serves as a handle, and scattered around it
> some walnuts, two or three cherries and a
> few small bunches of grapes.[8]

There are a pair of still lifes by
Chardin that fit Diderot's description of
the "Basket of Plums"—the Norfolk
painting and a second, nearly identical ver-
sion found today in a private Paris collec-
tion (fig. 14).[9] Scholars are uncertain as to
which of these two works the artist dis-
played at the 1765 Salon,[10] but Diderot's
rapturous response could surely have been
elicited by either piece:

> You come just in time, Chardin, to
> restore my eyesight . . . you great magi-
> cian, with your silent arrangements!
> How eloquently they speak to the artist!
> How much they tell him about the
> imitation of nature, the science of color,
> and harmony! How freely the air circu-
> lates around these objects.[11]

"This magic," Diderot marveled, "is
beyond comprehension."[12]

NOTES:
1. For these allegorical still lifes, see Rosenberg,
1979, pp. 145–151.
2. *Ibid.*, pp. 286–289, 339–344, 347–351.
3. *Ibid.*, pp. 157–158.
4. *Ibid.*, p. 190.
5. *Ibid.*, p. 296.
6. "Plusieurs Tableaux sous le même numéro, dont
un représent une Corbeille de raisins." See *Collections
des Livrets des Anciennes Expositions depuis 1673
jusqu'en 1800. Exposition de 1765.* Paris, 1870, p. 17,
no. 49.
7. See especially Rosenberg, 1979, pp. 331-333, and
J. Seznec, *Diderot Salons,* Oxford, 1979, II, p. 114.
8. "Placez sur un banc de pierre un panier d'osier
plein de prunes, auquel une méchante ficelle serve
d'anse, et jetez autour des noix, deux ou
trois cerises, et quelques grappillons de raisin."
See Seznec (note 7), p. 114; translated in Rosen-
berg, 1979, pp. 333–334.
9. Signed, oil on canvas, 32 × 40.5 cm. The paint-
ing was formerly owned by the noted Chardin
collector Eudoxe Marcille (1814–1890) and appar-
ently now belongs to his descendants. For a full
account of this painting, see Rosenberg, 1979, pp.
333–334. In his description of Chardin's *Basket of
Plums,* Diderot made a minor mistake: the "few
small bunches of grapes" that he professed to see are
actually white currants, as both the Norfolk and
Paris paintings reveal. See Rosenberg, 1979, p. 334.
10. See, most recently, Rosenberg, 1979, p. 334.
11. "Vous venez à temps, Chardin, pour récréer
mes yeux . . . grand magicien, avec vos composi-
tions muettes! qu'elles parlent éloquemment à
l'artiste! Tout ce qu'elles lui disent sur l'imitation
de la nature, la science de la couleur, et l'harmonie!
Comme l'air circule autour de ces objets!" See
Seznec (note 7), p. 111; translated in Rosenberg,
1979, p. 333.
12. Rosenberg, 1979, pp. 37–38.

HUBERT ROBERT

14. LANDSCAPE WITH A TEMPLE

Oil on canvas, 64″ × 46″

COLLECTIONS:
Achille-Fould, Château de Beychevelle (near Bordeaux); Samuel W. Pray, Philadelphia; Acquavella Galleries, 1950; Samuel W. Pray, 1953; Walter P. Chrysler, Jr.; Chrysler Museum, Norfolk, 1981.

EXHIBITIONS:
Finch College, 1963, no. 31; Nashville, 1977, no. 25.

Robert was quite likely the most widely known painter of antique ruins in later eighteenth-century France, a distinction that earned him the nickname "Robert of the ruins." A native Parisian, he was the son of Nicolas Robert, *valet de chambre* to the Marquis de Stainville, the Duc de Lorraine's envoy to France. Robert's parents initially encouraged him to enter the church, but in time they acceded to his wish to study art. After receiving some instruction in drawing from the Paris sculptor Michel-Ange Slodtz, the young artist departed for Rome in 1754. There his fluent landscape sketches found favor at once with the director of the Académie de France, Charles Joseph Natoire, who was himself an ardent devotee of landscape painting. Robert was made a *pensionnaire* at the Académie de France in 1759, and, at the urging of Natoire, he and the young Fragonard traveled widely in Italy, making landscape drawings out-of-doors. Among the teachers at the Académie was the painter Giovanni Paolo Panini, whose *vedute*—imaginary views of the sculptural and architectural remains of classical Rome—confirmed Robert's calling as a painter of ancient ruins.

Robert returned to Paris in 1765 and within a year was both *agréé* and *reçu* by the Académie Royale as a "painter of architecture." His work first appeared before the public at the 1767 Salon, where he showed thirteen paintings and "several small sketches and drawings" from his Italian sojourn.[1] These elicited unanimous praise, and the artist's *vedute* were soon eagerly sought by aristocratic collectors both in France and England, many of whom had made the Grand Tour of Italy and purchased Robert's paintings as poetic souvenirs of their travels in the south.

From 1769 Robert also began to exhibit views of contemporary Paris. In them he documented the great building campaigns then underway in the capital and depicted as well the diversions and disasters of eighteenth-century Parisian life, among them the city's many fairs and festivals and the great fire that swept the Opéra in the spring of 1781.[2] With his innovative designs for the gardens at Versailles, Robert was named *dessinateur des jardins du Roi*—landscape gardener to the king—in 1778, and six years later he achieved comparable fame with his plans for the park at Méréville. A noted connoisseur and collector in his own right, Robert was made guardian of the royal painting collection in 1784. During the Reign of Terror he was briefly imprisoned for his aristocratic ties, but after his release he was made a curator of the revolutionary government's newly created Musée des Arts.

Though the free and feathery brush technique of Robert's early *vedute* and his equally spirited drawing style are tied to the Rococo, the archeological tone of his paintings quite clearly reflects the rising Neoclassical interest in the Roman antique. His works project at the same time a wistful and sometimes sublime mood that has been justly described as proto-Romantic. His *vedute* function not only as nostalgic evocations of Rome's vanished grandeur, but as melancholy reminders of the transitoriness of all human achievement, a notion central to the art of the Romantics. In his commentaries on the 1767 Salon, Diderot was overwhelmed by the elegiac power of Robert's ruins:

The ideas which the ruins awake in me are grand. Everything vanishes, everything dies, everything passes, only time endures . . . I see the marble of tombstones fall into dust and I do not wish to die! . . . In that deserted sanctuary, unbelievably solitary and vast, I have broken with all the obstacles of life; no one pushes me, no one hears me; I can talk out loud to myself, grieve, shed tears without constraint.[3]

Fig. 15. Hubert Robert, STATUE OF A CAPTIVE BARBARIAN PRINCE, Musée des Beaux-Arts, Valence.

Fig. 16. Hubert Robert, ROMAN LANDSCAPE WITH VIEW UNDER A BRIDGE, present location unknown.

In many of his *vedute* Robert juxtaposed ancient buildings and sculptures that were actually located miles apart in Rome. In the painting displayed here we find just such a capricious assembly of antique monuments: the Colosseum, the Pantheon, a sculpture of a captive barbarian and one of the Horse Tamers of Monte Cavallo are all made to occupy the same acre of land.

The portico of the Pantheon inspired many of Robert's architectural *capricci*, including a closely related black chalk drawing in the Kupferstichkabinett, Staatliche Museen Preussischer Kulturbesitz, West Berlin.[4] The statue of the captive barbarian occurs as well in a red chalk drawing by Robert in the Musée des Beaux-Arts, Valence (fig. 15).[5] The painting was originally paired with Robert's ROMAN LANDSCAPE WITH VIEW UNDER A BRIDGE, formerly in the collection of Walter P. Chrysler, Jr. (fig. 16).[6]

NOTES:
1. ". . . plusieurs petites Esquisses, & plusieurs dessins, colorés d'après nature, à Rome," according to the *livret* of the 1767 Salon. See J. Seznec, *Diderot Salons,* Oxford, 1963, III, p. 33, and P. de Nolhac, *Hubert Robert 1733–1808,* Paris, 1910, p. 39, which still serves as our principal source of information on the life and art of Robert.
2. Nolhac (note 1), p. 64.
3. "Les idées que les ruines réveillent en moi sont grandes. Tout s'anéantit, tout périt, tout passe, il n'y a que le monde qui reste, il n'y a que le temps qui dure . . . Je vois le marbre des tombeaux tomber en poussière; et je ne veux pas mourir! . . . Dans cet asyle désert, solitaire et vaste je n'entends rien, j'ai rompu avec tous les embarras de la vie; personne ne me presse et ne m'écoute; je puis me parler tout haut, m'affliger, verser des larmes sans contrainte." See Seznec (note 1), pp. 228–229; translated in *French Painting. 1774–1830. The Age of Revolution,* exhib. cat., Grand Palais, Paris, etc., 1975, p. 590.
4. See *Vom späten Mittelalter bis zu Jacques Louis David,* exhib. cat., Staatliche Museen Preussischer Kulturbesitz, Berlin, 1973, p. 103, no. 184.
5. Inv. no. D.27, 370 × 290 mm. See M. Beau, *La Collection des dessins d'Hubert Robert au Musée de Valence,* Lyon, 1968, no. 64.
6. Oil on canvas, 64″ × 46″. See Finch College, 1963, no. 30.

JEAN-BAPTISTE GREUZE

15. SAINT MARY OF EGYPT *(Le Repentir de sainte Marie l'Egyptienne dans le désert)*

Oil on canvas, 71½″ × 57¼″

COLLECTIONS:
Lucien Bonaparte, Prince de Canino, Paris, 1800; Bonaparte sale, London, May 14–16, 1816, no. 26; T . . . and L . . . sale, Paris, March 20–21, 1840, no. 30(?); Durand-Duclos, Paris; Durand-Duclos sale, Paris, Feb. 18, 1847, no. 29; Prousteau de Montlouis, Paris; de Montlouis sale, Paris, May 5–6, 1851, no. 74; Marquis de Maison, Paris; Marquis de Maison sales, Paris, June 10–12, 1869, no. 4 (bought in), and Paris, Feb. 24, 1896, no. 2; Durand-Ruel et Cie., Paris; Walter P. Chrysler, Jr., 1954; Chrysler Museum, Norfolk, 1971.

EXHIBITIONS:
Salon, Paris, 1801, no. 158; Salon, Paris, 1804, no. 219(?); Dayton, 1960, no. 2; E. Munhall, *Jean-Baptiste Greuze 1725–1805*, Wadsworth Atheneum, Hartford, California Palace of the Legion of Honor, San Francisco, and Musée des Beaux-Arts, Dijon, Dec. 1, 1976—July 31, 1977, pp. 14, 15, 222–224, no. 113.

REFERENCES:
M.B. (Baron Boutard), "Beaux-Arts, Salon de l'an XIII," *Journal des débats*, Jan. 5, 1805, pp. 5–6; C. de Valori, "Notice sur Greuze et sur ses ouvrages," *Greuze, ou l'Accordée de village*, Paris, 1813 (reprinted A. de Montaiglon, ed., in *Revue universelle des arts*, 11 [1860], pp. 371–372); J. Smith, *Catalogue raisonné of the Works of the Most Eminent Dutch, Flemish and French Painters*, London, 1837, VIII, no. 64; A. Houssaye, *Galerie de Portraits du XVIIIe siècle*, Paris, 1848, p. 263; E. and J. de Goncourt, *L'Art du dix-huitième siècle*, Paris, 1880, I, p. 329; J. Martin and C. Masson, *Catalogue raisonné de l'oeuvre peint et dessiné de J.-B. Greuze*, Paris, 1908, no. 2; *Le Dessin français de Claude à Cézanne dans les collections hollandaises*, exhib. cat., Institut Néerlandais, Paris, etc., 1964, p. 76, under no. 92; A. Brookner, *Greuze: The Rise and Fall of an Eighteenth-Century Phenomenon*, London and Greenwich, Connecticut, 1972, p. 133; R. Rosenblum, "The Greuze Exhibition at Hartford and elsewhere," *Burlington Magazine*, 119 (1977), p. 149, fig. 108; *Apollo*, 1978, pp. 16–18, fig. 2; J. Hagstrum, *Sex and Sensibility, Ideal and Erotic Love from Milton to Mozart*, Chicago and London, 1980, p. 312, fig. 25.

The painter Greuze was an extraordinarily original, uncompromising, and often abrasive figure who repeatedly challenged the artistic conventions of his era. At the height of his influence—between 1760 and 1785—he was one of the most popular portrait and genre painters in France. Humbly born, he was the sixth child of a roofer in provincial Tournus. Having mas-

tered the rudiments of his art under the mediocre Charles Grandon in Lyon, he arrived in Paris around 1750 and enrolled in the Académie Royale, where he dazzled his mentors with his artistic talents. Even as a student in Paris, however, he doggedly pursued his own path, exhibiting a fierce independence and an arrogant disdain of his colleagues that in time would make him a good many enemies within the Académie. He became an associate member of the Académie in 1755 and made his debut at the Salon that same year. He was in Italy in 1755–57 and upon his return displayed twelve paintings at the Salon, including his four famous Italian genre scenes, LES QUATRE TABLEAUX DANS LE COSTUME ITALIEN.

Fame now came quickly to Greuze. During the 1760s he was known particularly for his sentimental genre scenes of familial trials and tragedy. These he invested with the emotional force and moral weight of history painting, creating a novel form of genre picture that defied the Académie's venerable hierarchy of subjects. He was lauded for his efforts by the critic Diderot, who saw in his intense, high-minded genre scenes a welcome departure from the frivolities of the Rococo.

In 1767 Greuze was excluded from the Salon because for more than a decade he had neglected to submit his presentation piece to the Académie. Haughtily dismissing the reprimand,[1] the artist turned to traditional historical subjects in hopes of being *reçu* as a history painter. For his *morceau de réception*, the 1769 SEPTIMIUS SEVERUS REPROACHING CARACALLA (Louvre), Greuze not only chose a theme that had never before been depicted by a French artist, but devised a thoroughly new style as well, an austere, heroic mode that directly foreshadowed the Neoclassicism of Jacques-Louis David. The academicians were unimpressed, however, and offered Greuze membership only as a genre painter. Stung by their rebuke, he angrily withdrew from the Académie and the Salon and did not return to either until after the Revolution.

The artist's private life was equally unsettled. His wife, Anne-Gabrielle Babuti, was notorious in Paris for her amo-

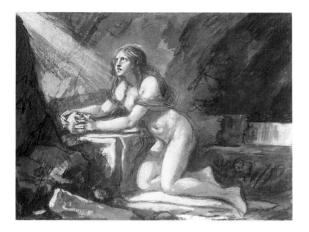

Fig. 17. Jean-Baptiste Greuze, SAINT MARY OF EGYPT WITH A SKULL, Musée des Beaux-Arts, Dijon.

Fig. 18. Jean-Baptiste Greuze, FEMALE NUDE, Fondation Custodia (coll. F. Lugt), Institut Néerlandais, Paris.

rous affairs and violent temper, which Greuze endured for decades. Even a close friend like Diderot acknowledged the flaws in both husband and wife, and in 1767 he strongly objected to plans then afoot to send Greuze to the court of Catherine the Great:

> I think we shall definitely not send Greuze to Russia. He is an excellent artist, but a thoroughly unruly person . . . Furthermore, his wife is, by unanimous consent, . . . one of the most dangerous creatures on earth. I should not give up hope that one fine day, her Imperial majesty might not send her on tour to Siberia.[2]

When Greuze finally divorced his wife in 1793, the settlement ruined him financially, and he spent his final years impoverished and dispirited.

Nowhere is the melancholy of his late period more poignantly revealed than in the SAINT MARY OF EGYPT, one of the artist's rare religious pieces. The painting was produced in 1800 for Napoleon's brother, Lucien Bonaparte, France's Minister of the Interior. So precarious was Greuze's position that he wrote twice to Bonaparte pleading for advances against the unfinished SAINT MARY:

> I have lost everything, except talent and courage. I am seventy-five years old, not a

single commissioned work; all my life I have never had so painful a moment to live through. You have a good heart, I flatter myself that you will have consideration for my suffering as soon as possible, for it is urgent.[3]

According to medieval legend, the sixth-century Alexandrian harlot Mary of Egypt embraced the Christian faith at the door of the Holy Sepulchre in Jerusalem. She then retired into the wilderness and there devoted the remainder of her life to penance and prayer. The lion—her saintly attribute—allegedly appeared after her death to help a passing priest dig her grave. As scholars have suggested, Greuze's sorrowful saint—naked and repentant in her desert cave—almost certainly mirrors the anguish of his own life.[4] His final figure painting, SAINT MARY has been aptly described as Greuze's "last will and testament, translating a world of private sorrow into a final public statement."[5]

Greuze had apparently painted the same subject earlier in his career. In that work, which has been lost, he depicted Saint Mary with blond hair.[6] Among the several sketches by Greuze that anticipate the Norfolk painting[7] are a brush drawing of SAINT MARY, ca. 1790 and now in the Musée des Beaux-Arts, Dijon (fig. 17),[8] and an even earlier red chalk drawing of a female nude in the Institut Néerlandais,

ANTOINE-JEAN GROS

16. ACIS AND GALATEA

Paris (fig. 18).[9] The composition of the Norfolk painting was reproduced in an engraving by Angelo Testa.

NOTES:
1. Diderot reports that Greuze's response was "a model of vanity and impertinence." See Munhall, 1976–77, p. 22.
2. ". . . je crois que nous n'enverrons point Greuze en Russie. C'est un excellent artiste, mais une bien mauvaise tête . . . Et puis, sa femme est, d'un consentement unanime, . . . une des plus dangereuses créatures qu'il y ait au monde. Je ne désespérerois pas qu'un beau jour, sa Maj. Imp. ne l'envoyât faire un tour en Sibérie." See Munhall, 1976–77, pp. 22–23, whose translation is followed here.
3. See Goncourt, 1880, p. 329, and Munhall, 1976–77, pp. 222, 224: ". . . j'ai tout perdu, or le talent et le courage. J'ai soixante-quinze ans, pas un seul ouvrage de commande; de ma vie je n'ai eu un moment aussi pénible à passer. Vous avés le coeur bon, je me flatte que vous aurés égard à mes peines le plus tôt possible, car il y a urgence."
4. See, for example, Munhall, 1976–77, p. 222.
5. Rosenblum, 1977, p. 149.
6. Munhall, 1976–77, p. 222.
7. For a listing of related drawings that appeared in nineteenth-century auction catalogues, see Munhall, 1976–77, p. 224.
8. Brush, black ink wash, black chalk, over pencil, on tan paper, 12″ × 16⅛″. See Munhall, 1976–77, p. 222.
9. Red chalk on white paper, 11½″ × 16⅝″. See *Le Dessin français*, 1964, pp. 75–76, no. 92.

Oil on canvas, 51½″ × 64″
Signed and dated lower right: *Gros 1833*

COLLECTIONS:
The artist, 1833–35; the artist's atelier sale, Paris, Nov. 23, 1835, no. 22; Urvoy de Saint Bedan, Paris, 1835–63; Jean-Baptiste Delestre, Paris, 1863–71; Delestre sale, Paris, Oct. 13–14, 1871, no. 3; M. Dinin, Paris, 1936; Kochitz-Kalmaznine, Paris, 1954; Walter P. Chrysler, Jr.; Chrysler Museum, Norfolk, 1971.

EXHIBITIONS:
Salon, Paris, 1835, no. 990; *Gros, Ses Amis, Ses Elèves*, Petit Palais, Paris, May-July 1936, no. 101; Portland, 1956–57, no. 74; Provincetown, 1958, no. 25; Dayton, 1960, no. 11; Wildenstein, 1978, no. 14; *The Seven Ages of Man*, London Regional Art Gallery, London, Ontario, May 3—June 15, 1980.

REFERENCES:
Ch. Le Blanc, *Histoire des Peintres de Toutes les Ecoles*, Paris, 1863, III, p. 29; J.-B. Delestre, *Gros, Sa Vie et Ses Ouvrages*, Paris, 1867, pp. 286–289; H. Lemonnier, *Gros*, 1928, pp. 87–91; J. Tripier Le Franc, *Histoire de la Vie et de la Mort du Baron Gros*, Paris, 1880, pp. 501–502, 505, 677.

Guided by his parents, both of whom were painters of miniatures, the young Gros joined in 1785 the Paris atelier of Jacques-Louis David. There he mastered the stern and lofty precepts of David's Neoclassical style and, in so doing, became one of the master's most valued students. Gros developed, too, a profound loyalty to the principles of Davidian academicism, a philosophical commitment that would become increasingly difficult to maintain as his career progressed.

Gros enrolled in the Académie de Peinture in 1787, but failed to win the *Prix de Rome*. When the Académie was dissolved by Robespierre in 1793, however, Gros departed for Italy. By the time of Napoleon's North Italian campaign, he had settled in Genoa. There in 1796 he was introduced to Josephine Bonaparte, and through her offices, he met Napoleon himself in Milan and joined his entourage. In Milan Gros helped to oversee the French confiscation of Italian art works and painted his famous BONAPARTE AT ARCOLA (Versailles). After returning to Paris in 1800, he established himself as one of Napoleon's principal painters, glorifying

the emperor and his military exploits in a series of vast and heroic canvases. In these Gros deployed a style influenced less by the Neoclassicism of David than by the paintings of Rubens, which he had studied in Italy. It was a style whose passionate emotion and vibrant color were hailed by the rising generation of French Romantic painters. The most famous of his Napoleonic history paintings, The PESTHOUSE AT JAFFA (Louvre), was the highlight of the 1804 Salon. With it, Gros's reputation was made.

The artist's fortunes did not falter with Napoleon's downfall and the Bourbon Restoration. He was named portraitist to King Louis XVIII in 1814, and two years later he assumed the exiled David's position as professor at the Académie des Beaux-Arts, where he was revered by his many students. One of the prize commissions of the Napoleonic era—the suite of French history paintings for the dome of the Panthéon—was awarded to Gros in 1811. The project was supported by Louis XVIII and by Charles X, who made Gros a baron when the work was finished in 1824.

Despite the "superabundance of honors"[1] bestowed upon him, Gros feared that he had abandoned the principles of David's art for the "impertinence and vagabondage"[2] of the Romantics, and with David's death in 1825 he sensed the need to return to a style more strictly aligned to the Neoclassicism of his former mentor. This reversion to an older and no longer fashionable manner isolated Gros from any of his earlier supporters, and his art became the object of mounting criticism. The crisis came at the Salon of 1835 when Gros exhibited two works of decidedly classical style and subject matter—HERCULES AND DIOMEDES, presently found in the Musée des Augustins, Toulouse, and ACIS AND GALATEA in Norfolk, which the artist had painted in David's memory two years before. The critical response to these pictures was devastating, and Gros fell into a deep depression. When his former student Jean-Baptiste Delestre visited him at the time, Gros greeted him with this rueful remark: "Ah, it is you, my friend; thank you for your courageous visit; you are not afraid to visit a dead man in his graveyard."[3] Soon after, Gros drowned himself in the Seine. Today Gros is rightly recognized as the crucial link "between the austere and learned classicism of his teacher David and the more colorful Romanticism of . . . Delacroix."[4]

As told by Ovid in his META-MORPHOSES (13:738ff.), the beautiful sea-nymph Galatea was courted by the hideous Cyclops, Polyphemus, whose love she spurned for that of the shepherd Acis. To proclaim his love, the Cyclops made music one day upon his pipes, while Acis and Galatea hid nearby listening. Polyphemus soon spied the pair and, livid with jealousy, crushed Acis beneath a boulder. In Gros's painting the terror-stricken lovers conceal themselves in a cave at water's edge, cowering at the approach of Polyphemus, who stalks the countryside blowing his horn. Galatea covers her ears, vainly trying to escape the giant's fierce protestations of love. At Acis's death Galatea transformed him into a river, and Gros alludes to this in the pose of the shepherd, whose left leg trails in the water. Glowing warmly in the dimness of the cave, the bodies of Acis and Galatea capture marvelously the effects of the shadowy half-light reflecting from the walls and watery floor of the grotto.

Gros's critics complained that the two figures lacked grace, but conceded that they were effectively drawn and animated.[5] In truth, both were modeled upon classical prototypes. Galatea's pose recalls that of the so-called "Crouching Aphrodite,"[6] while Acis mimics the stance of a combative Hercules.[7] In 1863 the painting was purchased by Delestre, who authored the first biography of Gros.

NOTES:
1. W. Friedländer, *David to Delacroix*, Cambridge, Massachusetts, and London, 1952, p. 65.
2. ". . . impertinence et vagabondage." See Friedländer (note 1), p. 65.
3. "Ah! c'est vous, mon ami, merci de votre courageuse visite; vous ne craignez pas de venir voir un mort, dans son cimetière," Tripier Le Franc, 1880, p. 519.
4. *Seven Ages of Man*, 1980, no pag.
5. Tripier Le Franc, 1880, p. 502.
6. Delestre, 1867, p. 286.
7. One thinks, for example, of the many antique Hercules sarcophagi on which similarly posed relief figures appear. See S. Reinach, *Répertoire de reliefs grecs et romains*, Paris, 1912, III, pp. 169, 340–341, 374.

JEAN-AUGUSTE-DOMINIQUE INGRES

17. RAPHAEL AND THE FORNARINA

Oil on canvas, mounted on panel, 27⅛" × 21¼"

COLLECTIONS:
The artist, ca. 1860–1867; the artist's estate sale, Paris, April 27, 1867, no. 8; Madame Ingres, Paris; bequeathed by Madame Ingres to André Hache, Paris, 1887; private collection, Paris; M. Knoedler and Co., Paris and New York, 1957 to 1972; Walter P. Chrysler, Jr.

EXHIBITIONS:
Man, Glory, Jest and Riddle, M. H. de Young Memorial Museum, California Palace of the Legion of Honor, and San Francisco Museum of Art, San Francisco, Nov. 10, 1964—Jan. 3, 1965, no. 195; *Maîtres Anciens*, M. Knoedler et Cie., Paris, June 4—July 31, 1969, no. 9; Nashville, 1977, no. 27.

REFERENCES:
H. Delaborde, *Ingres, sa Vie, ses Travaux, sa Doctrine*, Paris, 1870, p. 226, no. 55; H. Lapauze, *Ingres, sa vie et son oeuvre*, Paris, 1911, p. 512; L. Hourticq, *Ingres*, Paris, 1928, p. 36; G. Wildenstein, *Ingres*, London, 1954, p. 226, no. 297, fig. 47; *Ingres in American Collections*, exhib. cat., P. Rosenberg and Co., New York, 1961, p. 58, no. 71, ill.; *Ingres, Centennial Exhibition, 1867–1967*, exhib. cat., Fogg Art Museum, Cambridge, Mass., 1967, under no. 25; E. Radius and E. Camesasca, *L'Opera completa di Ingres*, Milan, 1968, pp. 94–95, no. 72e; J. Pope-Hennessy, *Raphael*, New York, 1970, pp. 11, 260, note 15; *Ingres*, exhib. cat., National Museum of Western Art, Tokyo, etc., 1981, under no. 5, fig. 7; E.N. van Liere, "Ingres' 'Raphael and the Fornarina': Reverence and Testimony," *Arts Magazine*, 56 (Dec. 1981), pp. 114, 115, fig. 12; W. Johnston, *The Nineteenth Century Paintings in the Walters Art Gallery*, Baltimore, 1982, p. 36, under no. 4; P. Condon, *Ingres. In Pursuit of Perfection: The Art of J.-A.-D. Ingres*, exhib. cat., J.B. Speed Art Museum, Louisville, etc., 1983–84, pp. 24, ill., 243, 251.

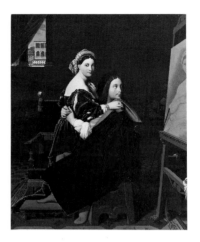

Fig. 19. Jean-Auguste-Dominique Ingres, RAPHAEL AND THE FORNARINA, courtesy of the Fogg Art Museum, Harvard University, bequest Grenville L. Winthrop.

With the death of Jacques-Louis David in 1825, Ingres assumed the mantle of leadership of the French Neoclassical school. Throughout his career he used his lofty historical paintings and meticulously executed portraits to demonstrate the superiority of Neoclassic line over Romantic color, the primacy of craft and finish over the more painterly methods of Delacroix (cat. no. 20) and his disciples. Ingres received his first instruction in drawing from his father, a painter and ornamental sculptor, in his native town of Montauban. He proceeded with his training in 1791 at the Académie Royale in Toulouse and six years later went to Paris to study with David. In 1797 he gained admission to the Ecole des Beaux-Arts, and after two unsuccessful bids at the *Prix de Rome*, he won the coveted government scholarship in 1801 with THE ENVOYS OF AGAMEMNON (Ecole des Beaux-Arts, Paris).

Political and economic uncertainties in France delayed his stipend until 1806. He then left speedily for Italy, where he spent the next eighteen years, first as a student at the Académie de France à Rome and, after 1810, as an independent artist who maintained himself in Rome and Florence with his portrait paintings and drawings. While in Italy Ingres studied antique sculpture and made copies of the Old Masters. He was captivated by the linear refinements of Mannerist painting and was impressed above all by the High Renaissance classicism of Raphael.

Ingres enjoyed little critical success until 1824, when one of his Salon entries, THE VOW OF LOUIS XIII (Cathedral, Montauban), was widely acclaimed. The painting signaled the artist's triumphant return to Paris, and within a year he had been appointed to the Académie des Beaux-Arts of the Institut de France. His first major public commission, the painting of THE APOTHEOSIS OF HOMER for the ceiling of the Musée

Fig. 20. Jean-Auguste-Dominique Ingres, RAPHAEL AND THE FORNARINA, Musée Ingres, Montauban (inv. no. 867.2085).

Fig. 21. Jean-Auguste-Dominique Ingres, RAPHAEL AND THE FORNARINA, Musée Ingres, Montauban (inv. no. 867.2086).

Charles X in the Louvre, quickly followed in 1826. As the head of a large atelier and professor at the Ecole (from 1829), he expounded the doctrine of Neoclassicism to scores of students. Through them the standards of French academicism were kept alive until the end of the century.

After his MARTYRDOM OF ST. SYMPHORIAN (Cathedral, Autun) was criticized at the Salon of 1834, a disillusioned Ingres went back to Rome as director of the Académie de France, a position he held for seven years. Returning to Paris in 1841, he was welcomed back to his homeland with honors and a series of royal and aristocratic commissions, and during the final decades of his life he was revered as the conscience of the classical tradition in France.

Throughout his career Ingres was fascinated by the life and art of Raphael, whose paintings he viewed as paradigms of aesthetic perfection. His veneration of the Master of Urbino was already apparent at the age of twelve, when he saw his first "Raphael," a copy of THE MADONNA OF THE CHAIR.[1] Profoundly influenced during his years in Italy by Raphael's flawless classicism, Ingres came to consider the great sixteenth-century painter his spiritual mentor:

I am, myself, in the unhappy position of having to regret throughout my life, I

was not born in his century. When I think that three hundred years earlier, I might actually have been his disciple.[2]

Ingres's enduring admiration for Raphael was chronicled most eloquently in his five paintings and numerous drawings and tracings of Raphael and the Fornarina, Raphael's model and mistress.[3] These historical genre pictures drew their inspiration in part from the Abbé Comolli's highly anecdotal 1790 account of Raphael's life and ruinous loves. In almost all of these images Raphael is shown seated in his studio, placed between his mistress and the picture he paints of her—an arrangement meant to symbolize the creative coexistence of earthly love and aesthetic ideals. In both Raphael's life and art Ingres sensed a perfect blending of the sensual and the spiritual, which he strove to emulate himself. For Ingres, the theme of Raphael and the Fornarina became an allegory of his own artistic ideal.[4]

Ingres's first version of the subject was painted in 1813 (lost, World War II).[5] His second was produced one year later and is found today in the Fogg Art Museum in Cambridge (fig. 19).[6] During the 1830s he returned to the theme in a picture in the Kettaneh collection in New York,[7] and in 1840 he painted yet another version, now located in the Gallery of Fine Arts, Col-

18. THE BILLIARD PLAYERS (*La Partie de billard*)

Oil on canvas, 22¼″ × 32¼″

COLLECTIONS:
René Fribourg, New York, 1963; Fribourg sale, Sotheby's, London, June 26, 1963, no. 72; sale, Palais Galliera, Paris, Dec. 6–7, 1965, no. 142; French and Co., New York, 1976; Walter P. Chrysler, Jr.

REFERENCES:
Le Dessin français de Claude à Cézanne dans les collections hollandaises, exhib. cat., Institut Néerlandais, Paris, etc., 1964, p. 113, under no. 136; E. Zafran, "Vigée-Lebrun, Boilly Join Museum's French Masters," *Chrysler Museum Bulletin*, 5 (Nov. 1976), no pag., ill.; J. Hallam, *The Genre Works of Louis-Léopold Boilly*, diss. University of Washington, 1979, pp. 97, 180, note 195; *idem*, "The Two Manners of Louis-Léopold Boilly and French Genre Painting in Transition," *Art Bulletin*, 63 (1981), pp. 628–629, 630, fig. 15.

The painter and lithographer Boilly specialized in small-scale, bust-length portraits and richly anecdotal genre scenes of contemporary Parisian life. His career of some sixty years stretched from the end of the *Ancien Régime* to the final years of Louis Philippe's reign, and in his paintings he provided a precious record of the shifting social mores and often violent political events of this stormy half-century. He was born in La Basse, near Lille, the son of a wood sculptor. Though he received some grounding in drawing and painting from his father, Boilly was largely self-taught. After working initially in Douai and Arras, he settled in Paris in 1785, where his early genre paintings—rustic rural images of family harmony and more suggestive *scènes galantes*—owed much to the late-eighteenth-century *sensibilité* and muted eroticism of Greuze and Fragonard.[1]

With his more explicitly carnal boudoir pictures he ran afoul of official taste during the Reign of Terror. Indeed, in 1794 the painter Jean-Baptiste Wicar denounced Boilly before the radical Société Populaire et Républicaine des Arts, describing him as the perpetrator of "obscene works revolting to republican morality which should be burned beneath the tree of liberty."[2] To appease his accusers and avoid imprisonment, Boilly hurriedly

umbus, Ohio.[8] Ingres may have begun the Chrysler picture as early as 1850 and then resumed work on it in 1860. That year he reported to a friend that he was "taking up again the picture of Raphael and the Fornarina, my last edition of this subject, which will, I hope, cause the others to be forgotten."[9] The painting was left in a somewhat unfinished state at Ingres's death in 1867.

As his mistress bends over him, Raphael turns to gaze at his portrait of her on the easel. This Ingres derived from Raphael's image of LA FORNARINA (previously thought to be by Raphael, but now ascribed generally to Giulio Romano) in the Galleria Borghese in Rome. Just visible in the gloom behind them is the TRANSFIGURATION, Raphael's last painting, and beyond the narrow window is the Loggia of Old St. Peter's, where Raphael and his shop produced one of their most famous fresco suites. A pair of preparatory pencil sketches for the Chrysler painting are in the Musée Ingres in Montauban (figs. 20, 21).[10]

NOTES:
1. Delaborde, 1870, p. 18.
2. Van Liere, 1981, p. 110.
3. For the fullest accounting of Ingres's many renderings of the subject, see van Liere, 1981, pp. 108ff., and *Ingres: In Pursuit of Perfection*, 1983–84, p. 243.
4. Van Liere, 1981, pp. 108–115, esp. pp. 108–109.
5. Wildenstein, 1954, p. 211, no. 86.
6. Oil on canvas, 68 x 55 cm. See M. Cohn and S. Siegfried, *Works by J.-A.-D. Ingres in the collection of the Fogg Art Museum*, Cambridge, Mass., 1980, pp. 54–57.
7. Wildenstein, 1954, p. 178, no. 89.
8. See *The Frederick W. Schumacher Collection, The Columbus Gallery of Fine Arts*, Columbus, Ohio, 1976, pp. 107–109.
9. "Je reprends le tableau de *Raphaël et le Fornarina*, ma dernière édition de ce sujet, et qui, j'espère, fera oublier les autres." See Delaborde, 1870, p. 226, no. 55.
10. Inv. nos. 867.2085 and 867.2086; 29.1 × 21.7 cm. and 37 × 25.2 cm., respectively. See *Ingres*, Tokyo, etc., 1981, nos. 4–5.

produced a number of suitably patriotic works, chief among them his TRIUMPH OF MARAT, in the Musée des Beaux-Arts, Lille.[3]

The stern morality and fierce republicanism of the Reign of Terror dissipated with Napoleon's rise, and Boilly returned to his light-hearted *scènes familières*, which were quickly popularized through engravings. In general, however, his genre paintings after 1795 were less overtly erotic than his previous works had been. He evolved, too, a more objective style in these years, and with it he produced more straightforward pictures of *la vie moderne* that anticipated the works of the later nineteenth-century Realists.[4] A few of these paintings contained controversial bits of social commentary. His GALLERIES OF THE PALAIS-ROYAL, for example, presented a frank, unvarnished view of Parisian prostitution that shocked the public when the painting was displayed at the 1804 Salon.[5] Yet most of his mature genre pieces offered more neutral, incidental vignettes of ordinary middle-class life—café views and street scenes, promenades in the park and private gaming parties like that depicted in THE BILLIARD PLAYERS. The smooth and precise realism of these later works and their decidedly narrative flavor reveal the influence of seventeenth-century Dutch genre paintings, which Boilly himself collected.[6]

Boilly exhibited faithfully at the Salon until 1824. He was awarded a gold medal at the 1804 Salon and in 1833 was enrolled in the Legion of Honor. He remained aloof from official court circles throughout his career, however, and with the advent of Romanticism, his genre pieces gradually fell out of fashion. He passed the final two decades of his life in relative obscurity, supporting himself and his large family with his lithographs and numerous portraits *de petit format*.

In THE BILLIARD PLAYERS a casual party in fashionable, Napoleonic dress has gathered in the game room of an upper-class residence to watch and play billiards. The walls of the room are hung with large landscape pictures. Boilly painted his first version of the subject, now in The Hermitage in Leningrad, in 1807 (fig. 22).[7] It was

Fig. 22. Louis-Léopold Boilly, THE BILLIARD PLAYERS, The Hermitage, Leningrad.

shown at the Salon of 1808, where the critics and public alike applauded its good-humored informality and amusing anecdotal detail. As one writer reported, the painting regularly attracted a crowd: "One stops with pleasure at this picture, and I can say that at your [i.e., Boilly's] billiard game, there is always a line."[8]

Among the several preparatory sketches for the Leningrad painting are a sheet of studies in black and white chalk for the two mothers seated at the lower left[9] and a black chalk drawing of the young woman who leans against the billiard table, about to make her shot.[10] There is also a preparatory drawing in pen and sepia wash in the Clifford Duits collection in London,[11] in which the room's walls are decorated not with landscapes, but with hunting scenes in the manner of Frans Snyders. The popularity of the 1807 picture prompted Boilly to paint at least two comparably sized replicas, the undated Chrysler version and an 1827 variant that he lithographed together with a pendant, THE CARD GAME, in 1828.[12]

NOTES:
1. Hallam, 1981, pp. 618–619.
2. ". . . d'ouvrages d'une obscénité révoltante pour les moeurs républicaines qu'il faut brûler au pied de l'arbre de la liberté." See, for example, *Louis Boilly 1761–1845*, exhib. cat., Musée Marmottan, Paris, 1984, p. 106.
3. Hallam, 1981, p. 620.

JEAN-LOUIS-ANDRÉ-THÉODORE GÉRICAULT

19. LANDSCAPE WITH AQUEDUCT

4. *Ibid.*, pp. 618ff.
5. Boilly's 1804 composition survives in a replica of 1809 that hangs today in the Musée Carnavalet, Paris. See C. Eliel, "Louis-Léopold Boilly's 'The galleries of the Palais-Royal'," *Burlington Magazine,* 126 (1984), pp. 275–279.
6. On April 13–14, 1829, Boilly sold at auction thirty-seven of his own paintings and a part of his private art collection. Among the pieces sold were paintings by Van de Velde, Van Mieris, and Terborch. See *Louis Boilly* (note 2), p. 110.
7. Signed and dated 1807, oil on canvas, 56 × 81 cm. See *The Hermitage Museum. Department of Western Art. Catalogue of Paintings* (in Russian), Leningrad and Moscow, 1958, I, p. 285, no. 5666.
8. "On s'arrête avec plaisir à ce tableau, et je puis dire qu'à votre billard, il y a toujours queue." See H. Harrisse, *Louis-Léopold Boilly,* Paris, 1898, p. 81, no. 35. The French word "queue" serves here as well as a punning reference to billiard "cue."
9. Possibly identical with Harrisse (note 8), p. 177, no. 1091. Formerly in the collection of Eliot Hodgkin and sold in London, Sotheby's, March 28, 1968, p. 130, no. 168.
10. Harrisse (note 8), p. 170, no. 972. Formerly in the collection of J.P. Haseltine and sold in London, Sotheby's, May 27, 1935, p. 77, no. 220.
11. See *Le Dessin français,* 1964, p. 113, no. 136.
12. Hallam, 1979, p. 97; *idem,* 1981, p. 629, note 46; Harrisse (note 8), p. 190, nos. 1226–1227.

Oil on canvas, 98½″ × 86½″

COLLECTIONS:
Painted by the artist in 1818 for a M. Marceau, Villers-Cotterêts, France; M. Dornan, France, 1859; sale, Hôtel Drouot, Paris, May 30, 1903, no. 23; private collection, Paris, 1953; P. Brame and C. de Hauke, Paris, 1954; Walter P. Chrysler, Jr.

EXHIBITIONS:
Théodore Géricault (1791–1824), Kunstmuseum, Winterthur, Aug. 30—Nov. 8, 1953, no. 71; Portland, 1956–57, no. 73; *Paintings from Private Collections. Summer Loan Exhibition*, Metropolitan Museum of Art, New York, 1958, no. 64; Dayton, 1960, no. 14; Finch College, 1965–66, no. 14; L. Eitner, *Géricault*, Los Angeles County Museum of Art, Detroit Institute of Arts, and Philadelphia Museum of Art, Oct. 12, 1971—May 14, 1972, no. 31.

REFERENCES:
L. Eitner, "Two Rediscovered Landscapes by Géricault and the Chronology of his Early Work," *Art Bulletin*, 36 (1954), pp. 131–142, fig. 2; M. Huggler, "Two Unknown Landscapes by Géricault," *Burlington Magazine*, 96 (1954), pp. 234–235; R. Lebel, "Géricault, ses ambitions monumentales et l'inspiration italienne," *L'Arte*, Oct.-Dec. 1960, pp. 327ff., fig. 2; J. Szczepińska-Tramer, "Recherches sur les paysages de Géricault," *Bulletin de la Société de l'histoire de l'art français*, 1973, pp. 299ff.; E. Zafran, "French 19th-Century Art and 'The Collapse of Style'," *Chrysler Museum Bulletin*, 3 (May 1974), no pag., ill.; J. Thuillier and P. Grunchec, *L'opera completa di Géricault*, Milan, 1978, p. 107, no. 129, pl. XXVI; P. Grunchec, *Géricault*, exhib. cat., Académie de France à Rome, Villa Medici, Rome, 1979–80, pp. 218–221, under no. 19, fig. A; L. Eitner, *Géricault. His Life and Work*, London, 1983, pp. 142–145, 340, 136, ill.

Géricault's career was tragically brief. He had worked as a painter for little more than a decade when his life was cut short at the age of thirty-three by a spinal tumor. Few of his works were exhibited during his lifetime, and only a handful were sold. Nonetheless, he played the crucial role in the genesis of early Romantic painting in France and inspired an entire generation of younger Romantic artists, Delacroix among them.

Descended from wealth on both his mother's and father's side, Géricault left his native Rouen around 1795 and moved with his parents to Paris. At her death in 1808, his mother bequeathed him a generous annuity. Wealthy now in his own

right, Géricault was free to follow an independent course as an artist and to choose his projects without concern for public taste or approval. Between 1812 and '24 he rapidly worked his way through a succession of highly personal, experimental paintings and prints in widely differing styles.

Géricault trained with the equestrian painter Carle Vernet and the Neoclassicist Pierre-Narcisse Guérin. He was temperamentally drawn, however, to the military themes of Baron Gros (cat. no. 16), and at the Salon of 1812—his public debut—he paid homage to Gros's Rubensian art with the dashing and colorful CHARGING CHASSEUR (Louvre). But almost immediately Géricault abandoned the exuberance and spontaneity of this painting for a more disciplined, monumental "grand manner." The first manifestation of this new, sculpturally massive style was his WOUNDED CUIRASSIER (Louvre), which he sent to the 1814 Salon, and during his Roman period of 1816–17, he perfected the style through a study of Michelangelo and antique sculpture.

Upon his return to Paris, Géricault struggled to wed his heroic, Michelangelesque manner to a suitably grand contemporary subject. The fruit of his labor was the spectacular RAFT OF THE MEDUSA of 1819 (Louvre), the central masterpiece of early Romantic painting. Though admired by Delacroix and other young artists, the MEDUSA was coolly received by the critics at the Salon. Emotionally drained by the project and eager to escape the trauma of an unhappy love affair with his aunt, Géricault departed in 1820 for London, where he put the MEDUSA on public view. There, under the influence of British animal painters, he temporarily abandoned the heavy monumentality of the MEDUSA in a series of more spirited and casual equestrian drawings. He also produced a set of lithographs that documented with unflinching eye the misery of London's poor.

Returning to Paris in 1822, Géricault began to make plans for another major project in the manner of the MEDUSA, but his failing health soon brought his work to a halt. He did produce, however,

Fig. 23. Théodore Géricault, LANDSCAPE WITH FISHERMEN, Munich, Neue Pinakothek.

in his final period a set of extraordinary portraits of the patients at the Salpêtrière mental hospital near Paris. By the time of his death in 1824, he had explored for Delacroix and other young painters an entire range of Romantic themes, from the glamour and dash of his early mounted horsemen to the darkest accounts of human suffering and despair.

Géricault's principal passions were the human and equine forms, and the subjects that most absorbed him were those that dealt with struggle and confrontation —"man pitted against animal, or nature against man."[1] Rarely did he concern himself with pure landscape painting, though in the summer and fall of 1818, soon after he had begun work on the MEDUSA, he did create a set of three monumental landscape pictures.[2] These works—the Chrysler LANDSCAPE WITH AQUEDUCT, the LANDSCAPE WITH FISHERMEN in Munich's Neue Pinakothek (fig. 23),[3] and the LANDSCAPE WITH ROMAN TOMB in the Petit Palais, Paris (fig. 24)[4]—were apparently designed to hang in the home of a Monsieur Marceau, a close friend of Géricault, who lived in Villers-Cotterêts, outside of Paris.[5] Unique as landscapes, the paintings are also remarkable for their colossal size. Only three other paintings by the artist—the CHASSEUR, CUIRASSIER, and the MEDUSA itself—exhibit similarly mural dimensions. As

Fig. 24. Théodore Géricault, LANDSCAPE
WITH ROMAN TOMB, Musée du Petit Palais,
Paris. Photo Bulloz.

Lorenz Eitner has observed, Géricault "did
not need or seek commissions at the time"
he produced the landscapes, and "he prob-
ably painted them as a labor of love, to
please a friend or to satisfy an urge to work
on an architectural scale."[6]

Géricault's three Italianate vistas
derive much from the classical landscape
prospects of Claude, Poussin, and Gaspard
Dughet, artists he could easily have stud-
ied during his Roman sojourn.[7] He must
have looked even more closely at the fash-
ionable eighteenth-century landscapes of
Claude-Joseph Vernet, who employed in
his *vedute* the same sorts of motifs seen in
the Chrysler canvas—the umbrella pine
at the upper left, for example, and the
Spoletan aqueduct in the distance.[8] Like
Vernet's landscape ensembles, Géricault's
three vistas were probably intended to
evoke different times of day. Thus, the
Munich painting may well depict dawn
(fig. 23), the Paris picture midday (fig.
24), and the LANDSCAPE WITH AQUE-
DUCT the coolness and calm of dusk.[9]

The aggressively sculptural, blocky
bulk of the Chrysler landscape was con-
ceived by Géricault in the same heroic,
Michelangelesque spirit as the slightly
later MEDUSA. More specifically, the mas-
sively muscled bather climbing out of the
water in the lower right foreground was
modeled directly after one of the soldiers

in Michelangelo's BATTLE OF CASCINA.
With its crumbling, vine-hung ruins sil-
houetted against the setting sun, the paint-
ing conveys a mood of tranquil melancholy,
a sense of nostalgic yearning for a long-lost
Golden Age.

NOTES:
1. Eitner, 1971–72, p. 14.
2. Géricault purchased the canvas for the three
paintings in July and August of 1818. See Eitner,
1983, p. 142, and D. Rosenthal, "Géricault's Ex-
penses for *The Raft of the Medusa*," Art Bulletin.
62 (1980), pp. 639–640.
3. Oil on canvas, 254 × 220 cm. See Eitner, 1983,
p. 340, note 24.
4. Oil on canvas, 250 × 220 cm. *Ibid.*, note 25.
5. In a letter dated Nov. 14, 1984, Christopher Sells
speculated that "Monsieur Marceau" may have been
Jean-Henri Marceau, who died at Villers-Cotterêts
in June of 1840.
6. Eitner, 1983, p. 143.
7. Eitner, 1971–72, p. 68.
8. Eitner, 1983, p. 144.
9. *Ibid.*, pp. 142–144.

FERDINAND-VICTOR-EUGÈNE DELACROIX

20. ARAB HORSEMAN GIVING A SIGNAL

Oil on canvas, 22″ × 18¼″
Signed and dated lower left: *Eug. Delacroix 1851*

COLLECTIONS:
Sale "A", Paris, May 5, 1860; sale "M.B.", Paris, Dec. 22, 1860; M. Cachardy, Paris; Cachardy sale, Paris, Dec. 8, 1862; Baron Michel de Trétaigne, Paris; de Trétaigne sale, Hôtel Drouot, Paris, Feb. 19, 1872, no. 20; E. LeRoy and Co., Paris, 1889; M. Knoedler and Co., New York, 1889; William O'Leary and Co., Detroit, 1893; Alexander M. Byers, Pittsburgh, 1932; E.M. Byers, Pittsburgh, 1944; John Frederic Byers, Pittsburgh, 1948; Mrs. John Frederic Byers, Westbury, New York, 1964; E.V. Thaw and Co., New York, 1976; Walter P. Chrysler, Jr., 1976; Chrysler Museum, Norfolk, 1983.

EXHIBITIONS:
Exposition des Oeuvres d'Eugène Delacroix, Société Nationale des Beaux-Arts, Paris, 1964, no. 94; *Delacroix*, Art Institute of Chicago, March 20—April 20, 1930, no. 36; *An Exhibition of the Alexander M. Byers Collection of Paintings*, Carnegie Institute, Pittsburgh, Jan. 8—March 15, 1932, no. 17; *The Romantic Revolt*, Springfield Museum of Fine Arts, Springfield, Mass., Feb. 7—March 5, 1939, no. 17; *Eugène Delacroix 1798–1863*, Wildenstein Gallery, New York, Oct. 18—Nov. 18, 1944, no. 33; *Loan Exhibition of Masterpieces by Delacroix and Renoir*, Paul Rosenberg and Co., New York, Feb. 16—March 13, 1948, no. 7; Nashville, 1977, no. 28; *Eastern Encounters: Orientalist Painters of the Nineteenth Century*, Fine Art Society, London, June 26—July 28, 1978, no. 83; *From Veneziano to Pollock*, Chrysler Museum, Norfolk, May 18—June 24, 1984, pp. 17–19; *Man and the Horse*, Metropolitan Museum of Art, New York, Dec. 3, 1984—Sept. 1, 1985, pp. 54–55.

REFERENCES:
A. Robaut, *L'Oeuvre Complet de Eugène Delacroix*, Paris, 1885, p. 317, no. 1187; L. Bortolatto, *L'Opera pittorica completa di Delacroix*, Milan, 1972, p. 122, no. 582; *Apollo*, 1978, pp. 19, 18, fig. 3.

Rumored to be the natural son of the famous French diplomat Charles Maurice de Talleyrand, the Romantic painter Delacroix was himself a mysterious and romantic figure, a brooding artist-dandy in the manner of Lord Byron. "Even those who are most favorably inclined," he once wrote, "think of me as an interesting madman, but one whom it would be dangerous to encourage in his vagaries and bizarre ways."[1] He was born in Charenton-Saint-Maurice, just southwest of Paris, and in 1815 enrolled in the studio of Pierre-Narcisse Guérin, under whom he continued to study at the Ecole des Beaux-Arts. Guérin's Neoclassical paintings interested Delacroix far less, however, than the Romantic works of Géricault. The RAFT OF THE MEDUSA affected him deeply — he even posed for one of its figures — and his first Salon offering of 1822, the Louvre BARQUE OF DANTE, was clearly made with Géricault's great painting in mind. Purchased by the French government, the controversial BARQUE established Delacroix's reputation in Paris, and when Géricault died suddenly two years later, he quickly assumed the leadership of the French Romantic school.

During the later 1820s Delacroix produced a succession of masterpieces that are viewed today as milestones in the history of French Romanticism, beginning with the MASSACRE OF CHIOS of 1824 (Louvre) and culminating six years later in his LIBERTY LEADING THE PEOPLE (Louvre). In these paintings Delacroix revived in full force the high-baroque exuberance of Rubens, surpassing the earlier proto-romantic experiments of the Baron Gros. He loudly proclaimed the primacy of intense emotion, vibrant color, and a vigorous, painterly style. In so doing, he pitted himself directly against Jean-Auguste-Dominique Ingres (cat. no. 17), the standard-bearer of the opposing camp of Neoclassical painters.

In the decades following Napoleon's Egyptian campaign of 1798, the mysteries of the Islamic East were gradually revealed to a fascinated public in France. In their quest for novel and exotic experiences, many Romantic artists journeyed to Morocco, Egypt, and the Holy Land, where they discovered new subjects for genre painting in the "Orientalist" cultures of North Africa and the Near East. Among the first and by far the most important of these French artist-travelers was Delacroix, who in 1832 joined the Comte de Mornay on a diplomatic mission sent by the French government to the sultan of Morocco. Though Delacroix's Moroccan visit lasted only six months, it transformed his art. In enthusiastic letters sent from Morocco in February of 1832, he professed to have found in North African

culture a source of artistic inspiration more authentic and vital than that of classical Rome:

> I am truly sorry for the artists gifted with imagination who can never have any idea of this virgin, sublime nature . . . I can only look forward with sadness to the moment when I shall leave forever the land of beautiful orange trees covered with flowers and fruit, of the beautiful sun, of the beautiful eyes and of a thousand other beauties . . . Rome is no longer in Rome . . . Imagine, my friend, what it is to see figures of the Age of the Consuls, Catos, Brutuses, seated in the sun, walking in the streets, mending old shoes . . . The Antique has nothing that is more beautiful.[2]

Delacroix was so overwhelmed by the brilliant sunshine and vivid colors of the North African desert, so intrigued by the dignity of Arab life, that he devoted much of his later career to paintings of Orientalist themes, among them his ARAB HORSEMAN GIVING A SIGNAL of 1851.

For Romantic artists, the horse became a symbol of their own restless and passionate souls. Like Géricault, Delacroix was fascinated by these creatures, by their nervous beauty and untamed energy. Among beasts only lions interested him more. Both Géricault and Gros inspired Delacroix to begin early on a study of equine anatomy. Géricault, he later wrote:

> . . . was best at rendering the strength of horses, but he never managed to paint an Arab horse as Gros did . . . He hasn't the impetuosity and lightness of Gros [who has] rendered better than anyone . . . the movement and soul of a horse, its eye, its coat and the brilliance of the gleams that pass over it.[3]

By the end of his life Delacroix had devoted more than a hundred and fifty works — paintings, drawings, watercolors — to equine subjects, and in many of these he captured the splendid wildness of a galloping or rearing steed. In the Norfolk painting an Arab sentry, his brilliant red cloak whipped furiously by the dry desert wind, halts in mid-gallop to signal his comrades, who descend a narrow mountain path in the distance. The painting's exotic Orientalist theme and spirited, summary brush technique, its gleaming, jewel-like colors and vigorously animated forms combine to create a perfect example of Delacroix's mature Romantic style.

NOTES:
1. From an 1828 letter to his friend Soulier: "Les plus favorables pour moi s'accordent à me considérer comme un fou intéressant, mais qu'il serait dangereux d'encourager dans ses écarts et sa bizarrerie." See E. Delacroix, *Correspondance générale d'Eugène Delacroix*, A. Joubin, ed., Paris, 1935, I, p. 217, and *French Painting 1774–1830: The Age of Revolution*, exhib. cat., Grand Palais, Paris, etc., 1975, p. 377.
2. "Je plains véritablement à présent les artistes doués de quelqu'imagination qui ne doivent jamais prendre une idée des merveilles de grâce et de beauté de ces natures vierges et sublimes . . . et . . . je ne verrai pas sans tristesse le moment de quitter . . . le pays des beaux orangers, couverts de fleurs et de fruits, du beau soleil, des beaux yeux et de mille autres beautés . . . Imagine, mon ami, ce que c'est que de voir couchés au soleil, se promenant dans les rues, raccommodant des savates, des personnages consulaires, des Catons, des Brutus . . . L'antique n'a rien de plus beau." See Delacroix (note 1), I, pp. 313, 319, and *The Orientalists: Delacroix to Matisse*, exhib. cat., National Gallery of Art, Washington, D.C., 1984, p. 19.
3. E. Faure, *Oeuvres littéraires*, G. Crès, ed., Paris, 1923, II, p. 230.

MARC-GABRIEL-CHARLES GLEYRE

21. THE BATH *(Le Bain)*

Oil on canvas, 35″ × 25″
Signed and dated lower right: *C. GLEYRE*
1868.

COLLECTIONS:
Purchased from the artist by John Taylor Johnston;
Johnston sale, Chickering Hall, New York, Dec.
19–22, 1876, no. 183; Charles Stewart Smith;
Smith sale, American Art Association, New York,
Jan. 4, 1935, no. 38; John H. McKay, New York;
McKay sale, Parke-Bernet, New York, March 12,
1969, no. 110; Walter P. Chrysler, Jr.; Chrysler
Museum, Norfolk, 1971.

EXHIBITIONS:
Hofstra, 1974, no. 52; *The Second Empire 1852–1870.*
Philadelphia Museum of Art, Detroit Institute of
Arts, and Grand Palais, Paris, Oct. 1, 1978—July
2, 1979, no. VI-62; W. Hauptman and N. New-
house, *Charles Gleyre 1806–1874,* Grey Art Gallery,
New York, and University of Maryland Art Gallery,
College Park, Feb. 6—May 2, 1980, p. 54, adden-
dum; Atlanta, 1983, no. 40.

REFERENCES:
P. Mantz, "Charles Gleyre," *Gazette des Beaux-Arts,*
1875, p. 411; C. Clément, *Gleyre étude biographique et
critique,* Paris, 1878, p. 428, nos. 110–111,
407–412; E. Strahan, *The Art Treasures of America,*
Philadelphia, 1881, II, p. 88, ill. opp. p. 89; C.
Cook, *Art and Artists of our Time,* New York, 1881,
I, pp. 12–13; H. Marcel, *La Peinture française,*
Paris, 1905, p. 140; *Charles Gleyre ou les illusions
perdues,* exhib. cat., Kunstmuseum, Winterthur,
1974–75, pp. 46, 102, 161, 186–187, 217; *Ingres
and Delacroix through Degas and Puvis de Chavannes:
The Figure in French Art, 1800–1870,* exhib. cat.,
Shepherd Gallery, New York, spring 1975, p. 147;
Apollo, 1978, p. 24, pl. VIII; L. Randall, ed., *The
Diary of George A. Lucas,* Princeton, 1979, II, pp.
278–282; K. Baetjer, ed., "Extracts from the Paris
Journal of John Taylor Johnston," *Apollo,* 114 (Dec.
1981), p. 414.

Born in the village of Chevilly in the Swiss
canton of Vaud, Gleyre lost both his par-
ents at an early age and was sent to Lyon to
be raised by an uncle. He arrived in Paris
in 1825 to begin his artistic studies under
the academic painter Louis Hersent, and
though his subsequent career was centered
in Paris, he maintained close professional
and personal connections with his native
Switzerland. In Rome (1828–32) he found
an enthusiastic mentor in the painter Hor-
ace Vernet, the director of the Académie de
France. At Vernet's suggestion he joined
the wealthy Bostonian John Lowell on a
tour of Greece, Turkey, and Egypt. These
Near Eastern encounters dazzled Gleyre;
he documented the exotica of the trip for
Lowell in brilliant watercolors and pencil
sketches[1] and devoted his first few years
back in Paris to paintings of fashionable
Orientalist themes. But the pleasures of
the journey were enjoyed at a price, for the
artist and Lowell often clashed, and in
Egypt Gleyre fell victim to ophthalmia, a
painful eye disorder that left him tempo-
rarily blind. It is likely that this eye ail-
ment and the mental depression that
accompanied it plagued him for much of
the rest of his life.[2]

Gleyre returned to France impover-
ished and reclusive in 1837 and made his
debut virtually unnoticed at the 1840
Salon. Fame, however, found him soon
after. His reputation was already assured in
1843, when his most famous painting, the
Romantic LE SOIR, or LOST ILLUSIONS
(Louvre), was unanimously applauded at
the Salon and earned him a second-class
medal. When the great academic painter
Paul Delaroche left for Italy that same year,
Gleyre took charge of his studio. His lib-
eral aesthetic views and professional gen-
erosity—he dispensed with most of the
traditional atelier fees[3]—attracted several
fledgling Impressionists to his studio, and
in later years he achieved considerable
renown in the city as a teacher of painting.
In 1845 Gleyre again traveled to Italy. His
earlier Roman encounter with Michel-
angelo's sculpture and the paintings of
Raphael was now broadened as he studied
the luminary and coloristic refinements of
Byzantine mosaics and the painters of
Renaissance Venice.

Gleyre was a meticulous craftsman
who sometimes labored for years on a sin-
gle canvas. The masterpieces of his middle
period—a pair of decidedly nationalistic
Swiss history paintings for the Musée
Arlaud in Lausanne—are a case in point,
for the earlier of these two commissions,
MAJOR DAVEL, required four years to
finish (1846–50), while the more complex
ROMANS PASSING UNDER THE YOKE
took eight (1850–58). His brooding per-
fectionism made it difficult for him to
meet the deadlines of the annual Salon,
and, in fact, he exhibited there only five
times. His last Salon showing was in 1849.

Though his precise draftsmanship, crystal clarity of form, and unerring eye for historically accurate detail marked him as an academic, he was by no means a conservative, "establishment" artist. Indeed, throughout his life he remained a solitary figure who spurned wealth and official honors for a career of selfless teaching. He was also an outspoken political liberal whose withdrawal from the Salon after 1849 was made in part to protest the rise of Louis Napoleon.[4]

Having initially devoted himself to Orientalist themes and then to a succession of grandiose historical works, Gleyre turned late in life to more modest, poetic visions of the unclothed female form. Imbued with a "sense of grace and quiet introspection,"[5] these pellucid genre and mythological paintings are said to reflect the serenity of Gleyre's final years.[6] THE BATH, 1868, figures among these later works. A captivating bit of antique Roman genre, it is one of only a handful of paintings by Gleyre found today in the United States. The setting is the atrium of a patrician Roman household, where a mother prepares to bathe her infant son.[7] The gloriously nude girl who attends at the right, her supple form radiating light, may be her daughter. The artist may have derived the subject from a terracotta relief in the Campagna collection, housed at that time in the Musée Napoleon III in Paris. Following traditional academic practice, Gleyre perfected his figurative designs for THE BATH in a series of exquisite preliminary drawings and painted sketches. Four of these preparatory works—pencil drawings of the mother, infant, and girl in full-length (fig. 25) and an oil study of the girl's head—are in the Musée Cantonal des Beaux-Arts, Lausanne.[8]

The painting was commissioned from Gleyre by John Taylor Johnston, a well-known New York art collector and first president of the Metropolitan Museum. While in Paris in the autumn of 1868, Johnston visited the artist's studio and recorded his first impressions of THE BATH in his journal. "I was delighted to find that it was really a remarkable picture of great power and sweetness," he wrote, "and such as I am perfectly satisfied to

Fig. 25. Charles Gleyre, FEMALE NUDE, courtesy Musée Cantonal des Beaux-Arts, Lausanne, Switzerland, inv. no. D1182.

take."[9] Later writers have responded with equal ardor, as is seen, for example, in Edward Strahan's glowing tribute:

> The picture, in its blond perfection and ivory translucence, gives rather the idea of statuary than of painting . . . It is such an achieved bit of perfection as a teacher leaves but once or twice in his career.[10]

NOTES:
1. For these works, located in the Lowell Institute in Boston, see Hauptman and Newhouse, 1980, pp. 79–117.
2. *Ibid.*, p. 13. For additional speculation on the nature of Gleyre's recurring melancholia, see Hauptman and Newhouse, 1980, p. 37.
3. *Ibid.*, p. 14.
4. Atlanta, 1983, p. 120.
5. Hauptman and Newhouse, 1980, p. 54.
6. *Ibid.*
7. See Clément, 1878, p. 345, and Hauptman and Newhouse, 1980, pp. 54, 70, note 260.
8. Inv. nos. D1179, D1180, D1182, and 1327, respectively. The drawing illustrated here is executed in pencil and red chalk, 46 × 23 cm. Another drawing by Gleyre in the Musée Cantonal, this one of a woman's head and shoulders (inv. no. D1181), may also be a study for the figure of the mother in the Norfolk picture, though its design differs considerably from that of the painted figure. I am indebted to Dr. William Hauptman, who generously shared his research on the artist's drawings. For a more complete account of the drawings and oil sketches made by Gleyre in connection with *The Bath*, see Clément, 1878, nos. 110–111, 407–412.

WILLIAM ADOLPHE BOUGUEREAU

9. Baetjer, ed., 1981, p. 414.
10. Strahan, 1881, p. 88; see also Atlanta, 1983, p. 120.

22. ORESTES PURSUED BY THE FURIES
(Les remords d'Oreste)

Oil on canvas, 89½″ × 109⅝″
Signed and dated lower right:
W~BOUGUEREAU~1862

COLLECTIONS:
The artist, 1862–1870; sold by the artist, Nov. 4, 1870, to George Lucas for Samuel Avery; Mrs. Joseph Harrison, Philadelphia; Pennsylvania Academy of Fine Arts, Philadelphia; Giovanni Castano, Boston; Walter P. Chrysler, Jr.; Chrysler Museum, Norfolk, 1971.

EXHIBITIONS:
Salon, Paris, 1863, no. 227; Dayton, 1960, no. 43; Atlanta, 1983, no. 6; Louise d'Argencourt *et al.*, *William Bouguereau 1825–1905*, Petit Palais, Paris, Montreal Museum of Fine Arts, and Wadsworth Atheneum, Hartford, Feb. 9, 1984—Jan. 13, 1985, no. 29.

REFERENCES:
P. Mantz, "Salon de 1863," *Gazette des Beaux-Arts*, 1863, p. 488; T. Gautier, "Salon de 1863," *Le Moniteur Universel*, June 20, 1863, p. 1; C. de Sault, *Essais de critique d'art: Salon de 1863*, Paris, 1863, p. 39; J. Girard de Rialle, *A travers le Salon de 1863*, Paris, 1863, pp. 67–68; W. Strahan, *The Art Treasures of America*, Philadelphia, 1881, II, p. 104; Bellier and Auvray, *Dictionnaire Général des artistes de l'école française*, Paris, 1882, I, p. 135; L. Baschet, *Catalogue illustré des oeuvres de W. Bouguereau*, Paris, 1885, pp. 24–26; *Descriptive Catalogue*, Pennsylvania Academy of Fine Arts, Philadelphia, 1892, p. 19, no. 401; M. Vachon, *W. Bouguereau*, Paris, 1900, p. 147; H. Henderson, *The Pennsylvania Academy of Fine Arts*, Boston, 1911, pp. 164–165, ill.; *Apollo*, 1978, pp. 22, 18, fig. 4; *The Diary of George A. Lucas*, L. Randall, ed., Princeton, 1979, II, pp. 320, 322–323, 332; W. Hauptman, "Charles Gleyre: Tradition and Innovation," *Charles Gleyre 1806–1874*, exhib. cat., Grey Art Gallery, New York, etc., 1980, p. 50, fig. 63; J. House, "Pompier Politics: Bouguereau's Art," *Art in America*, 72 (1984), pp. 142–143, ill. cover.

The son of a wine merchant from La Rochelle, Bouguereau became one of the most powerful members of France's later-nineteenth-century art establishment, a conservative *grand maître* whose academic paintings help set the style of official French art in the decades between 1850 and 1900. Bouguereau's artistic interests were first fostered by a sympathetic uncle, who sent the youth to Pons in 1838 to learn drawing from the painter Louis Sage, a disciple of Ingres. To continue the boy's Latin studies, he also enrolled him in the

Collège de Pons. There and in Sage's studio Bouguereau developed a love of antiquity and the classical tradition that would serve as the philosophical foundation of his mature art.

After additional study in Bordeaux, he arrived in Paris in 1846 to perfect his craft under the tutelage of the Neoclassicist François Picot at the Ecole des Beaux-Arts. In 1850 he captured the *Prix de Rome* with his ZENOBIA FOUND BY SHEPHERDS ON THE SHORES OF THE ARAXES (Ecole national des Beaux-Arts, Paris). During the next four years he studied and traveled widely in Italy, where he was most impressed by the paintings of Giotto and other Trecento masters and by the High Renaissance art of Raphael.

Resettling in Paris, he quickly won recognition as a history painter, portraitist, and decorator of fashionable Paris townhouses, garnering a second-class medal at the Exposition Universelle of 1855, first prize at the 1857 Salon, and in 1856 an important state commission to paint NAPOLEON III VISITING THE FLOOD VICTIMS OF TARASCON (Hôtel de Ville, Tarascon). His career thereafter was a dazzling succession of professional triumphs and increasingly prestigious awards. In 1858 he was named *chevalier* of the Legion of Honor, in 1875 professor at the Ecole des Beaux-Arts, and from 1876 he served as a leading member of the all-powerful Institut de France. After 1859 he began a series of immensely popular genre pictures—sentimental images of peasant children and devoted mothers rendered in a flawlessly realistic academic style—and by the mid-1860s his paintings fetched the highest prices from wealthy collectors in France, England, and America.

A pure product of the Ecole and its rigorous academic regimen, Bouguereau throughout his life stressed the superiority of the classical ideal. As a teacher he preached the importance of precise draftsmanship and a tight, craftsmanly painting technique. Those avant-garde artists who ignored such traditional concerns—chief among them, the Impressionists—he dismissed with scorn:

Fig. 26. William Adolphe Bouguereau, A FURY, present location unknown.

. . . Nowadays painters go much too far . . . they say they have exhausted the formula and that one ought to seek something new . . . they want to succeed too fast, this is how they go about inventing new aesthetics, pointillism, *pipisme*! All this is just to make noise . . . One has to seek Beauty and Truth . . . There is only one kind of painting. It is the painting that presents the eye with perfection, the kind of beautiful and impeccable enamel you find in Veronese and Titian.[1]

The avant-garde had its revenge soon enough. Indeed, with the triumph of Modernism after World War I, Bouguereau's art rapidly fell out of fashion. Only recently has his work attracted once again the critical attention it so richly deserves and his name begun to regain its former luster.

ORESTES PURSUED BY THE FURIES is based on the *Orestia* by Aeschylus, in which Orestes, the son of Agamemnon, kills his mother Clytemnestra to avenge her murder of his father. Orestes is then set upon by the Furies, or Eumenides, the three spirits of retributive justice, who relentlessly pursue him as he seeks to purge his guilt at Delphi and in Athens. In Bouguereau's splendid painting of 1862, the Furies Tisiphone, Alecto, and Megaera, their hair swarming with snakes, confront Orestes with his crime, pointing

23. LANDSCAPE IN A THUNDERSTORM
(Campagne Romaine, vallée rocheuse)

angrily at the corpse of his mother. The horrified Orestes lurches away, vainly trying to escape the Furies and their hideous cries of accusation. The grisly scene is given a dramatic nocturnal setting — especially appropriate as the Furies were the daughters of Night — and the figures are pulled from the darkness, and Orestes's guilt exposed, by the light of the torch held by the Fury at the right. Among the surviving preliminary studies for the painting is a pencil drawing of the torch-bearing Fury (fig. 26)[2] and a compositional sketch in charcoal.[3]

Exhibited at the 1863 Salon, ORESTES was harshly judged by the critics, who balked at its heavy, melodramatic tone. Bouguereau had seldom before attempted so pure an expression of Romantic *Grand Guignol*; among earlier pictures only the 1850 DANTE AND VIRGIL IN HELL (private collection, France) matches the lurid intensity of the Norfolk picture. When his ORESTES was condemned at the Salon, Bouguereau abandoned the genre for good. Thereafter he returned to a more balanced, quiet, Raphaelesque style and favored far less dramatic pictures of beggar children, the Madonna, and coolly erotic mythological nudes. "I soon found that the horrible, the frenzied, and the heroic does not pay," he later confided, "and as the public of today prefers Venuses and Cupids and I paint to please the public, it is to Venus and Cupid I chiefly devote myself."[4]

NOTES:
1. D'Argencourt *et al.*, 1984–85, pp. 53–54.
2. Dimensions and present location unknown. See Vachon, 1900, p. 47.
3. Charcoal on paper, 41 x 49 cm., private collection. See d'Argencourt *et al.*, 1984–85, p. 163, no. 30.
4. See A. Werner, "Great Boug-Bear of Academic Painting," *Antioch Review*, Dec. 1955, p. 490, and Atlanta, 1983, p. 55.

Oil on canvas, 38½" × 53¼"
Signed and dated lower left: *Corot 1856* (partially effaced)

COLLECTIONS:
Bernheim-Jeune, Paris; Georges Bernheim, Paris; Conrad Pineus, Göteborg, Sweden, 1924; Walter Halvorsen, Paris; Thannhauser Galleries, Berlin and Lucerne, 1927; Acquavella Galleries, New York, 1949; Walter P. Chrysler, Jr.; Chrysler Museum, Norfolk, 1971.

EXHIBITIONS:
French Paintings, Moderna Museet, Stockholm, 1924, no. 2; *Corot-Daumier. Eighth Loan Exhibition*, Museum of Modern Art, New York, Oct. 16—Nov. 23, 1930, no. 15; Portland, 1956–57, no. 75; Provincetown, 1958, no. 12; Dayton, 1960, no. 26; Provincetown-Ottawa, 1962; Finch College, 1965–66, no. 15; *Corot*, Wildenstein Gallery, New York, Oct. 30—Dec. 6, 1969, no. 20.

REFERENCES:
A. Robaut, *L'Oeuvre de Corot*, Paris, 1905, II, pp. 92–93, no. 259, ill.; V. Barker, "October Exhibitions," *The Arts*, Oct. 1930, p. 17, ill.

One of the first members of the Barbizon school of landscapists, Corot exerted a formative influence on both his fellow Fontainebleau painters and the Impressionists who followed in their wake. Indeed, his crucial role in the development of mid-nineteenth-century French landscape painting was rivaled only by that of his younger colleague Rousseau (cat. no. 24).

Corot's desire to become a painter manifested itself early, though his parents, who owned a successful dressmaker's shop in Paris, initially had other plans for him. They boarded him at schools in Rouen and Poissy and later demanded that he take up the family trade. A reluctant apprentice, Corot worked for more than five years in two Paris textile firms. Finally, at the age of twenty-six, he won his father's consent to study art and entered the atelier of the landscape painter Achille Etna Michallon. Within months of his arrival, Michallon died, but he had succeeded in impressing Corot with the importance of sketching *en plein air*.[1] By the time he joined the studio of the classical landscapist Jean-Victor Bertin, Corot had already begun to travel the countryside, working *sur le*

motif at Fontainebleau, Dieppe, and elsewhere.

Corot spent the years from 1825 to 1828 in Italy. In Rome he received valuable instruction from the landscapist Caruelle d'Aligny and perfected his first landscape style, a markedly classical manner featuring broadly faceted landscape forms clearly defined in crystalline light and bathed in southern sun. He also worked in Venice, Naples, and Narni and submitted a pair of his Italian landscapes — LE PONT DE NARNI and CAMPAGNE DE ROME — to the 1827 Salon, his public debut.

Back in France Corot's work regimen shifted with the seasons. The warm months found him in the provinces, where he made brilliant landscape studies out-of-doors. In winter he retreated to his Paris studio and there used his warm-weather sketches to compose larger, finished landscapes for the Salon. To make his landscapes more acceptable to the Salon jurors, Corot often added small-scale religious and mythological scenes to them.

His work slowly gained acceptance during the 1830s and '40s. He captured a second-class medal at the 1833 Salon, began to attract state patronage in the early 1840s, and in 1846 was enrolled in the Legion of Honor. To nourish and sustain his art, he continued to travel throughout France, his mobility abetted by his bachelor state. He was in Switzerland in 1842 and twice returned to Italy, in 1834 and '43.

Corot's career at last began to crest in 1849. In that year he jurored the Salon and sold one of the paintings he showed there — his CHRIST IN THE GARDEN OF GETHSEMENE (Musée, Langres) — to the government. Around 1850 he embarked on a new style. His earlier classical landscapes now gave way to a series of Romantic *souvenirs* — gauzy, poetic landscape visions suffused with a silvery light. The style of these later works, which found a parallel of sorts in the contemporary Rococo-revival art of Adolphe Monticelli and Diaz (cat. no. 25), was much favored by Second-Empire society. The official stamp of approval came at the 1855 Exposition Universelle, when Corot garnered a first-class medal and his SOUVENIR DE MARCOUSSIS (Louvre) was acquired by Napoleon III. Rich and successful, a kindly mentor to many a younger artist, "Papa" Corot became one of France's most popular living painters.

Though LANDSCAPE IN A THUNDERSTORM is dated 1856, the relative lucidity of its forms and atmosphere suggests an earlier moment in Corot's career, well before he embraced the gauzy manner of his *souvenirs*. Quite possibly it was painted around 1835 and then kept by the artist, who retouched it in 1856 and only then signed and dated it.[2] A date of ca. 1835 would place the painting just after Corot's second visit to Italy, and it is possible that the landscape depicts an Italian vista. On at least one occasion the painting has been described as a portrayal of a rocky valley in the Roman *Campagna*.[3] In the early 1830s Corot was influenced briefly by the works of the seventeenth-century Dutch landscapists, particularly Jacob van Ruisdael. The rushing stream and twisted vegetation in the Norfolk painting, the drama and foreboding of the oncoming storm, bring Ruisdael to mind, a fact that serves to support a date of ca. 1835. A lonely sentinel in this desolate landscape, the tree at the left is struck by the chilly, lowering light that often precedes a storm, a ghostly illumination that lends a spectral clarity and depth to both the tree and the surrounding landscape. In the middleground, beyond the stream, a shepherd with his dog and flock awaits the approaching line of rain.

NOTES:
1. Weisberg, Tokyo, 1985, no pag.
2. Robaut, 1905, pp. 92–93, no. 259.
3. *Corot*, Wildenstein Gallery, 1969, no. 20.

PIERRE-ETIENNE-THÉODORE ROUSSEAU

24. CLEARING IN THE FOREST OF FON-
TAINEBLEAU *(Carrefour de la Reine-Blanche)*

Oil on canvas, 32½″ × 57¼″
Signed lower left: *Rousseau.*

COLLECTIONS:
The artist, ca. 1860/62–1867; the artist's studio sale, Hôtel Drouot, Paris, April 27—May 2, 1868, no. 38; Arthur Stevens; Ernest Brugeman, Brussels; E. Le Roy et Cie., Paris; Arthur Tooth and Sons, New York, 1903; Frank G. Logan, Chicago; Walter P. Chrysler, Jr.; Chrysler Museum, Norfolk, 1971.

EXHIBITIONS:
Salon, Paris, 1859, no. 2641(?); Dayton, 1960, no. 30; Palm Beach, 1962, no. 44; Finch College, 1965–66, no. 20; *The Second Empire 1852–1870,* Philadelphia Museum of Art, Detroit Institute of Arts, and Grand Palais, Paris, Oct. 1, 1978—July 2, 1979, no. VI-103; Weisberg, Tokyo, 1985, no. 89.

REFERENCES:
A. Sensier, *Souvenirs sur Th. Rousseau.* Paris, 1872, p. 270, note 1; *Théodore Rousseau 1812–1867.* exhib. cat., Louvre, Paris, 1967–68, p. 83, under no. 55.

The landscapist Rousseau was a founding member of the Barbizon group of painters. In the late 1820s he was already at work at Chailly, near the Fontainebleau forest. There, and on subsequent visits to the Auvergne (1830) and Normandy (1831), he produced a revolutionary series of vibrant and spontaneous *plein-air* landscapes, "pure" landscapes that dispensed with traditional narrative subject matter and classical compositional schemes.

Though Parisian by birth, Rousseau spent much of his childhood in the French countryside, where he early discovered his passionate love of landscape and his genius for painting directly from nature. Preoccupied with their prosperous tailoring business, his parents boarded the boy with a family outside of Paris. By 1821 he was at school near Anteuil, and in 1825 he worked briefly in the sawmill of a family friend in the Franche-Comté region of eastern France. Returning to Paris, he convinced his parents of his calling as an artist. He then studied with the painters Jean Charles Joseph Rémond and Guyon Lethieres in hopes of winning the *Grand Prix* in historical landscape painting. His attempt failed, and he abandoned Paris in 1830 to work in the remote Auvergne, far

to the south. Rousseau first bowed before the public at the 1831 Salon, where he exhibited one of his Auvergne landscapes.[1] These broadly handled, experimental *paysages* impressed the leading lights of the emerging Romantic movement—chief among them Delacroix and the influential Ary Scheffer, drawing master to the children of Louis Philippe—and during the 1830s Rousseau became a spokesman for France's younger generation of avant-garde landscapists.

The artist displayed his works at the Salon without serious incident until 1836, when the conservative jury banished all of his submissions. For the next five years his paintings were consistently rejected by the Salon, a cruel example of official persecution that scandalized his supporters and earned him the sardonic soubriquet, *le grand réfusé.* In 1841 the frustrated Rousseau finally turned his back on the Salon. He did not exhibit there again until 1849, when, in the wake of a recent revolution, liberal forces gained control of the jury and welcomed him back with a first-class medal.

For a time Rousseau's circumstances improved. He was named to the Legion of Honor at the 1853 Salon. He served on the jury of the Exposition Universelle and captured yet another first prize. His long-standing financial problems—his desperate attempt to raise funds from a public sale of his paintings in 1850 had ended in disappointment—also eased as art dealers began to promote his work. In the late 1840s he emerged as an outspoken conservationist, spearheading a crusade against the commercial deforestation of his beloved Fontainebleau woods and petitioning Napoleon III in 1853 to halt the mass planting of pines in the forest. In the same year the Emperor proclaimed part of the forest a natural preserve.[2]

Rousseau's good fortune was fleeting, however. Problems with his agents and his own chronic overspending brought him once more to the brink of economic ruin in 1861, when he suffered yet another unsuccessful sale of his pictures. Not until 1866, when the dealers Durand-Ruel and Brame purchased all of his unsold early sketches, did the crisis end. In 1867, only months

Fig. 27. Théodore Rousseau, CLEARING
IN THE FOREST OF FONTAINEBLEAU,
Louvre, Paris, photo Agraci.

before his death, he was suddenly acclaimed
with unprecedented enthusiasm, winning
a grand medal at the Exposition Univer-
selle and the long-awaited title of officer in
the Legion of Honor. He was proclaimed
in death what he had seldom been called in
life: one of "the most admired and influen-
tial landscape painters of mid-nineteenth-
century France."[3]

The years of rejection by the Salon
had their effect on Rousseau, who took
care after 1850 to produce landscapes more
in line with official taste. These composed
and carefully worked pictures borrowed
much from the landscape art of the seven-
teenth-century Dutch masters. Indeed, the
artist was often loath to relinquish his
paintings for fear they were not "finished"
enough. He was faulted for his compulsive
reworking of some of his later landscapes
by his critics and friends alike.

The Norfolk canvas, one of a series of
landscapes that Rousseau undertook at
Barbizon in 1860–62, is a splendid exam-
ple of his mature, more finished and tradi-
tional style. Its composition and the
handling of foliage recall particularly the
works of the Dutch landscapist Meindert
Hobbema.[4] The painting first came to
light at the 1868 sale of Rousseau's studio,
where it was described as the "CARRE-
FOUR DE LA REINE-BLANCHE. Spring-
time. Painting nearly completed. 1860."[5]

The site depicted—the "Crossroads of the
White Queen" in the Fontainebleau forest
—was a favorite of Rousseau. Three of his
other paintings show the same spot; the
best-known of them is found today in the
Louvre (fig. 27).[6] The Norfolk picture
conveys the clarity and dewy calm of a
spring morning, when the first rays of the
rising sun dust the leaves with gold. As
Gabriel Weisberg so aptly noted in a
recent discussion of the painting, Rous-
seau viewed the ancient oaks of Fontaine-
bleau as

> . . . patriarchal figures whose existence
> mirrored the continuation of the past
> into the present. Nowhere are these pan-
> theistic and adulatory qualities better
> conveyed than in this large-scale landsca-
> pe . . . the dominance of the trees, the
> great expanse of the sky, and brilliant
> illumination convey a sense of the sub-
> limity of the environment . . . the
> bountifulness and richness that Rousseau
> always found in the landscape of the
> countryside.[7]

NOTES:
1. Weisberg, Tokyo, 1985, no pag.
2. *Ibid.*, p. 142, no. 89.
3. *The Second Empire,* 1978–79, p. 352.
4. *Ibid.*
5. "*Carrefour de la Reine-Blanche.* Effet de prin-
temps. Tableau presque terminé. 1860." See *Cata-
logue de la Vente . . . Théodore Rousseau,* Hôtel
Drouot, Paris, April 27—May 2, 1868, p. 39,
no. 38.
6. For the Louvre painting (signed, oil on panel,
28 × 53 cm.), which has been dated ca. 1862, see.
C. Sterling and H. Adhémar, *Musée National du
Louvre. Peintures Ecole française XIXe siècle,* Paris,
1961, IV, p. 19, no. 1692. Another painting of the
same site was formerly on the Paris art market,
Galerie Georges Petit. An engraving of yet another,
smaller landscape of the same subject appeared in A.
Silvestre, *Galerie Durand-Ruel: recueil d'estampes,
gravées à l'eauforte,* Paris, 1873, I, pl. 18. See *The
Second Empire,* 1978–79, p. 352.
7. Weisberg, Tokyo, 1985, p. 142, no. 89.

NARCISSE VIRGILE DIAZ DE LA PEÑA

25. Young Girl with Her Dog
(La Rêverie)

Oil on paper, mounted on canvas, 80½" × 47¼"
Signed lower left: *N. Diaz.*

COLLECTIONS:
Galerie Durand-Ruel, Paris; Comte de Comondo;
James S. Inglis, New York; Inglis sale, American
Art Association, New York, March 11–13, 1909,
no. 111; Tedesco Frères, Paris; Walter P. Chrysler, Jr.;
Chrysler Museum, Norfolk, 1971.

EXHIBITIONS:
Dayton, 1960, no. 29; Wildenstein, 1978, no. 16;
A. Sheon, *Monticelli. His Contemporaries, His Influ-
ence*, Museum of Art, Carnegie Institute, Pitts-
burgh, Art Gallery of Ontario, Toronto, Corcoran
Gallery of Art, Washington, D.C., and Rijks-
museum Vincent Van Gogh, Amsterdam, Oct. 27,
1978—Sept. 2, 1979, pp. 39–40, no. 84.

REFERENCES:
A. Silvestre, *Galerie Durand-Ruel: recueil d'estampes,
gravées à l'eau-forte*, Paris, 1873, II, no. CLXXXIV;
"Cottier-Inglis Sale," *American Art News*, 7 (March
6, 1909); *Apollo*, 1978, pp. 22–23, pl. XIII.

Diaz's parents were from the Spanish prov-
ince of Salamanca. Apparently implicated
in a plot against the French occupational
government of Spain, they emigrated to
France and settled in Bordeaux, where
Diaz was born in 1807. Diaz's father died
in 1812 on a trip to England, and his
mother, who worked thereafter as a govern-
ess in Bordeaux, Lyon, and Paris, died
seven years later. The orphaned Diaz was
taken in by a Protestant pastor in Meudon.
At the age of thirteen he had to have a leg
amputated due to complications arising
from a snake bite. Neither he nor his
career was significantly hampered by the
handicap, though he could not always
match the mobility of his future Barbizon
colleagues as they traveled the French
countryside in search of the perfect
landscape.

After studying briefly in a printer's
shop, Diaz worked as a decorator of porce-
lain at Sèvres under Arsène Gillet, the
uncle of the landscape painter Jules Dupré.
In his spare time he tried his hand at still
lifes, flower paintings, and landscapes *en
plein air*. After 1830 he turned exclu-
sively to painting, influenced especially by
the Romantic, Orientalist themes and
vibrant brushwork of Delacroix and by the
works of the Barbizon landscapist Rous-
seau, with whom he was closely associated
after 1837 (cat. no. 24). Indeed, Diaz
made the first of many trips to the forest of
Fontainebleau in 1835, and the friendship
that grew up there between him and Rous-
seau served to inspire and attract several of
the later arrivals to the Barbizon colony,
including Millet and Jacque (cat. nos. 28,
27).

Diaz exhibited regularly at the Salon
between 1831 and 1859. Included among
the landscapes, Oriental and Spanish
subjects, and mythological pictures he
showed was a group of Romantic fantasy
images, dreamlike visions of Bohemians,
gypsies, and nymphs in deeply shadowed
forest and garden settings. These pictures,
which he seems to have turned to in the
mid-1840s, derived much from the earlier
garden scenes and *fêtes galantes* of Antoine
Watteau and other Rococo artists. They
clearly reflect the nostalgic taste for eigh-
teenth-century art and culture that pre-
vailed in France around 1850 through the
Second Empire. One of the loveliest and
grandest of Diaz's fantasy pictures is
YOUNG GIRL WITH HER DOG of ca.
1850. As Eric Zafran has astutely noted,
Diaz's brightly colored, poetic images of
beautiful girls in fancy dress may have
been prompted in part by the neo-Rococo
patterns the artist encountered many years
earlier as a painter of porcelain.[1]

Buoyed particularly by the great pop-
ularity of his fantasy pictures, Diaz's repu-
tation soared in the years after 1844, when
he won his first official recognition at the
Salon—a third-class medal. A first-class
medal followed four years later, and in
1851 he was made *chevalier* of the Legion
of Honor. His career was consummated at
the 1855 Exposition Universelle, where
his paintings were warmly received by
critics and public alike. His influence
spread to younger painters like Adolphe
Monticelli, who first met Diaz in Paris in
1855 and immediately began to produce
his own Rococo-revival garden scenes.

Diaz eventually became so wealthy
and successful that he no longer felt
obliged to show his works publicly. He
withdrew from the Salon after 1859 and
subsequently depended on private sales

JEAN-LÉON GÉRÔME

and patrons to support himself. YOUNG GIRL WITH HER DOG, an unusually large and opulent piece for Diaz, was not shown at the Salon and may well have been a lucrative private commission. Among the horde of aristocratic collectors who competed for his work, and his company, were two of the most prominent figures in Second-Empire society—the art-loving Princesse Mathilde, daughter of Napoleon III, and Count Alfred de Nieuwerkercke, the Emperor's director of museums and Superintendant of Fine Arts. In later years the successful Diaz cultivated a taste for precious *objets d'art* and also used his wealth to help his less fortunate Barbizon colleagues, including Rousseau and Millet.

Following in the tradition of Delacroix, Diaz became "the principal colorist of his generation"[2] and a master of painterly brio. These qualities, which in the early 1860s drew Monet, Renoir, and other budding Impressionists to Fontainebleau to study with him, are readily revealed in the Norfolk painting. Here a young girl dressed in shimmering satin, her hair woven with pearls, poses in a broadly brushed landscape beneath a towering profusion of pink and white flowers. The effect is richly decorative. The extreme refinement of the girl and her little dog, the lush and feathery brush technique and the melting softness it imparts to figure and foliage are all superbly characteristic of Diaz's mature Romantic style. Like Diaz's other fantasy pictures composed in the spirit of *l'art pour l'art*,[3] the painting is virtually devoid of narrative distraction. All is designed to dazzle the eye and set the mind to dreaming. In fact, the painting has sometimes been called LA RÊVERIE, and the girl's eyes, lost in pools of shadow, proclaim that she herself is deep in dreams.

NOTES:
1. Wildenstein, 1978, no. 16.
2. W. Johnston, *The Nineteenth Century Paintings in the Walters Art Gallery,* Baltimore, 1982, p. 63.
3. Sheon, 1978–79, p. 38.

26. THE EXCURSION OF THE HAREM
(La Promenade de Harem)

Oil on canvas, 47½″ × 70″
Signed at left on the stern of the boat: *J.L. GEROME*

COLLECTIONS:
E. Pinkus, New York, 1963; Walter P. Chrysler, Jr.; Chrysler Museum, Norfolk, 1971.

EXHIBITIONS:
Salon, Paris, 1869, no. 1027; Hofstra, 1974, no. 46; Nashville, 1977, no. 34; Wildenstein, 1978, no. 15; *Eastern Encounters: Orientalist Painters of the Nineteenth Century,* Fine Art Society, London, June 26—July 28, 1978, no. 109; Atlanta, 1983, no. 34.

REFERENCES:
T. Gautier, "Le Salon de 1869," *L'illustration,* May-June 1869 (reprinted in *Tableaux à la plume,* Paris, 1880, pp. 304–305); J. Dolent, *Avant le Déluge,* Paris, 1869, p. 56; P. Perier, *Propos d'art à l'occasion de Salon de 1869,* Paris, 1869, pp. 204–205; J.A. Castagnary, *Salons 1857–70,* Paris, 1892, p. 358; J. Claretie, *L'Art et les artistes français contemporains,* Paris, 1876, p. 158; G. Lafenestre, *L'art vivant. La peintre et la sculpture aux Salons de 1868 à 1877,* Paris, 1881, I, pp. 129–130; E. Strahan, *Gérôme,* New York, 1881, I, pl. XLVIII; G. Sheldon, *Hours with Art and Artists,* New York, 1882, p. 88; *Oeuvres de J.L. Gérôme,* Goupil and Co., Paris, n.d., no. 1048; F.F. Hering, *The Life and Works of Jean-Léon Gérôme,* New York, 1892, pp. 209–210; G. Haller, *Nos Grands Peintres,* Paris, 1899, p. 98; C.H. Stranahan, *A History of French Painting,* New York, 1917, p. 318; P. Jullian, *The Orientalists,* Oxford, 1977, pp. 64–65; *Apollo,* 1978, p. 22, pl. XI; H.B. Weinberg, in *A New World: Masterpieces of American Painting 1760–1910,* exhib. cat., Museum of Fine Arts, Boston, etc., 1983–84, pp. 25–26, fig. 8; *idem, The American Pupils of Jean-Léon Gérôme,* Fort Worth, 1984, pp. 41–42, fig. 28; W. Gerdts, *American Impressionism,* New York, 1984, p. 19, fig. 7.

Like his colleague Bouguereau (cat. no. 22), Gérôme was a standard-bearer of French academic style, a grand *pompier* who carried the hallowed traditions of Davidian classicism into the second half of the nineteenth century. Like Bouguereau, too, he was one of the most influential artists of his day. For a full forty years (1863–1904) he served as professor at the Ecole des Beaux-Arts, where his impeccable professional credentials drew generations of students, many of them Americans, to his atelier. The American Thomas Eakins numbered among Gérôme's earliest pupils. The great modernist Fernand Léger numbered among his last.[1] Gérôme was

also a frequent fixture of the Salon jury and, from 1865 on, a member of the Institut de France. Thus, he held the fate of many a young artist in his hands, and as Bouguereau often did, he used his considerable power to thwart those avant-garde painters who, in his opinion, had strayed from the proper path. He despised Impressionism, dismissing it as "le déshonneur de la France," and after Manet's death in 1883, he spoke out against the Manet Memorial Exhibition mounted by the Ecole.

Gérôme's father, a goldsmith in provincial Vesoul, nurtured his son's ability as a draftsman, and after the boy earned his baccalaureate at Vesoul in 1840, he was enrolled in the Paris atelier of the academic painter Paul Delaroche. He soon became the master's prize pupil, and they toured Italy together in 1844. Back in Paris, Gérôme continued his training with Marc-Gabriel-Charles Gleyre (cat. no. 21), who had inherited Delaroche's studio. Under Gleyre's influence Gérôme produced the first of his *Néo-grec* paintings, fantasy visions of antique genre rendered in a polished, Ingresque style. The masterpiece of his early *Néo-grec* manner, the monumental COCK FIGHT (Louvre), was a highlight of the 1847 Salon and marked Gérôme's public debut. The picture charmed the critic Théophile Gautier, who launched the young painter's career with a series of highly flattering newspaper reviews.

Gleyre's colorful accounts of his journey through Greece, Turkey, and Egypt also stimulated in Gérôme an abiding interest in Egypt and the Near East. Indeed, in the years after 1854 Gérôme traveled repeatedly to North Africa and the Near East—he visited Egypt alone six times—and he devoted more and more of his art to genre images of Arab life. These Orientalist pieces presented a more balanced, "ethnographically accurate" portrait of contemporary Egypt and Arabia than had earlier Romantic painters, and they injected a new note of realism into Gérôme's work.[2] In the clarity and polish of their brushwork—in their careful crafting of detail and draftsmanly perfection —they remained, however, thoroughly academic.

Gérôme made his earliest tour of Egypt in 1856. He spent half of his eight-month sojourn in Cairo and the other half navigating the Nile, sketching the fabled waterway and its exotic river traffic. Thereafter the Nile became a favored setting for his Egyptian genre pieces, as can be seen in the well-known EXCURSION OF THE HAREM of 1869, in which a delicate private pleasure craft ferries a sultan's seraglio along the river. The painting appealed to Edward Strahan both as a document of Eastern exotica and a demonstration of flawless compositional logic:

> The veiled beauties of the seraglio are provided with a little kiosk-shaped house, latticed back and front, that they may be secure from the profaning glances of their attendants . . . a gigantic eunuch, with a red umbrella, mounts guard in front of them, and a second, perched on the high stern of the boat, steers with a long oar; a third attendant, turbaned and smoking, sits on the long, graceful prow . . . and the eight . . . rowers stretch their oars at full gallop . . . If we take away the crew of M. Gérôme's boat, or even any one of them, his skillful composition goes to pieces at once. Even the folds of the drapery of the two figures at the ends, falling below the outline of the boat, are of the utmost importance, and the steersman could not possibly hold his oar at any other angle without great aesthetic damage . . .[3]

Gérôme exhibited the painting at the Salon of 1869. In the same year he made his fourth return to Egypt to witness the opening of the Suez Canal as a guest of the French government. After viewing THE EXCURSION at the Salon, Gautier marveled at its atmospheric and luminary subtleties:

> The picture shows us a *caique* flying swiftly along the Nile . . . the boat slips over the clear transparent water, along the misty shore in a sort of luminous fog which produces a magical effect. The bark seems to float at the same time in the water and in the air. These effects which appear almost improbable to eyes that are not accustomed to the delicate

CHARLES-EMILE JACQUE

tones of the 'land of light' are rendered by Monsieur Gérôme with absolute fidelity.[4]

Eric Zafran has remarked upon the painting's poetic consonance of movements: "the boat gliding on the water, the caravan of camels on the shore, and the flight of birds in the sky above."[5] All of these features must have appealed to the young Thomas Eakins, who ended his study with Gérôme in 1869 and whose Philadelphia sculling pictures of the early 1870s owe a clear debt to Gérôme's EXCURSION and other Egyptian river scenes.[6]

NOTES:
1. G. Ackerman, *Jean-Léon Gérôme (1824–1904)*. exhib. cat., Dayton Art Institute, etc., 1972–73, p. 27.
2. *Ibid.*, pp. 11–12.
3. Strahan, 1881, I, no pag.
4. Gautier, 1869, p. 305; quoted in Atlanta, 1983, p. 108.
5. Atlanta, 1983, p. 108.
6. Gerdts, 1984, p. 19; Weinberg, 1984, pp. 41–43.

27. SHEPHERD AND HIS FLOCK *(Le grand troupeau au pâturage)*

Oil on canvas, 102¼″ × 82½″
Signed and dated lower right: *ch. Jacque. 80.*

COLLECTIONS:
The artist, 1880–1894; the artist's atelier sale, Georges Petit, Paris, Nov. 12–15, 1894, no. 1 (withdrawn?); the artist's son; Walter P. Chrysler, Jr.; Chrysler Museum, Norfolk, 1971.

EXHIBITIONS:
Salon, Paris, 1888, no. 1343; Dayton, 1960, no. 34; *The Past Rediscovered: French Painting 1800–1900*, Minneapolis Institute of Arts, July 3—Sept. 7, 1969, no. 52.

REFERENCES:
H. Houssaye, *Le Salon*, Paris, 1888, p. 72; T. Bartlett, "Barbizon," *Scribner's Magazine*, May 1890, p. 539; R. and C. Brettell, *Painters and Peasants in the Nineteenth Century*. Geneva, 1983, pp. 88–89, ill.

A Parisian by birth, the painter and printmaker Jacque spent part of his youth in Chalons-sur-Saône, where his father worked as a school teacher. The graphic skills he acquired during his apprenticeship to a Paris map engraver encouraged him to begin his career primarily as an illustrator. He eventually achieved extraordinary proficiency as an etcher, and his prints won several awards at the Salon, beginning with a third-class medal in 1851. After serving in the army, Jacque went to London, where he worked between 1836 and 1838 as a magazine illustrator and engraver of caricatural prints for the satiric *Le Charivari*.[1] Back in Paris, he continued his graphic output, supplying the publisher Léon Curmer with illustrations for *Les Français peints par eux-mêmes*.[2]

Jacque's growing interest in painting was confirmed in 1845, when he met the painter Millet in Paris (cat. no. 28). The two quickly became friends, and in 1849 they abandoned the French capital together for the rustic solitude of Barbizon. There Jacque perfected his specialties, producing rural genre scenes that owed much to the seventeenth-century Dutch "little masters," and pictures of animals of the farm and field, especially chickens and sheep. These unvarnished depictions of laboring peasants and their livestock are superior

examples of mid-nineteenth-century French Realism, and Jacque clearly intended that his earthy, populist images reflect the egalitarian sentiments that arose with the 1848 revolution. His paintings contain as well a rustic poetry, as a contemporary writer noted when he remarked that Jacque's

> . . . inns, his farms and poultry yards, his village streets, his skirts of forest, his old walls full of crevices, of stains of damp and crumbling plaster, his barns with cobwebs hanging from the ceiling, are full of the sentiment of life, as are also his far-away twilight skies.[3]

Jacque's interest in animals led in time to experiments in animal husbandry. He became a careful observer and breeder of chickens, and he published his scientific findings in an 1858 treatise, *Le Poulailler, monographie des poules indigènes et exotiques.* While at Barbizon he also made money as a land speculator, an enterprise that dismayed Millet and other members of that artist colony and caused his friendship with them to decline in the early 1850s.[4] Chided by his colleagues for his "ungenerous temperament," he finally left Barbizon in 1854 and settled in a studio just outside of Paris.

Jacque's earliest critical success as a painter came at the 1861 Salon, where he won a third-class medal. By the end of the 1860s he had been elected to the Legion of Honor (1867) and become "the most famous French painter of the farmyard scene."[5] His works were prized not only by French collectors, but by the English and Belgians as well.

After 1871 Jacque withdrew from the Salon. He returned only in 1888, when his major offering was the 1880 SHEPHERD AND HIS FLOCK in Norfolk. The painting's monumental size—it measures nearly nine by seven feet—conveys the grandeur of a genuine "Salon" scale. Its size also suggests that the painting was not produced directly from nature—a customary practice among members of the Barbizon group—but was made in the artist's studio from life studies.[6] Indeed, Jacque's small painting of a shepherd in the Petit Palais, Paris—LE VIEUX BERGER (fig.

Fig. 28. Charles-Emile Jacque, LE VIEUX BERGER, Ville de Paris, Musée du Petit Palais, Paris.

28)[7]—may have served as a study for the Norfolk herdsman.

Fleeing an approaching storm, the shepherd strides with crook in hand over the crest of a hill, leading his flock to safety. Before him his dog halts momentarily to survey the herd's progress. The broad, flat pasture land behind them sweeps to the horizon, conveying a sense of infinite space. Jacque's genius as a painter of animals is splendidly revealed in the sheep that crowd the foreground. Dramatically spotlighted by a shaft of sunlight, they are more fully characterized than their keeper, whose impassive, masklike face lies in shadow beneath his hat.

NOTES:
1. Weisberg, Tokyo, 1985, no pag.
2. *Ibid.*
3. See H. Stranahan, *A History of French Painting,* pp. 299–300, and W. Craven, "J. Foxcroft Cole (1837–1892): His Art and the Introduction of French Painting to America," *American Art Journal,* 8 (1981), p. 64.
4. Weisberg, Tokyo, 1985, no pag.
5. Craven (note 3), p. 64.
6. Indeed, there is, in the Smithsonian Archives of American Art, a photograph of Jacque in his studio near Paris. In it the artist is shown working on the Norfolk painting. See Craven (note 3), p. 58, fig. 9.
7. Inv. no. 84956, oil on canvas; unpublished.

JEAN FRANÇOIS MILLET

28. BABY'S SLUMBER *(Le sommeil de l'enfant)*

Oil on canvas, 18¼″ × 14¾″
Signed lower right: *J.F. Millet*

COLLECTIONS:
The artist, ca. 1855–1861; probably Alfred Sensier, Paris, 1861; S.F. Barger; C.C., John S., and Robert S. Allen, Kenosha, Wisconsin; Castano Galleries, Boston; Walter P. Chrysler, Jr., 1953; Chrysler Museum, Norfolk, 1971.

EXHIBITIONS:
Cercle de l'Union artistique, Paris, 1862; Dayton, 1960, no. 28; Palm Beach, 1962, no. 40; Province-town-Ottawa, 1962; R. Herbert, *Jean-François Millet*, Grand Palais, Paris, and Hayward Gallery, London, Oct. 17, 1975 — March 7, 1976, no. 83 (in Paris) and no. 58 (in London); Nashville, 1977, no. 31; Wildenstein, 1978, no. 19; *Millet, Corot and the School of Barbizon*, Seibu Museum, Tokyo, Hyogo Prefectural Museum of Modern Art, Kobe, Hokkaido Prefectural Museum of Modern Art, Sapporo, Hiroshima Museum, Kitakyushu Municipal Museum, March 14 — Aug. 10, 1980, no. T9; Weisberg, Tokyo, 1985, no. 21.

REFERENCES:
E. Wheelwright, "Personal Recollections of Jean-François Millet," *Atlantic Monthly,* 38 (Sept. 1876), pp. 272–273; T.H. Bartlett, "Barbizon and Jean-François Millet," *Scribner's Magazine*, 7 (June 1890), p. 740; A. Benezit-Constant, *Le livre d'or de J.F. Millet par un ancien ami*, Paris, 1891, ill.; J.M. Cartwright, *Jean-François Millet, his Life and Letters*, London, 1896, pp. 166–167, 201; R. Muther, *J.-F. Millet*, Berlin, 1903, English ed., New York, 1905, pp. 59–60; E. Moreau-Nélaton, *Millet raconté par lui-même*, Paris, 1921, II, pp. 27–28, 103, 108, fig. 108; A. Fermigier, *Jean-François Millet*, Geneva, 1977, pp. 31, 54, 56, 35, ill.; *Apollo*, 1978, pp. 22, 19, fig. 5.

Millet was one of the principal leaders of the artist colony at Barbizon in the years after 1850. Born into a family of prosperous peasants, he received his first art instruction from the portraitist Mouchel in Cherbourg, not far from his native village of Gruchy on the Norman coast. In 1835 he moved on to the Cherbourg studio of M. Langlois, a disciple of the Baron Gros.[1] At twenty-three Millet left home for Paris, where, with a fellowship from the Cherbourg town fathers in hand, he planned to complete his education under the academic painter Paul Delaroche at the Ecole des Beaux-Arts. But he withdrew from the Ecole in 1839 and embarked upon an independent course that brought him great personal and professional hard-ship during the 1840s. His early paintings, which sold poorly, were either rejected by the Salon or, if accepted, ignored by the critics. He was encouraged and sustained in Paris by his artist-friends —Jacque and the Barbizon landscapists Rousseau and Diaz (cat. nos. 24, 25)— and by Alfred Sensier, a sympathetic government bureaucrat who would later serve as Millet's agent.

Weary of urban life, Millet moved to Barbizon with Jacque in 1849 and remained there for most of the rest of his life. Inspired especially by seventeenth-century Dutch painting and warm recollections of his own childhood in Normandy, he produced at Barbizon a succession of rural genre scenes—among them BABY'S SLUMBER of ca. 1855—which took as their subject the lives and labors of the peasants. The humble naturalism of these pictures—their "naive directness of vision"[2]—helped shape the new Realist aesthetic that surfaced in French painting at mid-century. Though Millet dealt with a wide range of other subjects over the course of his career—from his early Cherbourg portraits and pastoral idylls to the landscapes of his final years—he was best known in his own lifetime, and is most celebrated today, for his rustic peasant scenes. Indeed, these pictures were loudly touted after 1848 by partisans of the revolutionary left, who saw them as militant commentaries on the social oppression of the common man. Millet himself felt little of this reformist zeal. He viewed his paintings more broadly, as reflections of the dignity and continuity of peasant life. He accepted and heroized the harsh fate of men tethered forever to the earth.[3]

After THE SOWER (Museum of Fine Arts, Boston) was championed by republican critics at the 1850 Salon, Millet's lot gradually improved. By the mid-1850s he had begun to attract an important group of supporters among the artists and collectors of Boston, and his GLEANERS of 1859 (Louvre) was greeted enthusiastically by the liberal press. His first-class medal at the 1861 Salon marked the end of his long-standing financial stress, and the large Millet retrospective at the 1867 Exposition Universelle brought him even wider popu-

lar acclaim.

In October of 1855 the American painter Edward Wheelwright (1824–1900) arrived at Barbizon to study with Millet. He stayed until the following spring and published his recollections in the *Atlantic Monthly* in 1876. Among the noteworthy events he recounted was his viewing of BABY'S SLUMBER. One Sunday morning, soon after the picture was finished, Wheelwright, Diaz, and several other painters visited Millet's studio while the artist was away in Paris on business. As they were inspecting his canvases one by one, they happened upon the painting:

> At last was brought out from its hiding place a picture representing the interior of a peasant's cottage. A young mother was seated, knitting or sewing, while with one foot she rocked the cradle in which lay a child asleep. To screen the infant from the light which streamed in from an open window behind it, a blanket had been folded around the head of the cradle, through which the light came tempered and diffused as by a ground-glass shade. The strongly illuminated and semitransparent blanket formed a sort of nimbus around the child's head; his little figure, from which, in his sleep, he had tossed most of the covering, lay in shadow, but a shadow lit up by tenderly transmitted or softly reflected lights. Anything more exquisitely beautiful than this sleeping child has rarely, I believe, been painted. Through the open window the eye looked out into a garden where a man with his back turned appeared to be at work. The whole scene gave the impression of a hot summer's day; you could almost see the trembling motion of the heated air outside, you could almost smell the languid scent of flowers, you could almost hear the droning of the bees, and you could positively feel the absolute quiet and repose, the solemn silence, that pervaded the picture. All those at least felt it who saw the picture upon that Sunday morning. A sudden hush fell upon all the noisy and merry party. They sat or stood before the easel without speaking, almost without breathing. The silence that was in some way painted into the canvas seemed to

distill from it into the surrounding air. At last Diaz said in a low voice, husky with emotion, "Eh bien! ça c'est biblique."[4]

Diaz's comment was a perceptive one. To give depth to his genre images, Millet frequently alluded to biblical or classical themes. The Norfolk painting brings to mind the domestic harmony of the Holy Family[5] — of the Virgin, Christ Child, and Joseph — a parallel that lends an air of sacredness to this modest peasant scene.

NOTES:
1. Weisberg, Tokyo, 1985, no pag.
2. Herbert, 1975–76, p. 13.
3. *Ibid.*, p. 11.
4. Wheelwright, 1876, pp. 272–273, and Moreau-Nélaton, 1921, II, pp. 27–28.
5. Indeed, the painting's composition and hushed, reverential tone bring to mind the Holy Family images of Rembrandt, and particularly his *Holy Family* in the Hermitage, Leningrad. See *The Hermitage. West-European Painting* (in Russian), Moscow, 1957, I. p. 289. For Millet's several closely related paintings and etchings of sewing peasant women, see A. Murphy, *Jean-François Millet*, Boston, 1984, pp. 72–73, 90–91, 97, 106, 120, and M. Melot, *L'Oeuvre gravé de Boudin. Corot. Daubigny. Dupré. Jongkind. Millet. Théodore Rousseau*. Paris, 1978, pp. 228, 232, 233.

THOMAS COUTURE

29. PIERROT THE POLITICIAN (*Pierrot politique*)

Oil on canvas, 44½" × 58"
Initialed and dated left edge: *T.C.*
1857

COLLECTIONS:
Collection V.J., Paris, 1857; William T. Blodgett; Blodgett sale, Chickering Hall, New York, April 27, 1876, no. 64; Darius C. Mills; Mrs. Ogden L. Mills; Mills sale, Parke-Bernet, New York, Jan. 23, 1952, no. 49; John Levy, New York; Walter P. Chrysler, Jr.; Chrysler Museum, Norfolk, 1971.

EXHIBITIONS:
Dayton, 1960, no. 23; Hofstra, 1974, no. 32; Wildenstein, 1978, no. 17; Atlanta, 1983, no. 21.

REFERENCES:
L. Lurine, *Catalogue des Tableaux Modernes Composant de Cabinet de M. V.J.*, Paris, 1857, p. 14; E. Strahan, *The Art Treasures of America*, Philadelphia, 1881, II, p. 99; T. Couture and Bertauts-Couture, *Thomas Couture (1815–1879)*, Paris, 1932, p. 40; *Wallace Collection Catalogues. Pictures and Drawings*, London, 1968, p. 73; *Apollo*, 1978, pp. 22–24, pl. XII; A. Boime, *Thomas Couture and the Eclectic Vision*, New Haven and London, 1980, pp. 309–312, pl. IX; A. Ingersol Davenport, *Thomas Couture, The Leader of "L'Ecole de Fantasie at The Galerie Deforges,"* diss. University of Pennsylvania, 1981, pp. 238, 262–266, pl. 38.

The son of a shoemaker from Senlis, Couture settled with his parents in Paris at the age of eleven. In 1830 he began a four-year course of study with the Baron Gros (cat. no. 16), who gave the young artist a solid grounding in the principles of academic painting and encouraged his latent genius as a colorist. "If you continue to paint like this," Gros exclaimed to Couture, "you will be the Titian of France."[1] After a period of recurring illness (1834–36) and the first of several failed bids at the *Prix de Rome* (1837), Couture moved on in 1838 to the atelier of Paul Delaroche. Though he had little sympathy for Delaroche's cold, "false academicism," Couture must have studied with interest the grandiose compositions of Delaroche's monumental mural THE APOTHEOSIS OF THE FINE ARTS for the Palais des Beaux-Arts (1837–41); his own later ROMANS OF THE DECADENCE displays a similarly expansive, classicizing design.[2]

Couture took his inaugural bow before the public at the Salon of 1840,

where he showed an early historical genre piece, his YOUNG VENETIAN AFTER AN ORGY. The influential critic Théophile Gautier recognized Couture's potential at once and praised the painting's "light and brilliant color," its "free and easy brush."[3] Couture's decadent VENETIAN also demonstrated a precocious interest in moralizing subject matter, a satiric strain that would continue throughout his career and find particularly sharp expression in his later *arlequinades*.

Couture's next few Salon submissions —THE PRODIGAL SON of 1841 (Musée des Beaux-Arts, Le Havre), the 1843 TROUBADOUR (Philadelphia Museum of Art), and the 1844 LOVE OF GOLD (Musée des Augustins, Toulouse)—continued to whet the critics' appetite and established his reputation as a promising newcomer whose vibrant-hued and broad-stroked canvases might yet "infuse new blood into the grey ghost of academic tradition."[4] That promise seemed to have been realized in 1847, when, after a three-year absence from the Salon, Couture triumphantly returned with his most elaborately staged historical genre painting to date, the spectacular ROMANS OF THE DECADENCE (Louvre). But the direction of Couture's work shifted decisively after the critical highpoint of the ROMANS. Indeed, he gradually renounced the high visibility of an official career for a less pressured, more secluded life. He devoted himself increasingly to his duties as a teacher and to more modest pictures— portraits, landscapes, and small-scale genre pieces of an often satiric nature—for private buyers in France and America. Of the several prestigious public commissions he received during the later 1840s and '50s, Couture finished only one: his mural cycle for the chapel of the Holy Virgin in the church of Saint-Eustache in Paris (1851–56). In the early 1860s he frequently abandoned Paris for the calmer ambience of his native Senlis, and after 1869 he retired permanently to his country estate at Villiers-le-Bel.

In his mature art Couture combined an interest in academic composition and subject matter with a more innovative commitment to open brushwork, resonant

color, and sharp tonal contrast. This style has been described as the very essence of the *Juste Milieu*, that moderating blend of conservative and avant-garde impulses that occupied so many later-nineteenth-century French painters.[5]

Chief among Couture's later easel pictures are his *arlequinades*, or harlequin paintings, in which he used the popular comic personae of the Commedia dell'Arte —Harlequin, Pierrot, Columbine, the Doctor—to satirize respectable middle-class life. The series, which spanned the years from 1854 to 1870 and includes PIERROT THE POLITICIAN and six other works, was allegedly prompted by "visions" the artist experienced while working on his murals in the chapel of the Holy Virgin in Saint-Eustache. As Couture reported in his autobiographical apologia *La Méthode*, these hallucinatory dreams were encouraged by his discovery that the renowned eighteenth-century performer Dominique—an actor who had made his reputation as Harlequin—was interred in the chapel of the Holy Virgin. During one of these apparitions, Couture claimed that "a tiny harlequin jumped upon my palette and turned a cartwheel."[6] The *arlequinades* he distilled from his visions served as allegories of modern folly, thinly-veiled indictments of the foolishness of mid-nineteenth-century lawyers, doctors, businessmen—"all the situations," Couture proclaimed, "of our contemporary world."[7]

In PIERROT THE POLITICIAN of 1857, two men have doffed their street clothes—an overcoat and top hat rest at right—and have donned the costumes of Pierrot (in white) and Harlequin for a fancy-dress *Bal Molière*. But they have abandoned the festivities for a bit of political shoptalk and gossip over the latest issue of *Le Moniteur universel*, the official newspaper of the French government. Couture despised the bourgeois preoccupation with "business, always business," and in the painting he takes a jab at those who, even at a costume gala, cannot forgo their dull, mundane concerns.[8] Emblazoned on the poster behind the men, the title of the ball alludes to the great seventeenth-century French dramatist Molière, whose

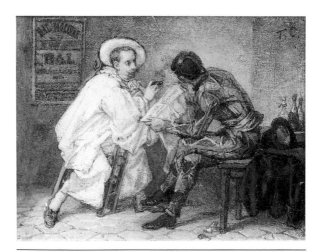

Fig. 29. Thomas Couture, TWO POLITI-CIANS, reproduced by permission of the Trustees, The Wallace Collection, London.

satiric comedies Couture deeply admired and used as a source of inspiration for his moralizing paintings. "I will tell you that Molière is my god," Couture once confided; " . . . by means of a different art, I am searching for this charming and diamond-sharp form which only this master of masters could have found . . ."[9] The surviving studies for PIERROT THE POLITICIAN include a black chalk drawing in the Cummings collection, Detroit,[10] and a preparatory oil sketch in The Wallace Collection, London (fig. 29).[11]

NOTES:
1. Quoted in *Thomas Couture: Paintings and Drawings in American Collections*, exhib. cat., University of Maryland Art Gallery, College Park, 1970, p. 11.
2. *Ibid.*, pp. 12–13.
3. *Ibid.*, p. 16.
4. *Ibid.*, p. 17.
5. Boime, 1980, pp. 36ff.
6. Atlanta, 1983, p. 82.
7. *L'Artiste*, October 12, 1856, p. 220; quoted in *Thomas Couture* (note 1), p. 20.
8. Boime, 1980, p. 310.
9. Quoted in *Thomas Couture* (note 1), p. 20.
10. 40 × 53.3 cm. See Boime, 1980, p. 311, fig. IX.20.
11. Oil on canvas, 12 × 16 cm. See *Wallace Collection Catalogues*, 1968, p. 73, no. P288.

CHARLES-FRANÇOIS DAUBIGNY

30. BEACH AT VILLERVILLE-SUR-MER AT SUNSET (*Plage de Villerville-sur-Mer. Soleil couchant*)

Oil on canvas, 30¼″ × 56½″
Signed and dated lower left: *Daubigny 1873*

COLLECTIONS:
The artist, 1873–1878; the artist's studio sale, Hôtel Drouot, Paris, May 6, 1878, no. 265; Verde-Delisle; Tedesco Frères, Paris, 1954; Walter P. Chrysler, Jr.; Chrysler Museum, Norfolk, 1971.

EXHIBITIONS:
Salon, Paris, 1873, no. 414; *Welt-Ausstellung*, Kunst Hof, Vienna, 1873, no. 172(?); Dayton, 1960, no. 33; Palm Beach, 1962, no. 19; Provincetown-Ottawa, 1962; *The Seashore*, Museum of Art, Carnegie Institute, Pittsburgh, Oct. 22—Dec. 5, 1965, no. 10; Wildenstein, 1978, no. 21; *French Marine Paintings of the Nineteenth Century*, Museum of Fine Arts, St. Petersburg, March 16—May 5, 1985, no. 8.

REFERENCES:
E. Moreau-Nélaton, *Daubigny*, Paris, 1925, p. 111; M. Fidell-Beaufort and J. Bailly-Herzberg, *Daubigny*, Paris, 1975, p. 68; R. Hellebranth, *Charles-François Daubigny, 1817–1878*, Morges, 1976, p. 208, no. 618, ill.

Though the landscape painter Daubigny visited the Fontainebleau forest on occasion following 1843, he spent most of his life removed from his fellow artists at Barbizon. Because he shared their deep commitment to nature and their passion for working out-of-doors—he was, perhaps, the most confirmed *plein-air* painter of his generation—he is viewed nonetheless as an important, if somewhat peripheral, member of the Barbizon group.

Daubigny had a studio in his native Paris, but his favorite spots were decidedly rural: Villerville, for example, on the coast of Normandy; Auvers, where he had a house; and the rivers Seine, Oise, and Marne, which he painted after 1857 from his studio-houseboat, the *Botin* ("Little Box"). His restless quest for new landscape sites, which anticipated the peripatetic spirit of the Impressionists, led him also to Brittany and the Channel coast, to Holland in 1871–72 and to England in 1866 and 1870. On his second visit to England he met the young Claude Monet in London and introduced him to the dealer Paul Durand-Ruel. Daubigny was fascinated by the shifting qualities of nature's color and light, above all by the reflective properties of water and the fleeting atmospheric effects of dusk and dawn. These he recorded with an ever freer and more rapid brush technique and an increasingly brighter and more vivid palette. By the 1860s his art verged on Impressionism, though it never embraced the most revolutionary tenets of the new style.

Daubigny's artistic interests were encouraged early in his life by his father and uncle, both painters. His love of France's rural landscape and waterways also took hold in his youth, for Daubigny spent much of his childhood in the country, living with a foster family in the tiny village of Valmondois, northwest of Paris on the river Oise.

After traveling through Italy in 1836, he joined the Paris studio of the portrait and history painter Pierre Senties and twice vied for the *Grand Prix* in historical landscape painting. On both occasions he was unsuccessful. He had better luck at the Salon, where he first exhibited in 1838. While his Barbizon colleagues were often severely criticized at the Salon and even excluded by its juries, Daubigny was generally spared such drubbing. His first triumph came with the 1840 showing of his ST. JEROME IN THE WILDERNESS (Musée de Picardie, Amiens). Between 1850 and 1852 he sold four of his Salon offerings to the government, and in 1853 his POND AT GYLIEU helped him win a first-class medal and was purchased by Napoleon III. He eventually was made *chevalier* in the Legion of Honor and was elected twice to the Salon jury, in 1865 and 1870. In short, he achieved a level of popular and critical acceptance remarkable for an avant-garde landscapist in mid-nineteenth-century France, and in later years he used his privileged position to defend and promote the highly controversial works of Monet and other struggling Impressionists. Indeed, when the Salon rejected all of Monet's entries in 1870, a frustrated Daubigny resigned from its jury in protest. Yet Daubigny's paintings did not always escape the attacks of conservative critics, who saw little difference between his work and that of the more

"dangerous" Impressionists. Even the generally enlightened *salonnier* Théophile Gautier grumbled on occasion about Daubigny's lack of finish:

> It is really too bad that this landscape painter, who possesses such a true, such a just and such a natural feeling, is satisfied by an impression and neglects details to this extent. His pictures are nothing but rough drafts, and very slightly developed rough drafts . . . Each object is indicated by an apparent or real contour, but the landscapes of M. Daubigny offer merely spots of color juxtaposed.[1]

A small fishing village and seaside resort in Daubigny's day, Villerville-sur-Mer is located just south of the Seine estuary on the Atlantic coast. To the north, across the harbor, is Le Havre. Further south is Trouville, which at that time was a fashionable tourist spot whose sandy strands were immortalized after 1860 in the paintings of Eugène Boudin (cat. no. 35). Daubigny first discovered Villerville on his initial visit to Normandy in 1854, and he returned regularly to paint its beach and coastal hamlet. There he met Boudin, under whose influence he began to work in a lighter and more spirited, Pre-Impressionist style. This more spontaneous manner he brought to bear on the Norfolk canvas, which was probably conceived at Villerville in 1872 and was exhibited one year later at the Salon, where it was favorably received.[2] In the painting a dramatic expanse of bluff and beach is evoked in broken, summary brushstrokes and cast in the rosy, failing light of sunset, one of Daubigny's preferred atmospheric settings. In the foreground a group of Norman peasants abandons the beach as night falls, ending a day of fishing. The quiet naturalism and gentle, contemplative mood of this seashore scene are typical of Daubigny's final landscape style.

NOTES:
1. Quoted by R. Gregg in Hellebranth, 1976, p. XIX.
2. There are at least two other closely related paintings by Daubigny of the beach at Villerville, one of them dated 1870 and the other 1874. For these, see Hellebranth, 1976, nos. 605, 622.

EDOUARD MANET

31. THE LITTLE CAVALIERS (*Les Petits Cavaliers*)

Oil on canvas, 18″ × 29¾″
Signed lower right: *Manet d'après Vélasquez*

COLLECTIONS:
The artist, ca. 1859—1878; purchased from the artist by Jean-Baptiste Faure, Paris, 1878; Comtesse de Béarn, Paris, 1908; Tryggve Sagen, Oslo, 1922; Paul Guillaume, Paris; Bignou Gallery, New York; private collection, Philadelphia; sale, Parke-Bernet, New York, Jan. 15, 1949, no. 62; Reid and Lefevre, London; D.W. Cargill, 1949; sale, Parke-Bernet, New York, April 22, 1954, no. 81; Walter P. Chrysler, Jr.; Chrysler Museum, Norfolk, 1971.

EXHIBITIONS:
Tableaux de M. Edouard Manet, Avenue de l'Alma, Paris, May 22, 1867; *Exposition de 24 Tableaux et Acquarelles par Manet formant la Collection Faure*, Galerie Durand-Ruel, Paris, March 1–17, 1906, no. 5; *Föreningen Fransk Konst*, Nationalmuseum, Stockholm, 1922, no. 3; *12 Masterpieces by XIXth Century French Painters*, Bignou Gallery, 1943, no. 9; *Manet*, Wildenstein and Co., New York, Feb. 26—April 3, 1948, no. 2; Wildenstein, 1978, no. 18.

REFERENCES:
H. de la Madelène, in *Le Salon des Refusés par une Réunion d'Ecrivains*, Paris, 1863, p. 41; A. Proust, "Edouard Manet inédit," *La Revue blanche*, Feb. 15, 1897, p. 174; T. Duret, *Histoire d'Edouard Manet*, Paris, 1902, p. 16, no. 6; J. Meier-Graefe, *Edouard Manet*, Munich, 1912, pp. 31, 58; A. Proust, *Edouard Manet, Souvenirs*, Paris, 1913, p. 24; J.E. Blanche, *Manet*, London, 1925, p. 22; E. Rosenthal, "Manet et l'Espagne," *Gazette des Beaux-Arts*, 2 (1925), p. 212; E. Moreau-Nélaton, *Manet raconté par lui-même*, Paris, 1926, I, p. 24, fig. 6; P. Jamot and G. Wildenstein, *Manet*, Paris, 1932, I, p. 115, no. 7, II, p. 5, no. 18; E. Lambert, "Manet et l'Espagne," *Gazette des Beaux-Arts*, 10 (1933), p. 372; A. Tabarant, *Manet et ses Oeuvres*, Paris, 1947, pp. 18–19, no. 4; M. Florisoone, *Manet*, Monaco, 1947, pp. xv, xix, xx, pl. 2; N. Gösta Sandblad, *Manet*, Lund, 1954, pp. 37–41, fig. 13; J. Richardson, *Edouard Manet Paintings and Drawings*, London, 1958, pp. 14–16, pl. 3; T. Crombie, "Velasquez Observed," *Apollo*, 78 (Aug. 1963), pp. 125, 128, fig. 3; T. Reff, "Copyists in the Louvre, 1850–1870," *Art Bulletin*, 46 (1964), p. 556; A. Coffin Hanson, *Edouard Manet*, exhib. cat., Philadelphia Museum of Art, etc., 1966–67, p. 39; S. Orienti, *The Complete Paintings of Manet*, New York, 1967, p. 87, no. 5; P. Schneider, *The World of Manet*, New York, 1968, p. 22; J. Isaacson, *Manet and Spain Prints and Drawings*, exhib. cat., University of Michigan Museum of Art, Ann Arbor, 1969, p. 24; G. Bazin, *Edouard Manet*, Milan, 1972, p. 13; A. Callen, "Faure and Manet," *Gazette des Beaux-Arts*, 84 (1974), p. 167; D. Rouart and D. Wildenstein, *Edouard Manet, Catalogue raisonné*, Lausanne and Paris, 1975, I, p. 40, no. 21; A. Coffin Hanson, *Manet and the Modern Tradition*, New Haven, 1977,

p. 182; *Apollo*, 1978, pp. 24, 20, fig. 7; *Manet 1832–1883*, exhib. cat., Grand Palais, Paris, etc., 1983, pp. 120–121, 506.

With his DÉJEUNER SUR L'HERBE and OLYMPIA of 1863 (both Musée d'Orsay, Paris), Edouard Manet embarked upon a career of controversy that kept him at the head of the French avant-garde until his untimely death at the age of fifty-one. He was, however, a reluctant revolutionary and longed throughout his career for conventional Salon success. In his paintings of the 1860s he borrowed liberally from the Old Masters but recast these classical borrowings in a thoroughly new, Realist style. Composing with broad masses of sharply separated lights and darks, Manet eschewed traditional pictorial concerns—"perspective, modeling, finish"[1]—and instead emphasized the painted surface. He became "the painter of painting itself,"[2] and, as such, a major progenitor of modern art.

The son of a well-to-do Paris bureaucrat, Manet entered the atelier of Thomas Couture (cat. no. 29) in 1850 and in the same year registered as a student copyist in the Louvre. Though he stayed with Couture for six years, he often took issue with his master's style and working method. Manet was especially disturbed by Couture's approach to light and shadow—his use of chiaroscuro and subtly graded halftones to model form. When challenged by Couture on this point, Manet allegedly replied that

> the light presents itself to me with such unity that one tone is sufficient to render it, and it is preferable, even if it seems brutal, to pass brusquely from light to dark than to accumulate things the eye cannot see and which . . . weaken the vigor of the lights . . .[3]

Manet soon found an antidote to Couture's art in earlier Spanish painting, and particularly in the works of Velázquez, which he began to copy at the Louvre in the late 1850s. The clarity of Velázquez's paintings delighted him, as did their abrupt tonal contrasts and informal figurative compositions. These elements would figure prominently in the genesis of his own mature style.

Fig. 30. Diego Velázquez (?), RÉUNION DE TREIZE PERSONNAGES, Louvre, Paris. Photo: Musées Nationaux.

Fig. 31. Edouard Manet, THE LITTLE CAVALIERS, The Metropolitan Museum of Art, New York, Gift of Edwin D. Levinson, 1927 (27.26).

More than a third of the paintings Manet produced between 1859 and '68 were of Spanish themes or bore the compositional and iconographic imprint of Spanish art. He made his debut at the Salon with a Spanish subject, the GUITARRERO (Metropolitan Museum of Art, New York), which won him an honorable mention (a small success soon overshadowed by the scandal of DÉJEUNER SUR L'HERBE), and in 1865 he made his long-anticipated trip to Spain "to seek the counsel of Velázquez."[4]

Among the most important of Manet's early studies after Velázquez is the Norfolk LITTLE CAVALIERS. In it Manet copied the RÉUNION DE TREIZE PERSONNAGES (fig. 30), a painting the Louvre acquired in 1851[5] and exhibited in Manet's day as a work of Velázquez, though in recent years it has been described more tentatively as a product of that master's atelier.[6] Manet, too, considered the painting to be by Velázquez and paid homage to him in the inscription — "Manet d'après Vélásquez" — at the lower right of the Norfolk canvas.[7]

Manet discovered the Louvre's RÉUNION soon after he joined Couture's shop, and he was immediately impressed by its bright, daylight clarity. "Ah, that's clean," he reportedly remarked at the time. "How disgusted one gets with all the stews and gravies."[8] As seen by the entry devoted to it in the Louvre's catalogue of 1858, the RÉUNION was believed to portray Velázquez himself, Murillo, and eleven other artistic luminaries of seventeenth-century Spain:

. . . the figures, thirteen in number, are thought to represent famous artists, contemporaries of Velázquez. He has placed himself, dressed in black, at the left, and Murillo, hardly more than his head visible, stands near him.[9]

With its presumed self-portrait of the great Velázquez, the RÉUNION must have held special significance for Manet. In any event, in his own full-length self-portrait in the 1862 MUSIC IN THE TUILERIES (National Gallery, London), Manet painted himself in a pose clearly based upon that of the black-garbed cavalier in the RÉUNION, a conceit meant to show him as "the Velázquez of his age."[10]

The dates proposed for THE LITTLE CAVALIERS have varied from 1852 to 1860.[11] Recent writers tend to agree with Theodore Reff, who argues that the painting was produced soon after July 1, 1859, the date when Manet, having completed his student years, registered as an artist for

Fig. 32. Edouard Manet, THE LITTLE
CAVALIERS, courtesy Museum of Fine Arts,
Boston. Lee M. Friedman Fund.

copying privileges at the Louvre.[12] Proba-
bly painted in 1859–60, THE LITTLE
CAVALIERS is one of the earliest surviving
documents of Manet's *espagnolisme* and one
of the first paintings of his early maturity
—a crucial transitional work that ushered
in his style of the 1860s.

In 1861 Manet produced the first
state of his etching of THE LITTLE
CAVALIERS (fig. 31),[13] probably basing it
not upon the RÉUNION itself, but upon
the Norfolk oil.[14] One of the proofs of the
first state, found today in the Museum of
Fine Arts in Boston, he retouched heavily
with watercolor (fig. 32).[15] Among the
first and most important of his prints,
THE LITTLE CAVALIERS etching ap-
peared in four subsequent states before
1867. That year Manet exhibited both the
etching and the Norfolk painting in his
first one-man show on the Avenue de
l'Alma in Paris.[16]

NOTES:
1. *Manet 1832–1883*, 1983, p. 18.
2. *Ibid.*
3. Quoted in Hanson, 1977, p. 182.
4. Quoted in Isaacson, 1969, p. 11.
5. Inv. no. 943, oil on canvas, 47.2 × 77.9 cm.
6. See *Catalogue des peintures du musée du Louvre II.
Italie, Espagne, Allemagne, Grande-Bretagne et divers,*
Paris, 1981, p. 71, where the painting is described as
a possible work of Velázquez's entourage.
7. Juliet Bareau has suggested (in correspondence)

that although Manet probably painted the Norfolk
canvas in 1859–60, he may have signed it only after
1863–64, when he abandoned "the typical early
form of his signature—'éd. Manet'—in favor of the
more dashing and cursive 'Manet.' As an early copy
after Velázquez, the painting was very much a studio
picture, and Manet probably did not sign it until he
came to exhibit it in 1867, giving it then an up-to-
date version of his signature."
8. Quoted in Isaacson, 1969, p. 24.
9. Quoted in *Manet 1832–1883*, 1983, p. 126.
10. See Isaacson, 1969, p. 24.
11. *Ibid.*
12. See Reff, 1964, p. 556; Rouart and Wilden-
stein, 1975, I, p. 40; Isaacson, 1969, p. 24; and
Manet 1832–1883, 1983, p. 506.
13. Etching and drypoint, 9¹¹⁄₁₆″ × 15⁵⁄₁₆″.
14. See *Manet 1832–1883*, 1983, p. 120.
15. Inv. no. 1972.88; etching and drypoint,
heightened with watercolor, 9⅝″ × 15⅜″. Many
scholars have misidentified the Boston proof as a
watercolor and have listed it among Manet's draw-
ings. Indeed, several writers have compounded the
error, dating this "watercolor" ca. 1855 and describ-
ing it as Manet's earliest copy of the Louvre *Réunion*.
When the nonexistent watercolor is removed from
the sequence of copies, however, the Norfolk oil of
1859–60 takes its rightful place as Manet's earliest
study after the *Réunion*. See *Manet 1832–1883*,
1983, p. 121.
16. *Ibid.*

PAUL CÉZANNE

32. BATHER AND ROCKS (*Le baigneur au rocher*)

Oil on canvas, transferred from plaster, 66″ × 41½″

COLLECTIONS:
The artist, Jas de Bouffan (near Aix-en-Provence), ca. 1864/68–1899; Louis Granel, Jas de Bouffan, 1899–1907; Josse Hessel, Paris, 1907; Georges Bernheim, Paris; Alphonse Kahn, Saint-Germain-en-Laye; Paul Rosenberg and Co., New York, by 1952; Walter P. Chrysler, Jr.; Chrysler Museum, Norfolk, 1971.

EXHIBITIONS:
Cézanne, Art Institute of Chicago, 1942; *Cézanne. Paintings, Watercolors and Drawings*, Art Institute of Chicago and Metropolitan Museum of Art, New York, 1952, no. 3; Portland, 1956–57, no. 76; Nashville, 1977, no. 40; Wildenstein, 1978, no. 26.

REFERENCES:
F. Burger, *Cézanne and Hodler*, Munich, 1920, pl. 44; L. Venturi, *Cézanne*, Paris, 1936, I, p. 84, no. 83, II, pl. 22; B. Dorival, *Cézanne*, Boston, 1948, p. 23, pl. III; D. Cooper, "The Jas de Bouffan," *The Selective Eye*, New York, 1955, pp. 26–27; R. Murphy, *The World of Cézanne 1839–1906*, New York, 1968, p. 37, ill.; *Apollo*, 1978, p. 25, fig. 11; D. Ashton, *A Fable of Modern Art*, London, 1980, fig. 5.

A major influence on early-twentieth-century modernism, the Post-Impressionist Cézanne labored to restore structure and intellectual control to painting following the era of Impressionism. "I want to make of Impressionism something solid," he once proclaimed, "like the art of the museums."[1] In his mature paintings of the 1880s and '90s, and particularly in his later landscapes, he redefined the visible world as an architectonic interlocking of colors and simple, reductive forms, a tight and "permanent" proto-abstraction that would lead to the Cubism of Picasso and Braque.

Cézanne's early years were often troubled. Prone to depression and fits of rage, he struggled against his father, a hard-nosed banker, who had little patience for his son's artistic interests and initially demanded that the youth study law in his native Aix-en-Provence. Finally, in 1861, the elder Cézanne acceded to his son's wishes and sent him to Paris, where Cézanne frequented the Louvre and the liberal Académie Swisse. Discouraged by what he perceived as his lack of artistic talent, he quickly withdrew to Aix and resolved to abandon painting for a career in his father's bank. But he regretted his decision at once, and from 1862 to '64 he again visited the French capital, falling temporarily under the influence of Courbet and Delacroix, and meeting Pissarro in 1863. It was Cézanne's work with Pissarro at Pontoise nine years later that prompted him to embrace the lighter hues and atmospheric concerns of Impressionism, though this method would serve only as a point of departure for the more "constructed" compositions of his ultimate, Post-Impressionist art.

Early in his career Cézanne divided his time between his native Provence and Paris, where his paintings were consistently refused by the Salon and ridiculed by the critics at the Impressionist exhibitions of 1874 and '77. After 1877 he secluded himself more and more in Provence—at L'Estaque and Aix—and there lived the life of an artistic recluse. He often worked during these years at the Jas de Bouffan, his family's country estate on the outskirts of Aix. In time this house became a sort of hermitage for Cézanne, his refuge from Paris and the hostilities of "the Bouguereau Salon."

Soon after his father purchased the Jas de Bouffan in 1859, he agreed to let Cézanne have a studio there. During the following decade he also allowed his son to decorate the salon of the Jas de Bouffan with murals of his own design. These large-scale paintings, which Cézanne executed in oil directly on the plaster walls of the salon, are among the most ambitious of his early works. In addition to four paintings of the personified SEASONS (ca. 1859–60), Cézanne produced there a portrait of his father (1860–63), an image called SADNESS (1864–68) and a CHRIST IN LIMBO after Sebastiano del Piombo (1864–68). He also painted two large landscape murals in 1860–62. After his Paris sojourn of 1862–64, Cézanne added to one of these landscapes—a rocky vista with pine trees and a rushing stream—the figure of a massively-muscled male nude seen from behind. This LANDSCAPE

CAMILLE PISSARRO

Fig. 33. Paul Cézanne, LANDSCAPE WITH BATHER, formerly Jas de Bouffan, Aix-en-Provence.

WITH BATHER (fig. 33) remained intact and in situ until 1907, the year after Cézanne's death. Then Louis Granel, who had purchased the house from the artist in 1899, had most of the murals detached from the walls, transferred to canvas, and sold.[2] Of the LANDSCAPE WITH BATHER, only the portion with the nude—i.e., the BATHER AND ROCKS in Norfolk—was removed from the wall.

The design and dorsal presentation of Cézanne's nude were clearly influenced by Courbet, as can be seen, for example, from that master's 1853 painting of THE BATHERS in the Musée Fabre in Montpellier.[3] The style of the figure, however, recalls Delacroix. With its heavy, black contours and turbulent brush technique, the painting is typical of Cézanne's youthful manner of the 1860s—a blunt and brooding Romantic style full of dark energy and often violent emotion.

NOTES:
1. Quoted in *Cézanne. Paintings, Watercolors and Drawings,* 1952, p. 42.
2. The *Seasons* and *Sorrow* are today in Paris, in the Petit Palais and Louvre, respectively. The *Christ in Limbo* was formerly in the Pellerin collection in Paris. For these and Cézanne's other works for the Jas de Bouffan, see Venturi, 1936, I, nos. 4–7, 14, 25, 83–87.
3. See R. Fernier, *Courbet,* Lausanne-Paris, 1977, I, pp. 86–87.

33. THE MAIDSERVANT *(La Bonne)*

Oil on canvas, 36½″ × 28¾″
Initialed lower right: *C.P.*

COLLECTIONS:
The artist, until 1903; Paulémile Pissarro, 1930; Walter P. Chrysler, Jr.; Chrysler Museum, Norfolk, 1971.

EXHIBITIONS:
Exposition Camille Pissarro, Musée de l'Orangerie, Paris, Feb.-March 1930, no. 23; Provincetown, 1958, no. 45; Dayton, 1960, no. 55; Provincetown-Ottawa, 1962; Wildenstein, 1978, no. 20.

REFERENCES:
C. Kunstler, *Camille Pissarro,* Paris, 1930, no. 7; L.-R. Pissarro and L. Venturi, *Camille Pissarro Son Art—Son Oeuvre,* Paris, 1939, I, p. 85, no. 53, II, pl. 10, no. 53; *Apollo,* 1978, pp. 24, 20, fig. 9.

The son of Jewish parents of Portuguese descent, Pissarro was born far from France, on the Caribbean island of St. Thomas, at that time a Danish possession. Though he lived and worked in France throughout his adult life, he never renounced his Danish citizenship. At the age of twelve he left St. Thomas for boarding school in Passy, near Paris, and there learned the rudiments of drawing. He returned home at seventeen to join his father's business. But in 1852 the Danish painter Fritz Melbye convinced Pissarro to pursue his artistic interests, and the pair abandoned St. Thomas for two years of painting and sketching in Venezuela. This interlude confirmed Pissarro's vocation as a painter, and, with his family's reluctant consent, he went back to Paris in 1855 to continue his studies as an artist.

During the next half-century Pissarro distinguished himself as the most pragmatic of the Impressionists, a tireless experimenter who tried his hand at a variety of styles and subjects "so as to be able to take advantage," he once said, "of any opportunity that presents itself."[1] His early French landscapes of the late 1850s and '60s bear the imprint of Corot, his first great teacher, and of Courbet and Daubigny as well. By 1869 he had fallen under the influence of Monet and other young Impressionists. His landscapes became brighter in hue and his brushwork more summary as he forged his personal version

of the new Impressionist style. From 1874 to '76 and again after 1879 Pissarro produced a number of peasant genre scenes that were clearly inspired by the figurative works of Millet and Degas. His lifelong concern with the compositional ordering of optical phenomena led him to experiment briefly with Divisionism, Seurat's Neo-Impressionist painting technique, in 1885–90. Thereafter he returned to a pure Impressionist style in the manner of Monet. This late style he perfected in a splendid series of urban views of Paris, Rouen, Dieppe, and Le Havre.

If he borrowed much from other masters, he also gave in abundance. One of the oldest and most trusted of the Impressionists, Pissarro served as mentor and helpmate to many in the group and, more importantly, to the Post-Impressionists Cézanne and Gauguin. "He was so much a teacher," wrote the American Impressionist Mary Cassatt, "that he could have taught stones to draw correctly."[2] In time he became a sort of patriarchal figure to France's younger generation of painters, their good, grey "père Pissarro."[3]

Though revered by his fellow artists, he attracted less public attention than Monet or Renoir, and for decades his canvases sold poorly. "Like Sisley," he once lamented, "I remain in the rear of Impressionism."[4] In fact, he developed slowly as an artist. He made his debut at the 1859 Salon but did not produce his first masterpiece, the MARNE RIVERBANK AT CHENNEVIÈRES (National Gallery of Scotland, Edinburgh) until 1865, when he was thirty-five. During the 1860s he exhibited at the Salon with only limited success and grew increasingly impatient with its rejections of both his own and his Impressionist colleagues' works. Finally in 1873 he turned his back on an official, Salon career and helped to organize the first independent showing of Impressionist paintings, the historic 1874 exhibition of the *Société anonyme coopérative des artistes* in Paris. Thereafter he labored indefatigably to hold the group together and mount its seven remaining shows (1876–1886).

Pissarro was one of the most politically radical members of the Impressionist school. Profoundly affected in 1865 by the anarchist ideology of Pierre Joseph Proudhon, he himself became an anarchist republican, espousing a worker's utopia of "agro-industrial" egalitarianism.[5] Thus, he was philosophically indifferent to the picturesque landscapes and sophisticated urban scenes of his fellow Impressionists, choosing instead for his paintings rather stark, utilitarian settings — mill scenes, industrial harbor and river views, anonymous village thoroughfares — and the common men who inhabited them — rural peasants and ordinary laborers like THE MAIDSERVANT. Emile Zola, one of Pissarro's earliest and most ardent champions among the critics, had already sensed the proletarian honesty and directness of his art at the 1866 Salon:

> I know that you were admitted [to the Salon] with great difficulty, and I offer my sincere congratulations . . . You choose a wintry scene with nothing but an avenue, a hill at the far end, and empty fields stretching to the horizon. Nothing whatever to delight the eye. An austere and serious kind of painting, an extreme concern for truth and accuracy, a rugged and strong will. You are a great blunderer, Sir — you are an artist that I like.[6]

Zola might well have made a similar comment about THE MAIDSERVANT, in which the humble figure of a tray-bearing domestic entering a garden is depicted without artifice, yet with quiet compassion. Dated by Venturi to 1867,[7] the picture is a rare example of Pissarro's early figurative art. Indeed, THE MAIDSERVANT is one of the few paintings by the artist that survived the Franco-Prussian war (1870–71), during which Pissarro's house at Louveciennes was occupied by invading Prussian troops and nearly fifteen hundred of his early works were destroyed. The woman's heavy, broadly modeled form and the paint thickly applied with a palette knife recall Courbet, whose influence on Pissarro was especially strong at this time.[8]

NOTES:
1. Quoted in *Camille Pissarro 1830–1903*, exhib. cat., Hayward Gallery, London, etc., 1980–81,

IGNACE-HENRI-JEAN-THÉODORE FANTIN-LATOUR

34. PORTRAIT OF LÉON MAÎTRE

p. 42.
2. A. Segard, *Mary Cassatt,* Paris, 1913, p. 45.
3. *Camille Pissarro* (note 1), p. 38.
4. *Ibid.*, p. 13.
5. *Retrospective Camille Pissarro,* exhib. cat., Isetan Museum of Art, Tokyo, etc., 1984, p. 13.
6. See E. Zola, *Le bon combat,* Paris, 1874, p. 74; quoted in *Camille Pissarro* (note 1), p. 46.
7. Pissarro-Venturi, 1939, I, p. 85, no. 53.
8. *Ibid.*, p. 20.

Oil on canvas, 51¾″ × 38¾″
Signed and dated lower left: *Fantin. 86*

COLLECTIONS:
Léon Maître, Paris; Henri Lerolle, Paris, 1906; David-Weill, Paris; Alfred Daber, Paris, 1954; Galerie Charpentier, Paris, 1954; Walter P. Chrysler, Jr.; Chrysler Museum, Norfolk, 1971.

EXHIBITIONS:
Salon, Paris, 1886, no. 912; *XXXIIIe Exposition triennale de Gand. Salon de 1886,* Casino, Ghent, 1886, no. 213; Royal Academy of Arts, London, 1887, no. 919; *Exposition de l'oeuvre de Fantin-Latour,* Palais de l'Ecole nationale des Beaux-Arts, Paris, May-June 1906, no. 57; Portland, 1956–57, no. 80; *Paintings from Private Collections. Summer Loan Exhibition,* Metropolitan Museum of Art, New York, 1958, no. 52; Dayton, 1960, no. 59; Provincetown-Ottawa, 1962; Nashville, 1977, no. 39; Wildenstein, 1978, no. 23; *Fantin-Latour,* Grand Palais, Paris, National Gallery of Canada, Ottawa, and California Palace of the Legion of Honor, San Francisco, Nov. 9, 1982—Sept. 6, 1983, no. 143.

REFERENCES:
A. Pigeon, *Le Passant,* Paris, 1886; "The Royal Academy Exhibition," *Art Journal,* 1887, p. 278; L. Bénédite, *Fantin-Latour,* Paris, 1903, p. 33; A. Jullien, *Fantin-Latour, sa vie et ses amitiés,* Paris, 1909, p. 205; E.L. Cary, *Artists Past and Present,* New York, 1909, ill. p. 112; H. Floury and Mme Fantin-Latour, *Catalogue de l'oeuvre complet (1849–1904) de Fantin-Latour,* Paris, 1911, p. 130, no. 1252; J.-E. Blanche, *Propos de Peintre, de David à Degas,* Paris, 1919, p. 35; F. Gibson, *The Art of Henri Fantin-Latour,* London, 1924, p. 212; G. Kahn, *Fantin-Latour,* Paris, 1926, pp. 43, 62, 130, pl. 21; E. Lucie-Smith, *Henri Fantin-Latour,* London, 1977, pp. 28, 147, no. 31, pl. 31; *Apollo,* 1978, pp. 24–25, fig. 10; F. Daulte, "Une grande amitié: Edmond Maître et Frédéric Bazille," *L'Oeil,* 272 (April 1978), p. 43, note 3.

During the final decades of the nineteenth century, Fantin-Latour achieved considerable fame in France and England as a portrait and still-life painter. He kept company with the most prominent artists and writers of the Parisian avant-garde—Manet, Renoir, Baudelaire, Zola—and he celebrated many of them in his five famous group portraits. Yet he himself was an aesthetic conservative, a traditionalist who championed the cause of the Académie and dismissed the Impressionists—many of them close friends—as mere "dilettantes who produce more noise than art."[1] When invited to join the first Impressionist exhi-

bition in 1874, he resolutely refused, preferring instead to follow the more orthodox route offered by the Salon and the Royal Academy in London.

Fantin received his first art instruction from his painter-father, Jean-Théodore, who moved his family from Grenoble to Paris when Fantin was five. There, in the early 1850s, the youth pursued his studies in drawing at the Petite Ecole de Dessin and in the atelier of Horace Lecoq de Boisbaudran. In 1854 he enrolled in the Ecole des Beaux-Arts but was dismissed within months. Thereafter he followed an independent course in the Louvre, studying and copying for more than a decade its endless array of Old Master pictures—its grandiose history paintings by Veronese and Poussin, portraits by Titian and Van Dyck, still lifes by Chardin, and *fêtes galantes* by Watteau. In the end, the paintings in the Louvre proved to be his best teachers. It was there, too, that he first met Manet, Whistler, and the other young artistic radicals who would figure so prominently in his later career.

Fantin emerged from this period of study as a painter of remarkably eclectic tastes. In mature portraits like the imposing LÉON MAÎTRE of 1886, he blended an austere, "bourgeois" realism with the venerable portrait types of Frans Hals and the sixteenth-century Italians. His flower pieces (fig. 34) and other still lifes, which owe much to Chardin, display an altogether different style, a dense, sensual, painterly approach that the English found particularly appealing. And in his allegorical figure paintings—Romantic fantasy pieces inspired by the music of Wagner, Schumann, and Berlioz—he evolved from his study of the Rococo a proto-Symbolist world of dreams.

Fantin's Salon career began disappointingly in 1859, when his first three submissions—all of them portraits—were rejected. That same year he traveled to England at Whistler's invitation. He made return visits in 1861 and '64 and discovered in London an enthusiastic market for his flower pieces, a market that a receptive British couple, Mr. and Mrs. Edwin Edwards, did much to develop. Fantin exhibited his portraits and still lifes almost

Fig. 34. Henri Fantin-Latour, LARGE VASE OF DAHLIAS, The Chrysler Museum, Norfolk, gift of Walter P. Chrysler, Jr.

yearly at the Royal Academy from 1862 until 1900. In Paris, he made his Salon debut in 1861 and had begun to achieve success by the mid-1860s, when his earliest group portrait, the 1864 HOMAGE TO DELACROIX (Louvre), and his 1867 PORTRAIT OF MANET (Art Institute of Chicago) caused considerable comment. Official recognition followed after 1870: he received a second-class medal at the 1875 Salon, was named *chevalier* of the Legion of Honor in 1879, and served two years later on the Salon jury.

Exhibited at the Salon in 1886 and at the Royal Academy one year later, LÉON MAÎTRE has been rightly ranked among the finest of Fantin's male portraits. The sitter, dressed in a black frock coat, is placed starkly against a luminous brown backdrop. In his hands he holds his top hat, a pair of yellow gloves, and his gold-tipped walking stick, the fashionable accessories of the late-nineteenth-century man about town. The purity and aloofness of Maître's profile stance are mitigated only slightly as he turns his head to gaze imperiously at the viewer. His aggressive, standing posture, knee-length presentation, and such details as his gloves, hat, and cane recall Fantin's 1867 likeness of Manet, the other principal masterpiece among Fantin's male portraits and a painting to which LÉON MAÎTRE is often

EUGÈNE-LOUIS BOUDIN

35. BEACHED BOATS AT BERCK

compared.

Léon was the elder brother of Edmond Maître, a cultivated Parisian dilettante and friend of the avant-garde, who shared Fantin's passion for Wagner and Schumann and became one of his most intimate friends after 1865. A good deal has been written about Edmond Maître and his association with the leading artists of his day.[2] Virtually nothing, however, is known of Léon or his wife, who lived for a time in South America—in Lima and Valparaiso. Fantin also painted two portraits of the wife; one, dated 1882, is in the Brooklyn Museum, and the other, from 1884, hangs in the City Art Gallery, Leeds.[3]

Fantin's LÉON MAÎTRE elicited almost universal praise at the Salon. One critic marveled at the "perfect naturalness" of the sitter's pose,[4] while another, A. Pigeon, proclaimed the painting "a serious and charming work" that "shows the very soul of the model and gives the essence of the figure . . . Portrait painters should meditate upon this grave and powerful work; they will recognize there all those masterful qualities that make them admire the most beautiful portraits of the old museums."[5] Among the Old Master portraits that inspired so much of Fantin's work, the profile images of the sixteenth-century North Italian portraitist Giovanni-Battista Moroni compare most closely to LÉON MAÎTRE.[6]

NOTES:
1. Quoted in Lucie-Smith, 1977, p. 15.
2. See especially Daulte, 1978, pp. 36–43. and *idem, Frédéric Bazille et son temps,* Geneva, 1952.
3. *Fantin-Latour,* 1982–83, nos. 139 and 141, respectively.
4. "Le pose . . . est d'un naturel parfait." See *Fantin-Latour,* 1982–83, p. 329.
5. ". . . oeuvre sérieuse et charmante [qui] montre l'âme même du modèle et donne ce qu'il y a d'essentiel dans une figure . . . Les peintres de portraits peuvent méditer cette oeuvre grave et forte; ils y reconnaissent toutes ces qualités maîtresses qui leur font admirer les plus beaux portraits des vieux musées." See *Fantin-Latour,* 1982–83, p. 329.
6. See, for example, Lucie-Smith, 1977, p. 28.

Oil on canvas, 32¼" × 59"
Signed and dated lower right: *E. Boudin. 1879*

COLLECTIONS:
Durand-Ruel, Paris, by 1891; sold to Reid and Lefevre, London, 1936; Sir Chester Beatty, Dublin; Galerie d'Atri, Paris, 1954; Walter P. Chrysler, Jr.; Chrysler Museum, Norfolk, 1977.

EXHIBITIONS:
Exposition des Oeuvres d'Eugène Boudin, Ecole des Beaux-Arts, Paris, Jan. 9–30, 1899, no. 162; *Exposition Boudin,* Galerie Durand-Ruel, Paris, 1927, no. 4; *Selected Pictures by Eugène Boudin,* Arthur Tooth and Sons, London, Oct. 25—Nov. 17, 1934, no. 21; *Eugène Boudin and Some Contemporaries,* Reid and Lefevre, London, Oct. 1936, no. 6; Portland, 1956–57, no. 77; Dayton, 1960, no. 57; Provincetown-Ottawa, 1962; Palm Beach, 1962, no. 2; Finch College, 1965–66, no. 34; Nashville, 1977, no. 32; Wildenstein, 1978, no. 22.

REFERENCES:
R.L. Benjamin, *Eugène Boudin,* New York, 1937, p. 173; G. Jean-Aubry, *Eugène Boudin,* Neuchâtel, 1968, p. 208, ill.; R. Schmit, *Eugène Boudin, 1824–1898,* Paris, 1973, II, no. 1271, ill.

The landscape and marine painter Boudin was born in Honfleur, the son of a Norman ship's captain, and in his mature pictures he portrayed again and again the grand sweep of sea and sky along the French Atlantic coast. He worked at first as a shopkeeper, opening a framing and stationery business in Le Havre in 1844. But his encounters with the landscapists Isabey and Constant Troyon, and with other artists whose work he displayed in his shop, encouraged him to give up his business for a career in painting. Supported for three years by a fellowship from the town of Le Havre, he arrived in Paris in 1850 to begin his artistic studies. Crucial to his early development were the land- and seascapes of the seventeenth-century Dutch and Flemish masters—Boudin first visited Belgium in 1848—and the paintings of Troyon and other Barbizon artists.

His first years as a painter were not easy. Impoverished and occasionally discouraged by his lack of success, he traveled often during the 1850s, first in Normandy and, after 1855, in Brittany as well, searching for a style and subject matter of his own. He remained faithful, however, to

his brisk, *plein-air* technique, and in 1858, at Rouelles, he began to teach the young Claude Monet how to paint out-of-doors. Monet, who was then working as a caricaturist, was initially a reluctant pupil, but he was soon entranced by the directness of Boudin's approach and by his ability to capture the ever-changing qualities of nature's light and atmosphere:

> I confess that the thought of painting in Boudin's idiom didn't exactly thrill me. But, when he insisted, I agreed to go painting in the open air with him . . . I watched him rather apprehensively, and then more attentively, and then suddenly it was as if a veil had been torn from my eyes. I had understood, I had grasped what painting could be. Boudin's absorption in his work, and his independence, were enough to decide the entire future and development of my painting . . . if I have become a painter, I owe it to Eugène Boudin. [1]

Boudin's role as mentor to Monet—a role later inherited by Jongkind (cat. no. 41) —confirmed his position as one of France's most important Pre-Impressionist painters.

Boudin himself was inspired by Jongkind in 1862 and toward the end of the '60s at last began to reach his stride as he produced his famous Trouville and Deauville beach scenes. These paintings of fashionable Second-Empire holidaymakers at seaside were displayed at the Salon, where Boudin had shown his work since 1859, and attracted the eye of art dealers and public alike. "They love my little ladies on the beach," he wrote at the time, "and some say that there's a thread of gold to exploit there." [2] His success, though it grew gradually, was thereafter assured. He exhibited at the Salon virtually without interruption until 1897, the year before his death, and had begun to garner official awards after 1880, winning a third-class medal in 1881, a second-class medal two years later, and in 1892 the cross of the Legion of Honor. He was awarded a gold medal at the 1889 Exposition Universelle, and in 1891 he granted the dealer Paul Durand-Ruel exclusive rights to his paintings, a move that brought him financial security for the last years of his life.

With the outbreak of the Franco-Prussian war, Boudin sojourned temporarily in Belgium. During the later 1870s and '80s he returned often to the Low Countries, visiting Brussels, Antwerp, Rotterdam, and Dordrecht and producing there some of his finest sea and harbor scenes. In 1878 he also added to his travel itinerary Berck-sur-Mer, a small village on the Channel coast between Dieppe and Calais. In the 1879 Norfolk painting of the shore at Berck—an unusually large landscape for Boudin—Norman fishermen have beached their boats and sit idly in the humid haze of a summer afternoon. The vast canopy of cloud-filled sky is masterfully portrayed, confirming Corot's salute to Boudin as "the king of skies." The Impressionists were fascinated by Boudin's ability to evoke specific kinds of weather and times of day. So, too, were the critics: "One can guess the very season, the time of day, and the wind" in Boudin's work, marveled Charles Baudelaire. [3]

NOTES:
1. Quoted in Jean-Aubry, 1968, pp. 24, 27.
2. *Ibid.*, p. 50.
3. C. Baudelaire, *Curiosités esthétiques, Salon de 1859. VII.*

JAMES JACQUES JOSEPH TISSOT

36. THE ARTISTS' WIVES (Les Femmes d'Artiste)

Oil on canvas, 57½" × 40"
Signed lower left: J.J. Tissot

COLLECTIONS:
Sale, Christie's, London, March 30, 1889, no. 134;
Mr. Day; Charles Field Haseltine; Art Association of
the Union League of Philadelphia, 1894; M.
Knoedler and Co., New York, 1981; Chrysler
Museum, Norfolk, 1981 (gift of Walter P. Chrysler,
Jr., and The Grandy Fund, Landmark Communica-
tions Fund, and "An Affair to Remember," 1982).

EXHIBITIONS:
Exposition J.-J. Tissot: Quinze Tableaux sur la Femme à
Paris, Galerie Sedelmeyer, Paris, April 19—June 15,
1885, no. 10; Pictures of Parisian Life by J.J. Tissot,
Arthur Tooth and Sons, London, 1886, no. 9; James
Jacques Joseph Tissot, 1836–1902, Museum of Art,
Rhode Island School of Design, Providence, and Art
Gallery of Ontario, Toronto, Feb. 28—May 5,
1968, no. 38; Atlanta, 1983, no. 63.

REFERENCES:
"Tissot's Novel Art Work," New York Times, May 10,
1885, p. 4; "The Chronicle of Art," The Magazine of
Art, London, 1886, p. xxiv; Catalogue of the Works of
Art in the Union League of Philadelphia, 1908, p. 27;
J. Laver, "Vulgar Society": The Romantic Career of
James Tissot, London, 1938, p. 74; Catalogue of the
Collection of Paintings Belonging to the Union League of
Philadelphia, 1940, p. 26; M. Whiteman, Paintings
and Sculpture at the Union League of Philadelphia,
Philadelphia, 1978, pp. 98, 90, ill.; J. James Tissot.
Biblical Paintings, exhib. cat., Jewish Museum,
New York, 1982, p. 22, ill.; J. Russell, Paris, New
York, 1983, pp. 222–223, ill.; M. Wentworth,
James Tissot, Oxford, 1984, pp. 162–167, pl. 187,
appendix V, no. 10.

A fashionable artist-dandy who enjoyed
great wealth and renown in his lifetime,
Tissot devoted much of his mature career
to contemporary genre images of modishly
dressed Parisians and Londoners. Though
he chose the same subject as Degas and his
other Impressionist friends—la vie moderne
—his precise, anecdotal realism and con-
servative, polished painting method placed
him more firmly in the camp of the
academics.

Born in Nantes to a rich cloth mer-
chant, Tissot arrived in Paris in 1856 to
begin his artistic training under Louis
Lamothe and Hippolyte-Jean Flandrin,
both disciples of Ingres. His first Salon was
that of 1859. In the same year he probably
traveled to Amsterdam for further study

with the Baron Hendrik Leys,[1] whose
highly finished, medieval costume pictures
determined his early style and initial incli-
nation toward historical genre subjects.
One of the first of his Leysian costume
pieces, THE MEETING OF FAUST AND
MARGUERITE (Musée du Luxembourg,
Paris) was purchased by the government at
the 1861 Salon. Barely twenty-five, Tissot
was suddenly famous.

By 1865 he had turned to society por-
traits and scenes of modern urban life that
featured an array of beautiful women.
These elegant images of chic Second-
Empire parisiennes were immensely popular
at the Salon, where Tissot exhibited
regularly until 1870. By 1868 he owned
a magnificent house in the Bois de Bou-
logne and reportedly earned 70,000 francs
a year from his paintings.[2] During the
Franco-Prussian war, the artist remained
in Paris and cast his lot with the ill-fated
Commune. Perhaps to avoid persecution
when government troops retook the city,
he fled to London in 1871, remaining
there for the next eleven years. Tissot
began his London career as a caricaturist
for the satiric Vanity Fair. But soon he
was again practicing his specialities as a
stylish society painter, producing portraits
of the British upper class and "conversa-
tion pieces" of affluent Victorians taking
tea by the Thames.

After the death of his beloved Irish
mistress Kathleen Newton in 1882, Tissot
resettled in Paris. To reawaken interest in
his work, he mounted at the Palais de
l'Industrie a retrospective of his English
paintings and prints and in 1885 displayed
at the Galerie Sedelmeyer a set of genre
paintings entitled LA FEMME À PARIS
(THE PARISIAN WOMAN), his first major
production since his return from London.
This ambitious series of fifteen large can-
vases, to which the Norfolk painting origi-
nally belonged, celebrated the fabled
beauty and style of the women of the
French capital—her debutantes and shop
girls (fig. 35), her performers and, as we
see in the Norfolk picture, the wives of her
artists. The series was also exhibited in
London, at the Tooth Gallery, in 1886. LA
FEMME À PARIS was Tissot's final effort at
la peinture mondaine. Prompted by a mysti-

Fig. 35. James Tissot, THE MILLINER'S SHOP, from LA FEMME À PARIS, Art Gallery of Ontario, Toronto, Gift from Corporations' Subscription Fund, 1968.

cal vision of the Man of Sorrows he allegedly had while in the church of St. Sulpice, the painter turned exclusively thereafter to the Bible for artistic inspiration. The last sixteen years of his life were devoted to his drawings of the LIFE OF CHRIST and various Old Testament stories.

Tissot envisioned initially a set of etchings after LA FEMME À PARIS with descriptive captions to be supplied by prominent writers of the day. As reported in the *New York Times* account of the Sedelmeyer show, the caption for the etching of THE ARTISTS' WIVES was to be written by Albert Wolff.[3] The project was halted, however, by Tissot's spiritual awakening. Only five of the prints were produced, and none published.

The heightened expressions and mannered poses of the figures in LA FEMME À PARIS, the compressive, often unstable spaces and insistence on decorative patterning lend an almost fevered intensity to the series that is typical of much of Tissot's later art. Perhaps these traits disturbed contemporary viewers, for the paintings were not especially well-received on either side of the Channel. An unsympathetic English reviewer dismissed the series' anecdotal bias as "easy reading like a clever, not too profound modern novel,"[4] while a contemporary French critic described the

works as "enlarged, tinted caricatures from *Punch*."[5] Today the series is valued as an extraordinarily rich chronicle of the popular mind and manners of Paris during *La Belle Epoque*.

The subject of the Norfolk painting is *le vernissage*, or Varnishing Day. On this, the eve of the official opening of the Salon, the participating artists traditionally gathered to view the exhibition privately and put a final, protective coat of varnish on their paintings. Here the artists with their wives and friends toast the year's effort on Varnishing Day with a luncheon at the restaurant Ledoyen, their smiling faces glowing from the salutary effects of gay company and good wine. Behind them is the entrance to the Palais de l'Industrie, which was built on the Champs Elysées for the 1855 Exposition Universelle and subsequently housed the Salon. Beckoned by the woman who turns in her chair to greet us, we are invited to take our seats at the tables in the foreground and join the happy crowd.

NOTES:
1. Wentworth, 1984, p. 28.
2. *Ibid.*, p. 58.
3. Atlanta, 1983, p. 162.
4. "Art Chronicle," *Portfolio* (Jan. 1886), p. 144.
5. "La Femme à Paris: Exposition Tissot," *La Vie parisienne* (May 2, 1885), p. 255.

ALFRED SISLEY

37. APPLE TREES IN FLOWER (*Pommiers en fleurs*)

Oil on canvas, 25¼″ × 31¾″
Signed lower left: *Sisley*

COLLECTIONS:
The artist, until 1882; Galerie Durand-Ruel, Paris, 1882–1893; H. Vever, Paris; Vever sale, Georges Petit, Paris, Feb. 1–2, 1897, no. 107; Berhend, Paris; Alfred Daber, Paris; Wildenstein and Co., Paris and New York; private collection, Switzerland; M. Knoedler and Co., New York; Walter P. Chrysler, Jr.; Chrysler Museum, Norfolk, 1977.

EXHIBITIONS:
Exposition d'oeuvres d'Alfred Sisley, Galeries Georges Petit, Paris, May 14—June 7, 1917, no. 70.

REFERENCES:
G. Besson, *Sisley,* Paris, n.d., pl. 43; F. Daulte, *Alfred Sisley,* Lausanne, 1959, no. 355, fig. 355.

Though celebrated today as one of the earliest and most creative of the Impressionists, the landscapist Sisley enjoyed no such recognition during his lifetime. From the early 1870s, when he began to paint professionally, until his death in 1899, he practiced his art in poverty and obscurity, struggling in vain against a hostile public and indifferent press. Of all the major Impressionist painters, Sisley was the most sadly ignored.

His life began auspiciously enough. He was born in Paris, where his father, a wealthy English businessman, operated a lucrative export trade in artificial flowers. At eighteen Sisley was sent to London to prepare for a career in business. Instead, he studied the works of the British landscapists—Turner, Constable, Bonnington— and after returning home in 1862, he persuaded his parents to let him take up painting. Sisley entered the Paris atelier of Charles Gleyre (cat. no. 21), where he quickly befriended fellow students Renoir, Monet, and Bazille. Within months the four young artists had departed from Gleyre's studio for Chailly-en-Bière and the nearby forest of Fontainebleau. There, through their communal experiments with *plein-air* painting, they sowed the first seeds of Impressionism.

Freed from financial constraints by his father's money, Sisley initially approached his art as a passionate amateur, producing little before 1870. During the Franco-Prussian war, however, the family business failed, and his father, broken and penniless, died soon after. Sisley was suddenly forced to rely solely on his painting to support himself, his wife (whom he had married in 1866), and his two children. The dark decades of hardship that followed were seldom brightened by good fortune. Despite the courageous support of the dealer Paul Durand-Ruel, who first met Sisley in 1872 and promoted his landscapes as best he could for the next twenty years, the artist earned almost nothing from his work. In a letter written to Durand-Ruel in November 1885, Sisley documented, as he often did, the grim details of his unending financial crisis:

> I have safely received {from you} the two hundred francs. That will suffice to pay a bill that falls due on the 20th of this month, as well as a few small debts. But after that? By the 21st I will again be without a sou. Yet I must give something to my butcher, to my grocer; to the one I have paid nothing for six months, to the other nothing for a year. With winter coming on, I will also need money for myself. There are necessities I lack.[1]

Sisley's greatest professional disappointment may have come in 1897, when a large retrospective of his work mounted by the Paris dealer Georges Petit was all but ignored by the critics. Plagued by debt and neglected by the Parisian art world, Sisley nonetheless refused to abandon or to compromise his painting. He valiantly "pursued his experiments in solitude, waiting patiently for the success that, unfortunately, came to him only after his death."[2]

The rather heavy, dour palette and massive, carefully delineated forms of Sisley's first few landscapes owe an obvious debt to the paintings of Courbet, Manet, and Corot. By 1870 the artist had begun to exhibit the clearer, high-keyed tones and more sketchy, broken color touches of Impressionism. Though his later landscapes displayed the formal disintegrations inherent in the Impressionist technique, Sisley remained committed throughout his career to an art of compositional and spa-

tial clarity, to "classically ordered," architectonically structured landscapes and carefully calibrated perspectives.

Sisley worked briefly in Normandy in 1867 and visited London again in 1874. Most of his life, however, he spent in the villages and countryside around Paris, living and working in or near Louveciennes (1871–74), Marly (1875–77), and Sèvres (1877–79) and showing a special interest in river and snow scenes. In later years (1880–99) he resided near Fontainebleau in the hamlets of Veneux and neighboring Moret, at the juncture of the Seine and Loing rivers, where again and again he painted the banks of these waterways and the adjacent fields.

Produced at the onset of his final Moret period, APPLE TREES IN FLOWER of 1880[3] portrays the crisp, breezy weather of early spring, when the chill of winter still lingers on the land. Its forms merely summarized by Sisley's dappling, Impressionist brush, the landscape is brought into structural focus through the anchoring verticals of the blossoming fruit trees. The receding lines of the trees also create a sense of deep space, a characteristic feature of Sisley's art. Sisley relished the challenge of capturing the transitory effects of light and weather and the fleeting magic of seasonal change. In an enthusiastic letter written from Moret in the spring of 1883, he reported:

> . . . the weather has been wonderful. I have started to work again, but unfortunately, because it has been such a dry spring, the fruit trees are not flowering all at once, and the blossoms are dropping very quickly. And I am trying to paint them![4]

NOTES:
1. "J'ai bien reçu les 200 fr. Cela servira à payer un billet qui échoit le 20 de ce mois, ainsi que quelques petites dettes. Mais après? Le 21 je serai encore sans le sou. Il me faut cependant donner quelque chose à mon boucher, à mon épicier; à l'un je n'ai rien donné depuis six mois, à l'autre depuis un an. Il me faut aussi quelque argent pour moi à l'entrée de l'hiver. Il y a des choses indispensables et qui me manquent." See Daulte, 1959, p. 32.
2. *Ibid.*, p. 15.
3. *Ibid.*, no. 355. Daulte has dated the painting to 1880 on the basis of its style and imagery.

4. Quoted and translated in *Sisley*, exhib. cat., Wildenstein and Co., New York, 1966, no pag.

PIERRE AUGUSTE RENOIR

38. THE DAUGHTERS OF DURAND-RUEL

Oil on canvas, 32″ × 25¾″
Signed and dated lower right: *Renoir. 82*

COLLECTIONS:
Paul Durand-Ruel, Paris, from 1882; Mme André-Felix Aude, Paris; Wildenstein and Co., New York, 1944; Mrs. Byron C. Foy, New York; Foy sale, Parke-Bernet, New York, May 13, 15–16, 1959, no. 15; Walter P. Chrysler, Jr.; Chrysler Museum, Norfolk, 1971.

EXHIBITIONS:
Renoir, Galerie Durand-Ruel, Paris, April 1–25, 1883, no. 5; *Renoir*, Galerie Durand-Ruel, Paris, May 1892, no. 1; *Tableaux de Renoir, Monet, Pissarro et Sisley*, Galerie Durand-Ruel, Paris, April 1899, no. 86; *Portraits par Renoir*, Galerie Durand-Ruel, Paris, June 5–20, 1912, no. 2; *Renoir*, Galerie Paul Cassirer, Berlin, Feb.-March 1912, no. 10; *Renoir*, Galerie Thannhauser, Munich, Jan. 19—Feb. 13, 1913, no. 10; *Französische Kunst des XIX. und XX. Jahrhunderts*, Kunsthaus, Zurich, Oct. 5—Nov. 14, 1917, no. 170; *Renoir*, Galerie Durand-Ruel, Paris, Nov. 29—Dec. 18, 1920, no. 53; *Renoir*, Wildenstein Gallery, New York, March 23—April 29, 1950, no. 41; *Masterpieces from Museums and Private Collections*, Wildenstein Gallery, New York, Nov. 8—Dec. 15, 1951, no. 45; *Renoir*, Wildenstein Gallery, New York, April 8—May 10, 1958, no. 40; Dayton, 1960, no. 63; Provincetown-Ottawa, 1962; *Four Masters of Impressionism*, Acquavella Galleries, New York, Oct. 24—Nov. 30, 1968, no. 32; *The Past Rediscovered: French Painting 1800–1900*, Minneapolis Institute of Arts, July 3—Sept. 7, 1969, no. 72; *Renoir*, Wildenstein Gallery, New York, March 27—May 3, 1969, no. 45; *Faces from the World of Impressionism and Post-Impressionism*, Wildenstein Gallery, New York, Nov. 2—Dec. 9, 1972, no. 59; *Paintings by Renoir*, Art Institute of Chicago, Feb. 3—April 1, 1973, no. 41; Nashville, 1977, no. 41; Wildenstein, 1978, no. 24.

REFERENCES:
A. Vollard, *Renoir, An Intimate Record*, New York, 1934, p. 241; F. Daulte, "Le Marchand des Impressionnistes," *L'Oeil*, 66 (June 1960), p. 59, ill.; *idem, Auguste Renoir*, Lausanne, 1971, I, no. 411, fig. 411; *idem, Renoir*, New York, 1973, p. 78, ill.; *Apollo*, 1978, pp. 24, 20, fig. 8; T. Norton, *100 Years of Collecting in America. The Story of Sotheby Parke Bernet*, New York, 1984, p. 171, ill.; B. White, *Renoir His Life, Art, and Letters*, 1984, New York, p. 129, ill.

Renoir was born in Limoges to humble, working-class parents. His father Léonard, a tailor, resettled his family in Paris when Renoir was three. There the youth was apprenticed to a porcelain painter and also worked as a decorator of ornamental fans and blinds. In time Renoir renounced these modest crafts for the middle-class

profession of painting, entering the studio of Charles Gleyre (cat. no. 21) in 1861 and enrolling one year later in the Ecole des Beaux-Arts. Joined by Monet and other students of Gleyre, Renoir was soon painting out-of-doors at Fontainebleau. Monet's bright palette and advanced, *plein-air* technique influenced him particularly in 1869, when he and Monet painted landscapes together at the weekend resort of La Grenouillère near Paris. These experiments did much to stimulate the birth of Renoir's Impressionist style in the early 1870s. By that time Renoir had developed, too, the range of subjects—portraits and formal figure pieces, genre scenes of modern urban and suburban life, landscapes, and still lifes—that would occupy him for the rest of his career.

The warm sensuality and sunny *joie de vivre* of Renoir's work certainly helped to make him more popular among the critics and more welcome at the Salon than were many of his Impressionist colleagues. He made his Salon debut in 1864 and achieved his earliest triumph there four years later with a full-length portrait, the 1867 LISE WITH A PARASOL (Museum Folkwang, Essen). Subsequent rejections in 1872 and '73 encouraged him for a time to seek more radical exhibition alternatives; he displayed his paintings at the Salon des Refusés in 1873 and took part in the Impressionists' first three group shows—in 1874, '76, and '77. But he remained unconvinced of the effectiveness of such unorthodox, independent showings. "There are barely fifteen collectors in Paris," he complained, "who are capable of liking a painter they have not seen at the Salon."[1] He returned to the Salon in 1878 and achieved genuine acclaim the following year with two large portrait pieces, MME CHARPENTIER AND HER CHILDREN (Metropolitan Museum of Art, New York) and MLLE JEANNE SAMARY (Hermitage, Leningrad).

Like Degas, Renoir was especially mindful of tradition, and between 1882/83 and 1887 he experimented with a more controlled and classically correct approach to modeling, tempering his loose and approximate Impressionist brush with a more precise draftsmanship and focused

Fig. 36. Pierre Auguste Renoir, PORTRAIT OF JOSEPH DURAND-RUEL, photo and collection Durand-Ruel, Paris.

Fig. 37. Pierre Auguste Renoir, PORTRAIT OF CHARLES AND GEORGES DURAND-RUEL, photo and collection Durand-Ruel, Paris.

formal structure. His search for greater technical control was undoubtedly encouraged by his 1881 trip to Italy, where the art of Raphael and the antique impressed him greatly. The culminating achievement of Renoir's classical, "Ingresque" phase was an ambitious, meticulously contoured figure piece, THE BATHERS of 1887 (Philadelphia Museum of Art).

The Paris art dealer Paul Durand-Ruel (1831–1921) was the most enthusiastic and generous commercial supporter of the Impressionists during their early decades of struggle,[2] and he became one of Renoir's dearest colleagues. Durand-Ruel met Renoir at the end of the Franco-Prussian war and purchased his first pictures from him in 1872. The critical success that the artist first enjoyed at the 1879 Salon was followed by lasting financial security in 1881, when Durand-Ruel began to buy his paintings regularly and in consistently large numbers. In 1883 the dealer gave Renoir his first one-man show, exhibiting seventy of his works in Paris, and in the 1880s he included Renoir's paintings in exhibitions in Brussels, New York, and Boston as well.

Though Renoir completed a number of fashionable, society portrait commissions in the manner of MME CHARPENTIER AND HER CHILDREN, he preferred to paint more intimate and informal images of family members and close friends. Thus, in 1882, when Durand-Ruel asked the artist to paint his five children, Renoir readily obliged with portraits of his eldest son Joseph (fig. 36)[3] and the younger Charles and Georges (fig. 37).[4] He also produced the Norfolk painting, a charming double image of Durand-Ruel's two daughters, Marie-Thérèse, then fourteen, and the twelve-year-old Jeanne. Dressed in light summer frocks and Milan straw hats (Jeanne has laid hers beside her), the sisters pose on a garden bench, smiling amid the coolness and light-dappled shadows of their tree-shaded perch. Renoir devoted much of his art to paintings of children and in his final years made a speciality of young girls in fancy hats. He was fascinated most by the natural beauty and innocence of children; "their mouths," he once said, "utter only those words which animals would speak if they could talk."[5]

Though painted toward the outset of Renoir's "Ingresque" period, the Norfolk double portrait betrays none of the draftsmanly discipline that would come to characterize so much of his art in the years around 1885. Executed entirely out-of-doors, the portrait retains instead the vibrant palette and vigorous, open brushwork—the broad scatter of gay color touches—of Renoir's "pure" Impressionist

HILAIRE-GERMAIN-EDGAR DEGAS

39. DANCER WITH BOUQUETS (*Danseuse aux Bouquets*)

period of the later 1870s.

Oil on canvas, 71" × 60"
Signed lower right: *Degas*

NOTES:
1. Quoted in *Renoir,* exhib. cat., Hayward Gallery, London, etc., 1985–86, p. 300.
2. See especially Daulte, *L'Oeil,* 1960, pp. 54–61, 75.
3. Oil on canvas, 81 × 65 cm. *Ibid.,* p. 60.
4. Oil on canvas, 65 × 81 cm. *Ibid.,* p. 61.
5. Quoted in *Renoir* (note 1), p. 14.

COLLECTIONS:
The artist, ca. 1895–1917; the artist's family, 1917–1918; Degas sale, Georges Petit, Paris, May 4, 1918, no. 1; J. Seligmann, Paris, 1918; Seligmann sale, American Art Association, New York, Jan. 27, 1921, no. 69; Ambroise Vollard, Paris, 1921; Durand-Ruel, New York, 1939; Walter P. Chrysler, Jr.; Chrysler Museum, Norfolk, 1971.

EXHIBITIONS:
Exhibition of Paintings by the Master Impressionists, Gallery Durand-Ruel, New York, Oct. 15 — Nov. 10, 1934, no. 3; *Origins of Modern Art,* Arts Club of Chicago, April 2–30, 1940, no. 7; Richmond, 1941, no. 42; Portland, 1956–57, no. 85; Dayton, 1960, no. 65; Provincetown-Ottawa, 1962; Nashville, 1977, no. 37; Wildenstein, 1978, no. 28; *Degas,* Virginia Museum of Fine Arts, Richmond, May 23—July 9, 1978, no. 19.

REFERENCES:
Art News, Jan. 17, 1941, cover ill.; J. Rewald, *Degas Works in Sculpture,* New York, 1944, p. 26, pl. 116; P. Lemoisne, *Degas et son oeuvre,* Paris, 1946, III, p. 734, no. 1264, ill.; F. Russoli and F. Minervino, *L'opera completa di Degas,* Milan, 1970, p. 136, no. 1116.

The eldest son of a wealthy Paris banker, Degas originally prepared for a career in law, but in 1855 he turned instead to art. At first he followed a traditional academic course of study in hopes of becoming a history painter. He enrolled in the Ecole des Beaux-Arts and worked under Louis Lamothe, whose mentor, the great Neoclassicist Ingres, Degas idolized. In 1856–59 Degas toured Italy, copying the Old Masters. Upon his return to Paris he devoted himself to portraits and such ambitious figurative works as his 1860 SPARTAN BOYS AND GIRLS EXERCISING (National Gallery, London). Though he would continue to paint portraits throughout his career, he soon sensed the limitations of his academic efforts. After 1866 he frequented the Café Guerbois, where his encounters with Manet (whom he had met in 1859), Renoir, Pissarro, and other young avant-garde painters confirmed his growing interest in contemporary themes and styles. He soon became an incisive chronicler of modern

Parisian life, taking his subjects from the ballet and the theater, from millinery shops and laundries, from cafés and the racecourse at Longchamps. He exhibited at the Salon with mixed success between 1865 and 1870 and cast his lot thereafter with the Impressionists, contributing to all of their Paris shows but one, the seventh in 1881.

The spatial and compositional novelties of Japanese prints had already begun to inspire Degas by 1860–62, and he became increasingly interested in perspectival abstraction and eccentric angles of vision. He was fascinated, too, by the naive immediacy of the photographic image—he was himself an amateur photographer—and he strove to give his painted figures the photographic quality of unstudied and instantaneous movement. In the process, he became one of the most experimental members of the Impressionist group. His eyesight deteriorated by the end of the century, and in his final years he turned from oil painting to work increasingly in pastel and sculpture, which were less taxing to his eyes.

Degas was most widely known in his own day, and is remembered most, as a painter of the dance. Already in 1867, in his MLLE FIOCRE IN THE BALLET FROM 'LA SOURCE' (Brooklyn Museum), he had begun to interpret subjects drawn from the ballet of the Paris Opéra. He would continue to do so—in hundreds of paintings, sculptures, pastels, and prints —for the next forty years. In the nineteenth century the ballet was one of the prime cultural diversions of the Parisian upper class. Degas's fascination with it may well have been fostered at an early age by his cultivated and moneyed father, who was himself deeply interested in music and surely held a subscription, or *abonnement*, to the Opéra.[1] Degas chose for his subjects not merely the seasoned stars of the Opéra stage, like the dancer portrayed in the Norfolk picture, but the lesser ranks of the *corps de ballet* and even the adolescent apprentices, the *petits rats*. He showed dancers in performance, at rest or in transit backstage, and at work in the rehearsal hall, moving their often reluctant bodies through endless hours of exercise

Fig. 38. Edgar Degas, DANSEUSE SALUANT, present location unknown.

at the practice bar. In the discipline of the dance Degas may have sensed a metaphor for his own lifelong quest for aesthetic control. "No art was ever less spontaneous than mine," he once stated. "What I do is the result of reflection and study of the great masters; of inspiration, spontaneity, temperament . . . I know nothing."[2] Most important to Degas, however, was the opportunity the ballet gave him to research the transitory effects of gesture and motion, the dynamics of human movement.

DANCER WITH BOUQUETS was produced around 1890–95, when Degas's eyesight was failing and he had begun to paint in broader and more vigorous strokes. Here a prima ballerina takes a bow at the end of a performance, at her feet bouquets of flowers tossed by an adoring audience. Standing before a painted landscape backdrop, she raises her hand as if to kiss the crowd beyond the footlights. These lights fill the scene with a magical, if rather harsh, incandescence and transform the gauzy layers of her gown into a smoldering violet-grey cloud. Though painted on a large, "official" scale, DANCER WITH BOUQUETS was not exhibited during Degas's lifetime, but remained in his studio, where it served as a model for other works.[3] Indeed, the dancer's pose was also used in one of Degas's later sculptures, THE BOW, which

PAUL GAUGUIN

40. THE LOSS OF VIRGINITY (*La Perte du pucelage*)

Oil on canvas, 35½″ × 51¼″

has been dated after 1896.[4] There are at least four preparatory studies of the Norfolk figure. One, a bust-length *étude* in pastel (fig. 38), was included in the second Degas atelier sale.[5] The remaining three —full-length figure studies in charcoal and pastel and yet another bust-length sketch in charcoal—were dispersed at the third of the posthumous Degas sales.[6]

In DANCER WITH BOUQUETS the scene is viewed obliquely, as if from the wings or a private side box. The odd angle of the viewer's vantage point and the tricks it plays with perspective and the dancer's pose are typical of Degas's later, abstracted compositions. The sharply lighted, unlovely features of the aging dancer's face and the sense of motion arrested also create an image of nearly photographic frankness and immediacy—an unstudied "snapshot" of reality stolen from the flow of time.

NOTES:
1. G. Shackelford, *Degas. The Dancers*, exhib. cat., National Gallery of Art, Washington, D.C., 1984–85, p. 14.
2. Translated in *Edgar Degas 1834–1917*, exhib. cat., Lefevre Gallery, London, 1970, p. 15.
3. Reported by Herbert H. Elfers of Durand-Ruel and Company, in a letter of February 1940.
4. J. Rewald, 1944, p. 26, no. LIII.
5. 50 × 65 cm. Galerie Georges Petit, Dec. 11–13, 1918, no. 143. See also Lemoise, 1946, III, p. 734, no. 1266.
6. Galerie Georges Petit, April 7–9, 1919, nos. 326, 54, 227, respectively. See also Lemoise, 1946, III, p. 734, nos. 1264, 1265.

COLLECTIONS:
The artist, 1891–1895; Gauguin sale, Hôtel des Ventes, Paris, Feb. 18, 1895, no. 42; Comte Antoine de la Rochefoucault, Paris, 1895–1948; Altarriba collection, Paris; Matthey collection, Paris, 1949; E. and A. Silberman Galleries, New York, 1954–55; Walter P. Chrysler, Jr.; Chrysler Museum, Norfolk, 1971.

EXHIBITIONS:
Gauguin, Galerie Dru, Paris, 1923, no. 20; *Gauguin*, Orangerie des Tuileries, Paris, summer 1949, no. 24; *Paul Gauguin*, Kunstmuseum, Basel, Nov. 26, 1949—Jan. 29, 1950, no. 41; *Gauguin*, Musée Cantonal des Beaux-Arts, Lausanne, 1950, no. 40; *Motif in Painting*, Norton Gallery of Art, Palm Beach, Feb. 7—March 2, 1952, no. 8; *Paul Gauguin. His Place in the Meeting of East and West*, Museum of Fine Arts, Houston, March 27—April 25, 1954, no. 23; *The Two Sides of the Medal. French Painting from Gérôme to Gauguin*, Detroit Institute of Arts, 1954, no. 107; *Gauguin Paintings, Engravings and Sculpture*, Royal Scottish Academy, Edinburgh, and Tate Gallery, London, Sept. 30—Oct. 26, 1955, no. 37; Portland, 1956–57, no. 84; Provincetown, 1958, no. 21; *Gauguin*, Art Institute of Chicago and Metropolitan Museum of Art, New York, Feb. 12—May 31, 1959, no. 26; Dayton, 1960, no. 69; Provincetown-Ottawa, 1962; *Gauguin and the Pont-Aven Group*, Tate Gallery, London, Jan. 7—Feb. 13, 1966, no. 36; *The Sacred and Profane in Symbolist Art*, Art Gallery of Ontario, Toronto, 1969, no. 89; *Puvis de Chavannes and the Modern Tradition*, Art Gallery of Ontario, Toronto, Oct. 24—Nov. 30, 1975, no. 52; *Le Symbolisme en Europe*, Museum Boymans-van Beuningen, Rotterdam, Musées Royaux des Beaux-Arts, Brussels, Staatliche Kunsthalle, Baden-Baden, and Grand Palais, Paris, Nov. 14, 1975—July 19, 1976, no. 55; Nashville, 1977, no. 42; Wildenstein, 1978, no. 25; B. Welsh-Ovcharov, *Vincent van Gogh and the Birth of Cloisonism*, Art Gallery of Ontario, Toronto, and Rijksmuseum Vincent van Gogh, Amsterdam, Jan. 24—June 14, 1981, no. 70.

REFERENCES:
J. de Rotonchamp, *Paul Gauguin. 1848–1903*, Paris, 1925 (first ed., 1906), pp. 81–82; J. Rewald, *Gauguin*, New York, 1938, p. 19; A. Wallas, "The Symbolist Painters of 1890," *Marsyas*, 1 (1941), pp. 117–152; R. Jean, *Gauguin*, Paris, 1948; D. Sutton, "*La Perte du Pucelage* by Paul Gauguin," *Burlington Magazine*, 91 (1949), pp. 103–105, fig. 13; R. Cogniat, *Paul Gauguin*, Paris, 1953, pp. 22–23; J. Rewald, *Post-Impressionism*, New York, 1956, p. 466; *idem, Gauguin Drawings*, London, 1958, p. 26; M. Serrulaz, *Les Peintres Impressionnistes*, Paris, 1959, p. 158; R. Huyghe, *Gauguin*, New York, 1959, p. 37; J. Leymarie, *Paul Gauguin*, Basel, 1961, no. 15; R. Alley, *Gauguin*, London, 1961, p. 36, pl. 23; G.

Wildenstein, *Gauguin*, Paris, 1964, I, p. 159, no. 412, ill.; G. Marchieri, *Gauguin*, New York, 1967, pl. 32; W. Andersen, "Gauguin's Motifs from Le Pouldu—Preliminary Report," *Burlington Magazine*, 112 (1970), pp. 615–620, fig. 60; *idem, Gauguin's Paradise Lost*, New York, 1971, pp. 100–111, 307, fig. 73; M. Sugana, *L'opera completa di Gauguin*, Milan, 1972, pp. 100–101, no. 236; M. Ikeyda and Y. Iwasaki, *Gauguin*, Tokyo, 1977, pl. 5; *Apollo*, 1978, pp. 25, 23, pl. XV; V. Jirat-Wasiutyński, "Paul Gauguin's Self-Portraits and the *Oviri*," *Art Quarterly*, 2 (1979), pp. 174, 178, fig. 6; A. Hammacher, *Symbolism, Fantastic Art and Surrealism*, New York, 1981, p. 151, no.131; J. Gedo, *Portraits of the Artist*, New York and London, 1981, pp. 155, 148, fig. 18; *Gauguin to Moore: Primitivism in Modern Sculpture*, exhib. cat., Art Gallery of Ontario, Toronto, 1981, p. 37, fig. 7; *Henri Rousseau*, exhib. cat., Grand Palais, Paris, etc., 1984–85, p. 41, fig. 3.

Gauguin was born in Paris but spent much of his youth abroad, living first in Peru (1849–55) with his widowed mother and sister and later traveling widely as a merchant marine and sailor in the French navy (1865–71). In 1871 he joined the Paris brokerage house of Paul Bertin. Two years later he married a Danish woman, Mette Gad, by whom he had five children. In the early 1870s Gauguin took up painting as an amateur, and by the end of that decade he had been drawn into the Impressionist orbit through his friendship with Pissarro (cat. no. 33), with whom he painted at Pontoise in 1879 and '81. Gauguin's contact with the Impressionists—he exhibited regularly with them from 1879 to '86 —confirmed his calling as a painter, and in 1883 he abandoned his career as a stockbroker—and, after 1886, his family as well—to devote himself wholly to his art.

Seeking inspiration from the religious myths and superstitions of "natural men" uncorrupted by modern culture, Gauguin embarked upon a restless search for "the savage and the primitive." This quest led him first to Brittany, where he worked on and off from 1886 to '90 at the artist colony at Pont-Aven and the nearby, but more secluded and "primitive" coastal spot of Le Pouldu. Gauguin's early visits to Brittany and his intervening sojourn in Panama and Martinique in 1887 were initial steps "in that retreat from European civilization which finally took

him to Polynesia" in 1891.[1]

Among the painters Gauguin worked with at Pont-Aven and Le Pouldu was Emile Bernard, who inspired him to put aside his earlier, Impressionist manner and experiment for a time with the more advanced, Post-Impressionist style of Cloisonism, or Synthetism. As can be seen in his Cloisonist masterpiece, THE LOSS OF VIRGINITY of 1890–91, Gauguin now began to compose in broad, flat fields of bright, unmodulated color compartmentalized by dark outlines. Adhering to the theories of Synthetism, Gauguin also rejected naturalistic representation in favor of a more purely Symbolist aesthetic, employing the colors, shapes, and objects of the visible world as subjective evocations of ideas and moods. "Art is an abstraction," he now proclaimed; "derive this abstraction from nature while dreaming before it."[2]

In November 1890 Gauguin returned to Paris from Le Pouldu with plans to depart for Tahiti, which he did in April of 1891. In the intervening months in Paris he fell briefly under the influence of the Symbolist poets and critics—Stéphane Mallarmé, Octave Mirbeau, Paul Verlaine. These writers, in turn, were fascinated by the mythic power and enigmatic themes of Gauguin's Brittany landscapes, peasant pictures, and wood sculptures, and they proclaimed him their principal spokesman among painters.

Though Wayne Andersen contends that Gauguin painted the undated LOSS OF VIRGINITY at Le Pouldu in the early autumn of 1890,[3] most writers have argued more convincingly that the work was produced slightly later in Paris, in the winter of 1890–91, when the artist was in contact with the Symbolists.[4] As Bogomila Welsh-Ovcharov writes, the painting is, in all likelihood, "Gauguin's final major statement in an overtly Cloisonist and Symbolist vein and as such constitutes both the culmination and termination of his pre-Tahitian development."[5] The painting's densely Symbolist theme was correctly explicated as early as 1906 by Gauguin's first biographer, Jean de Rotonchamp, who described the subject as that of "a virgin seized in her heart by the

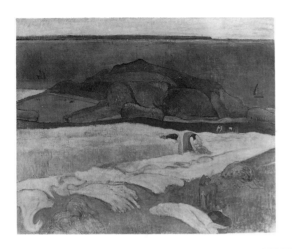

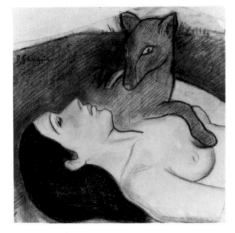

Fig. 39. Paul Gauguin, HARVEST:
LE POULDU, the Tate Gallery, London.

Fig. 40. Paul Gauguin, YOUNG GIRL
WITH A FOX, John Gaines collection, New
York. Photo courtesy E. V. Thaw and Co.

demon of lubricity."[6]—i.e., a young
woman's loss of sexual innocence. Lying
deathlike on the ground, the naked
maiden holds in her right hand a plucked
flower, a traditional symbol of lost inno-
cence. With her left arm she embraces an
evil-eyed fox, who precipitates her down-
fall with a paw upon her heart. In two of
Gauguin's wood sculptures of this period
—the 1889 BE IN LOVE AND YOU WILL
BE HAPPY (Museum of Fine Arts, Boston)[7]
and the LUXURIA of 1890–91 (Willunsens
Museum, Frederikssund)[8]—a fox also
appears as an emblem of lasciviousness.[9]
Indeed, in an 1889 letter to Bernard,
Gauguin identified the fox in BE IN
LOVE . . . as "the Indian symbol of per-
versity."[10] In the background of the Nor-
folk painting Breton peasants proceed
along a narrow path. A wedding party,
perhaps, or a group of pious churchgoers,[11]
they may symbolize the maiden's dream of
respectability.[12]

The landscape in THE LOSS OF
VIRGINITY is that of Le Pouldu, its wheat
fields leading down to the grass-covered
dunes at the mouth of the Laita River,
which flows into the Atlantic Ocean. The
season is autumn; the wheat has been
harvested, and a sheaf of it lies at the
maiden's feet. In planning the setting of
the painting, Gauguin probably consulted
one of his earlier landscapes painted on site

at Le Pouldu, the 1890 HARVEST: LE
POULDU in the Tate Gallery, London (fig.
39).[13] Gauguin's preparatory charcoal
drawing for the fox and young woman's
head is in the collection of Mr. and Mrs.
John Gaines, New York (fig. 40).[14]

Noting that the maiden's feet are
crossed, "as were the nailed feet of the
crucified savior," Andersen suggests that
Gauguin derived the supine pose of the
figure from that of the dead Christ often
found in late-medieval, Breton "Calvary"
sculptures.[15] From this he cogently con-
cludes that Gauguin intended to parallel
Christ's death on the cross with the sac-
rifice of the maiden's virginity.[16] Consult-
ing Breton harvest legends, Andersen also
interprets the new-mown wheat in sacri-
cial terms, viewing the bundle of wheat in
the foreground as emblematic of the
"reaping" of the maiden's innocence.[17]

Gauguin's symbolic treatment of the
painful passage from maidenhood to wom-
anhood may well have had a highly
personal, almost autobiographical mean-
ing for him. It has often been suggested
that the woman depicted resembles Gau-
guin's mistress at the time, a young seam-
stress named Juliette Huet. Huet met
Gauguin in Paris toward the end of 1890
and bore him a daughter after he left for
Tahiti. Gauguin may also have intended
that the fox in the Norfolk painting serve

JOHAN BARTHOLD JONGKIND

as a spiritual self-portrait.[18]

NOTES:
1. D. Sutton, in *Gauguin and the Pont-Aven Group*, 1966, no pag.
2. *Ibid*.
3. See Andersen, 1970, p. 616.
4. See, for example, Rotonchamp, 1925, pp. 81–82; Sutton, 1949, p. 103; Alley, 1949, p. 103; and especially the carefully reasoned argument offered by Welsh-Ovcharov, 1981, pp. 224–225.
5. Welsh-Ovcharov, 1981, p. 224.
6. "Une vierge saisie au coeur par le démon de la lubricité": Rotonchamp, 1925, pp. 81–82.
7. C. Gray, *Sculpture and Ceramics of Paul Gauguin*, Baltimore, 1963, no. 76.
8. See especially *Gauguin to Moore: Primitivism in Modern Sculpture*, 1981, pp. 35–37, no. 9.
9. Welsh-Ovcharov, 1981, p. 224.
10. Andersen, 1971, p. 106.
11. For varying views on the significance of these figures, see Sutton, 1949, p. 104, and Andersen, 1970, p. 616.
12. Rotonchamp, 1925, pp. 81–82; *Le Symbolisme en Europe*, 1975–76, no. 55; and Nashville, 1977, no. 42.
13. Signed and dated 1890, oil on canvas, 73×92 cm. See D. Wildenstein, 1964, I, p. 152, no. 396.
14. Charcoal on yellow paper, 12¼″×12¾″. For this study, which was owned originally by Octave Mirbeau, see particularly Rewald, *Gauguin Drawings*, 1958, p. 26, no. 27.
15. Andersen, 1971, p. 100. Other sources cited for the maiden's reclining posture are Manet's *Olympia* (Musée d'Orsay, Paris), which Gauguin copied in the winter of 1890–91, and Bernard's *Madeleine in the Bois d'Amour* of 1888 (Altarriba collection, Paris). See, for example, Andersen, 1971, pp. 99ff., and Welsh-Ovcharov, 1981, p. 226.
16. Andersen, 1971, pp. 100–101.
17. *Ibid*., pp. 101ff.
18. See, for example, Welsh-Ovcharov, 1981, p. 224.

41. ALONG THE OURCQ *(Vue du canal de l'Ourcq)*

Oil on canvas, 13⅜″×22¼″
Signed and dated lower right: *Jongkind 1866*

COLLECTIONS:
Probably Théophile Bascle, Bordeaux; Bascle sale, Georges Petit, Paris, April 12–14, 1883, no. 89; Serge Morin, Paris; Rex Evans, Los Angeles, 1954; Walter P. Chrysler, Jr.; Chrysler Museum, Norfolk, 1971.

EXHIBITIONS:
Dayton, 1960, no. 52; Palm Beach, 1962, no. 34; Provincetown-Ottawa, 1962; Finch College, 1965–66, no. 30; *Hommage à Baudelaire*, University of Maryland Art Gallery, College Park, March 1968; C. Cunningham, *Jongkind and the Pre-Impressionists*, Smith College Museum of Art, Northampton, and Sterling and Francine Clark Art Institute, Williamstown, Oct. 15, 1976—Feb. 13, 1977, no. 11.

The marine and landscape specialist Jongkind was perhaps the most important precursor of the French Impressionist school. He served in the early 1860s as mentor both to Boudin (cat. no. 35) and Claude Monet. As Boudin often did, Monet later acknowledged the revolutionary quality of Jongkind's sparkling *plein-air* pen sketches and watercolors and his formative influence as a teacher:

> His painting was too new and in a far too artistic strain to be then, in 1862, appreciated at its true worth . . . He asked to see my sketches, invited me to come and work with him . . . and thereby completed the instruction that I had already received from Boudin. From that time on he was my real master, and it was to him that I owed the final education of my eye.[1]

Born in Lattrop in the Dutch province of Overijsel, Jongkind was first trained at The Hague by the painter Andreas Schelfhout, whose wintry snowscapes made an enduring impression on his later work. With the aid of a government stipend granted by the Dutch king William III, he left Holland for Paris in 1846 and there continued his studies alongside Boudin in the atelier of the famous marine painter, Eugène Isabey. By 1847 Jongkind was already sketching along the coasts of Normandy and Brittany. He returned there

with Isabey in 1850 and began to devote himself thereafter to views of Honfleur and other Norman coastal spots, as well as to scenes of his native Holland (to which he often returned) and of Paris and its environs.

Official recognition of his art came surprisingly early. He made his first successful Salon submission in 1848 and four years later captured a third-class medal. Several of his paintings were purchased by the French government in the early 1850s. Three more were shown at the Exposition Universelle in 1855. But Jongkind had anticipated a more rapid rise for himself. Prone to depression, he dwelled on his setbacks, the first of which came in 1852, when his stipend from the Dutch crown was not renewed. During the next four years he was plagued by mounting debts and growing alcoholism. When his mother died in 1855, Jongkind suffered a nervous collapse and withdrew to Holland, where he lived for five years as an impoverished semi-recluse. Despairing at the apparent loss of so great an artist, Monet wrote to Boudin at the time, "You know also that the only good marine painter we have, Jongkind, is dead for art; he is completely mad."[2]

During the 1860s, however, Jongkind's fortunes gradually improved. With the financial assistance of his artist friends in France, he returned to Paris at the beginning of the decade. Soon after he met Josephine Fesser-Borrhée, a Dutch woman who taught drawing at a Parisian girls' school. Mme Fesser quickly became his cherished companion, and she devoted the rest of her life to Jongkind's work and mental well-being. In the summer of 1862 the artist encountered Monet in Normandy and there began to secure the foundation for the young painter's Impressionist style. Two years later Jongkind was introduced to the wealthy art collector Théophile Bascle, who became his most valued patron. Bolstered by Mme Fesser's love, Bascle's patronage, and the admiration of his fellow artists, Jongkind reached his creative pinnacle in the mid-1860s, producing some of the most vibrant and spontaneous of his Pre-Impressionist landscapes. Chief among these mature works is the 1866 ALONG THE OURCQ, which was

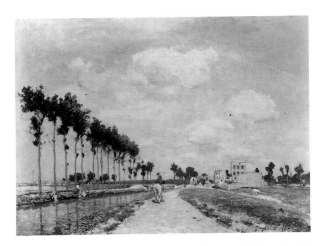

Fig. 41. Johan Barthold Jongkind, THE TOWPATH, from the collection of Mr. and Mrs. Paul Mellon, Upperville, Virginia.

apparently purchased from the artist by Bascle.

By 1885 Jongkind's art had brought him both critical and financial success. Indeed, his paintings fetched excellent prices and began to be recognized as a major influence on the Impressionists, whose art was then in full flower. After viewing an exhibition of Jongkind's work mounted in 1882 by the Paris dealer Détrimont, the eminent art historian Edmond de Goncourt observed that "every landscape which has any merit nowadays derives from this painter, makes use of his skies, his atmosphere, his familiar elements."[3]

Appearing at the left of the Norfolk painting is the Ourcq canal, which lies just northeast of Paris. Since Mme Fesser's brother-in-law lived along the canal, in the village of Pantin, Jongkind had ample opportunity to study and paint the waterway and its well-trodden towpaths. The Ourcq was, in fact, one of Jongkind's preferred sites in the mid-1860s, when he sketched and painted it repeatedly and under differing atmospheric conditions— in sunlight, in moonlight, in the rain.[4] An 1864 painting of the canal by Jongkind, today in the collection of Paul Mellon (fig. 41),[5] and a watercolor view from the same year (private collection, Paris)[6] directly anticipate the design of the 1866

PAUL SIGNAC

canvas. Jongkind customarily composed his paintings in the studio, consulting sketches he had made *sur le motif*. Though not painted out-of-doors, ALONG THE OURCQ nonetheless conveys the freshness and freedom of a rapidly executed *plein-air* impression, the very qualities that attracted Monet and, as Boudin said, "opened the door through which all the Impressionists passed."[7]

NOTES:
1. Quoted in "Claude Monet. The Artist as a Young Man," *Art News Annual*. 26 (1957), p. 198.
2. "Vous savez aussi que le seul bon peintre de marines que nous ayons, Jongkind, est mort pour l'art; il est complètement fou." Quoted in D. Wildenstein, *Claude Monet*. Lausanne-Paris, 1974, I, p. 420, and translated also in Cunningham, 1976–77, p. 27.
3. Translated in Cunningham, 1976–77, p. 30.
4. For the several paintings, watercolors, and pen drawings that Jongkind made of the Ourcq canal in 1864–65, see V. Hefting, *Jongkind*. Paris, 1975, nos. 294, 304, 321, 350, pp. 353, 357.
5. Oil on canvas, 13½″ × 18½″. *Ibid.*, no. 294, and Cunningham, 1976–77, p. 42.
6. 25.5 × 40.5 cm. See Hefting (note 4), no. 304, and Cunningham, 1976–77, p. 42.
7. "C'est Jongkind qui ouvert la porte par laquelle . . . tous les impressionnistes avaient pénétré." See *Jongkind*. exhib. cat., Musée de l'Orangerie, Paris, 1949, p. 5.

42. THE LAGOON OF ST. MARK, VENICE
(*Venise—Le Bassin de Saint Marc*)

Oil on canvas, 51″ × 64″
Signed and dated lower left: *P. Signac 1905*

COLLECTIONS:
The artist, Paris, 1905–1920; Galerie E. Druet, Paris, 1920; Dr. A. Roudinesco, Paris, 1920–1954; Walter P. Chrysler, Jr.; Chrysler Museum, Norfolk, 1977.

EXHIBITIONS:
Exposition de Peintures et d'Aquarelles de Henri Edmond Cross et Paul Signac, Galerie E. Druet, Paris, June 19—July 3, 1911, no. 15; *Trente Ans d'Art Indépendant 1884–1914*, Grand Palais des Champs-Elysées, Paris, Feb. 20—March 21, 1926, no. 2369; *Exposition Paul Signac*, Galerie Bernheim-Jeune et Cie., Paris, May 19–30, 1930; *Seurat et ses Amis*, Les Expositions des Beaux-Arts et de la Gazette des Beaux-Arts, Paris, Dec. 1933—Jan. 1934, no. 91; *Exposition Paul Signac*, Petit Palais, Paris, Feb.-March 1934, no. 23; *Il Divisionismo*, XXVI Biennale di Venezia, Venice, summer 1952, no. 26; Portland, 1956–57, no. 90; Dayton, 1960, no. 79; *"The Outline and the Dot": Two Aspects of Post-Impressionism*, Dallas Museum of Fine Arts, March 4–25, 1962, no. 35; *French Masters of the Nineteenth and Twentieth Century*. Finch College Museum of Art, New York, May 1—June 9, 1962, no. 40; Provincetown-Ottawa, 1962; Nashville, 1977, no. 47.

Georges Seurat spearheaded the Neo-Impressionist movement, but it was his close friend Paul Signac who served as its chief theorist and public spokesman. After Seurat's untimely death in 1891, Signac also became the leading practitioner of Neo-Impressionist style and its Divisionist technique. Though Signac produced, around 1890, a number of figurative works in the manner of Seurat, he devoted himself mainly—and, after 1896, exclusively—to marine and landscape paintings. In later years he executed an ambitious series of port and harbor scenes, among them THE LAGOON OF ST. MARK, VENICE, of 1905.

Born into a family of prosperous Paris shopkeepers, Signac did not choose painting as a profession until the age of nineteen. He received virtually no formal art instruction and evolved an early Impressionist style from his own study of the paintings of Monet and Armand Guillaumin. In 1884 he met Seurat in Paris, joining him in establishing the radical Société des Artistes Indépendants. To its

yearly exhibitions of avant-garde painting, the Salons des Indépendants, Signac contributed faithfully after 1884.

By early 1886 Signac had become an enthusiastic practitioner of Seurat's newly formulated Divisionist method. Following the theoretical doctrine of Divisionism, Seurat and Signac advocated that the loose, improvisational brushwork of the Impressionists be disciplined by the more controlled application of distinct, tight touches of paint in pure, prismatic colors. These separate, systematically applied particles of often sharply contrasting hues would, they maintained, be blended in the viewer's eye so as to recreate the broader color harmonies of earth, sea, and sky. In part they derived their precise, almost mechanical brushwork and the attendant principle of "optical mixing" from Ogden Rood's influential study of optical science, *Modern Chromatics*. Important, too, were the color theories of the brilliant mathematician Charles Henry, whom Seurat and Signac met in 1886. While the Impressionists "relied on instinct and instantaneity," Signac proclaimed, "we have turned to what has been carefully thought out, and to what is built to last."[1]

The first group showing of the Divisionist method was made at the eighth and final Impressionist exhibition in May of 1886. There Seurat, who showed his monumental SUNDAY AFTERNOON ON THE ISLAND OF LA GRANDE JATTE (Art Institute of Chicago), was joined by Signac and two other recent converts to Divisionism, Camille Pissarro (cat. no. 33) and his son Lucien. The originality of the group was recognized immediately by the younger Symbolist critics and poets—Gustave Kahn, Paul Adam, Félix Fénéon—who soon became its most ardent champions. It was Fénéon who, in the summer of 1886, coined the term "Neo-Impressionism" to describe the new movement and its program of reforming Impressionism along more purely "scientific" lines.

Between 1892 and 1911 Signac worked regularly at Saint-Tropez on the Mediterranean coast. He was joined there by fellow-Divisionist Henri-Edmond Cross, who moved to nearby Saint-Clair in the early 1890s. During these years Signac also

traveled to Holland, Venice, and Constantinople. Despite his wanderings, he remained active in the Indépendants, serving as its president between 1908 and 1934. In 1899 he published his famous treatise on Neo-Impressionist theory and technique, *D'Eugène Delacroix au Néo-Impressionnisme*.

Signac's early Divisionist works were painted in tiny, round color-dots in the style of Seurat. Between 1895 and 1905, however, he and Cross evolved a broader method and began to work in large, rectangular or mosaic-like squares of raw, bold color. This more audacious, later technique, which is revealed in THE LAGOON OF ST. MARK, VENICE, exerted a formative influence on Henri Matisse and his fellow Fauves, who often visited Saint-Tropez from 1902 to '06 to study with Signac and Cross.

With Cross Signac shared an enthusiasm for Venice and for the works of two British artists also enamored of the City of the Lagoon, J.M.W. Turner and John Ruskin. Indeed, during his English sojourn of 1898, Signac was much impressed with Turner's Venetian paintings of 1833–45. Signac himself visited Venice for the first time in 1904—he returned three years later—and began to produce his own series of Venetian scenes, the earliest of which he showed in Paris at the Galerie Druet in 1904.[2] In his preface to the catalogue of the Druet exhibition, Fénéon admired the "chromatic opulence" and "rhythmic audacity" of these paintings, in which "wave upon wave of color sweeps across the canvas."[3] Writing in *L'Ermitage*, Maurice Denis praised the ornamental richness of Signac's "decorative fantasies of Venice."[4] Signac's interest in Venice was no doubt sustained by the 1905 Paris publication of Ruskin's *The Stones of Venice*, wherein the painter found a theoretical endorsement for his mature Divisionist method: "It is necessary," Ruskin wrote, "to consider all of nature purely as a mosaic of different colors that we must imitate one by one in total simplicity."[5]

Though designed to reflect his Divisionist theories, THE LAGOON OF ST. MARK, VENICE, captures nonetheless the poetry and magic of the island city's color

HENRI MATISSE

43. Bowl of Apples on a Table

and light. Its sparkling palette of primary hues and parade of patterned sails convey, too, a festive mood of carnival gaiety. A preliminary study for the painting—a pencil and gouache drawing—was formerly in the van de Velde collection in Weimar.[6]

NOTES:
1. Translated in *Paul Signac 1863–1935,* exhib. cat., Marlborough Galleries, London, 1954, insert, no. pag.
2. For these, see *Signac,* exhib. cat., Louvre, Paris, 1963–64, pp. 70–74.
3. Translated in *Paul Signac 1863–1935* (note 1), p. 9.
4. Quoted in *Signac* (note 2), p. 72.
5. Cited in *Signac* (note 2), p. 73.
6. Pencil and gouache drawing on paper, mounted on canvas, 51″ × 62″. See *French Masters of the Nineteenth and Twentieth Century,* 1962, no. 39.

Oil on canvas, 45¼″ × 35¼″
Signed lower left: *Henri Matisse*

COLLECTIONS:
The artist; M. Duithuit, Paris; sale, collection Ch. V . . . , Hôtel Drouot, Paris, May 21, 1931, no. 23; Valentine Galleries, New York, by 1936; Walter P. Chrysler, Jr.; Chrysler Museum, Norfolk, 1971.

EXHIBITIONS:
Twenty Paintings by Henri Matisse, Valentine Galleries, New York, Nov. 28—Dec. 17, 1936, no. 1; Detroit, 1937, no. 39; *Picasso and Matisse,* Boston Institute of Modern Art, Oct. 19—Nov. 11, 1938, no. 28; *Paintings by Henri Matisse,* Arts Club of Chicago, March 30—April 18, 1939, no. 3; *Seven Centuries of Painting,* California Palace of the Legion of Honor and M.H. de Young Memorial Museum, San Francisco, Dec. 29, 1939—Jan. 28, 1940, no. Y-186; Richmond, 1941, no. 121; Provincetown, 1958, no. 41; Dayton, 1960, no. 116; Provincetown-Ottawa, 1962; *Henri Matisse, Exposition du Centenaire,* Grand Palais, Paris, April-Sept. 1970, no. 142; *Henri Matisse,* Acquavella Galleries, New York, Nov. 2—Dec. 1, 1973, no. 11; Nashville, 1977, no. 49; M. Mezzatesta, *Henri Matisse Sculptor/Painter,* Kimball Art Museum, Fort Worth, May 26—Sept. 2, 1984, no. 31.

REFERENCES:
A. Barr, *Matisse, His Art and His Public,* New York, 1951, p. 190; M. Luzi and M. Carrà, *L'opera di Henri Matisse, 1904–1928,* Milan, 1971, p. 95, no. 212; J. Russell, "Matisse en France," *L'Oeil,* 184 (April 1970), p. 23.

To please his father, a grain merchant who worked in provincial Bohain near Saint-Quentin, the young Matisse prepared for a legal career. He studied law in Paris in 1887–89 and was hired as a clerk in a Saint-Quentin law firm. In 1890 he was stricken with appendicitis and, to ease the boredom of his long convalescence, his mother gave him a box of oil colors. Matisse was enchanted with the paints —"I was," he later recalled, suddenly "free, solitary, and quiet"[1]—and by 1891 he had abandoned the legal profession and returned to Paris to become an artist. Finding his studies with the academic Bouguereau (cat. no. 22) confining, he quickly moved on to the atelier of the more progressive Gustave Moreau. There he encountered among his fellow students several of his future Fauvist colleagues.

A conventional career with official honors now appeared to stretch before

him, but his 1897 encounter with Pissarro and the Impressionist paintings of the Caillebotte bequest drew him instead into the camp of the avant-garde.[2] His early reverence for Cézanne, whom he called "the father of us all,"[3] was rivaled by his interest in the vibrantly hued canvases of Paul Signac (cat. no. 42). Matisse read Signac's Neo-Impressionist treatise *D'Eugène Delacroix au Néo-Impressionnisme* in 1899 and encountered him at the Salon des Indépendants, where Matisse first exhibited in 1901.

In 1904 Matisse spent the summer with Signac and Henri-Edmond Cross at Saint-Tropez, and soon after he painted his first great masterpiece, LUXE, CALME ET VOLUPTÉ (private collection, Paris), in their Divisionist style. For Matisse, however, Neo-Impressionism served merely as a point of departure for his more revolutionary experiments with bright, clashing color. He soon abandoned Divisionism and in 1905–06 emerged as the leader of a group of painters—André Derain, Maurice Vlaminck, Albert Marquet, Othon Friesz—who focused totally on the expressive and decorative potential of pure, rapturous color—color freed from the mundane task of realistic description and granted an independent, evocative power. When these painters exhibited their shocking-hued canvases at the 1905 Salon d'Automne, outraged critics dismissed them as "the wild beasts," *les fauves*.

The Fauvist movement had crested by 1907, and over the course of the next decade Matisse's passion for chromatic expression was rivaled increasingly by his commitment to greater formal discipline. In his search for a more structured art, he turned for inspiration to primitive African sculpture, Trecento and Quattrocento painting (which he studied in Italy in 1907), and Cubism. His interest in Cubist spatial abstraction was probably heightened in 1914, when he met Juan Gris at Collioure.[4] In any event, between 1914 and '16, influenced by Cubism, he produced a series of remarkably abstract paintings and sculptures, including his HEAD, WHITE AND ROSE (Musée National d'Art Moderne, Paris), his bronze BACK III, and the Norfolk BOWL OF APPLES ON

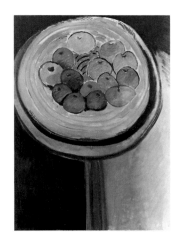

Fig. 42. Henri Matisse, APPLES, Gift of Florence May Schoenbern and Samuel A. Marx, courtesy of the Art Institute of Chicago.

A TABLE. Despite his growing formal concerns during these years, Matisse never renounced the opulence and sensuality of decorative color. Indeed, he strove throughout his career for an art that would delight and calm both the eye and the mind:

> What I dream of is an art of balance, of purity and serenity devoid of troubling or depressing subject matter, an art which might be for every mental worker, be he businessman or writer, like an appeasing influence, like a mental soother, something like a good armchair in which to rest from physical fatigue.[5]

In 1909 Matisse moved from Paris to nearby Issy-les-Moulineaux. There he built a studio and lived on and off until 1917, when Nice became his principal residence. It was at Issy in the late spring of 1916 that Matisse produced BOWL OF APPLES ON A TABLE and two other related paintings, the comparably designed APPLES in the Art Institute of Chicago (fig. 42)[6] and THE WINDOW, which is found in the Detroit Institute of Arts and features the same pedestal table as the Norfolk still life (fig. 43).[7] In a letter written to his friend Hans Purrmann on June 1, 1916, Matisse noted that he had finished THE WINDOW.[8] Michael Mezzatesta has argued that the undated Norfolk canvas must have been painted "in the weeks immediately

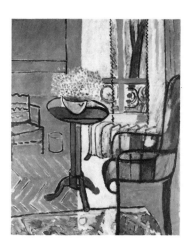

Fig. 43. Henri Matisse, THE WINDOW, Detroit Institute of Arts, City of Detroit Purchase.

following his letter to Purrmann."[9] The sketchy and improvisational APPLES served, perhaps, as a prelude to the more formal and finished Norfolk composition.[10]

In the Norfolk painting a humble still-life subject—a bowl of fruit on a table, with a curtain or louvered door at left—achieves an impression of "monumental dignity and colossal size," of "simplicity, symmetry, and scale,"[11] as a result of Matisse's closely cropped and frontally ordered design. As Mezzatesta observes, Cubist influence pervades the composition. It can be traced in "the linearity and simplified geometry focusing on the round tabletop; the strong vertical axis established by the table pedestal; the flattening of space caused by tipping the tabletop forward; the elimination of the third leg; and the folding out of the right side of the pedestal."[12] Over these formal considerations, however, the poetry of Matisse's color prevails. The apples, brilliant in hue, glow magically in their yellow bowl, as if lit from within.

NOTES:
1. Quoted by Lawrence Gowing in his introduction to *Matisse 1869–1954,* exhib. cat., Hayward Gallery, London, 1968, p. 7.
2. Mezzatesta, 1984, p. 6.
3. "Le père de nous tous": see *Henri Matisse, Exposition du Centenaire,* 1970, p. 52.

4. Mezzatesta, 1984, p. 100, and Barr, 1951, pp. 178, 188.
5. Quoted in Barr, 1951, p. 122.
6. Oil on canvas, 46″ × 35″; *Painting in the Art Institute of Chicago,* 1961, p. 304. See also Mezzatesta, 1984, p. 105. Comparable in design to the Norfolk and Chicago paintings are two other Matisse still lifes of 1916, the *Oranges* (Ellisen collection, Paris) and *Still Life with a Nutcracker* (Statens Museum for Kunst, Copenhagen). See Barr, 1951, pp. 189–190.
7. *Catalogue of Paintings in the Permanent Collection of the Detroit Institute of Arts,* Detroit, 1930, no. 142. See also Mezzatesta, 1984, p. 105.
8. Quoted in Barr, 1951, pp. 181–182.
9. Mezzatesta, 1984, p. 104.
10. *Ibid,* p. 105.
11. Barr, 1951, p. 189.
12. Mezzatesta, 1984, p. 105.

GEORGES BRAQUE

44. THE PINK TABLECLOTH (*La Nappe Rose*)

Oil and sand on canvas, 38¼" × 51¾"
Signed lower right: *G. Braque*

COLLECTIONS:
The artist; Valentine Gallery, New York; Walter P.
Chrysler, Jr.; Chrysler Museum, Norfolk, 1971.

EXHIBITIONS:
Paintings by Georges Braque, Reid and Lefevre,
London, July 1934, no. 37; *Twentieth Century Paint-
ings of the School of Paris*, Museum of Modern Art,
New York, June 5—Sept. 24, 1935; Choate Exhi-
bition, Wallingford, Connecticut, Jan. 17—Feb.
13, 1936; Palm Beach, 1936, no. 8; Chicago, 1937,
no. 18; Detroit, 1937, no. 23; *Braque Retrospective
Exhibition*, Arts Club of Chicago, Phillips Memorial
Gallery, Washington, D.C., and San Francisco
Museum of Art, Nov. 1939—Feb. 1940, no. 34;
Richmond, 1941, no. 28; *Georges Braque*, Museum
of Modern Art, New York, and Cleveland Museum
of Art, 1949, no. 69; *G. Braque*, Tate Gallery,
London, Sept. 28—Nov. 11, 1956, no. 68; Province-
town, 1958, no. 4; *Georges Braque*, Haus der Kunst,
Munich, Oct. 18—Dec. 15, 1963, no. 87; *Still Life
Painters: Pieter Aertsen 1508–1575 to Georges Braque
1882–1963*, Finch College Museum of Art, New
York, opened Feb. 2, 1965, no. 17; *Georges Braque:
The Late Paintings, 1940–1963*, Walker Art Center,
Minneapolis, April 14—June 14, 1983.

REFERENCES:
Minotaure, 3–4 (1933), p. 13; H. Hope, *Georges
Braque*, New York, 1949, pp. 124–127, ill.; M.
Gieure, *Georges Braque*, Paris, 1956, no. 79; R.
Rosenblum, *Cubism and Twentieth-Century Art*, New
York, 1959, pp. 318, 340, pl. XL; J. Richardson,
Georges Braque, Milan, 1960, pl. xxxix; *Catalogue de
l'Oeuvre de Georges Braque, III, Peintures 1928–1935*,
ed. Maeght, Paris, 1962, no. 92.

Though born in Argenteuil, Braque spent
most of his childhood in Le Havre, on the
Norman coast. Both his father and grand-
father were house painters, and they
expected him to follow in their footsteps.
Braque served as a house painter's appren-
tice in Le Havre in 1899–1900 and pur-
sued his craftsman's training thereafter in
Paris. But his early interest in painting as a
fine art—his father and grandfather were
amateur painters as well—soon triumphed
over the more practical wishes of his family,
and in 1902–04 he turned fully to the
study of art at the Académie Humbert in
Paris. Inspired particularly by fellow-Le
Havre artist Othon Friesz, the young
Braque experimented briefly with the hot
colors and expressive outline style of the

Fauves.

By 1907, however, Braque had dis-
covered Cézanne, whose tightly reasoned,
architectonic compositions prompted him
to begin a sequence of increasingly
abstracted, proto-Cubist landscapes and
still lifes. Equally influential was Picasso's
revolutionary DEMOISELLES D'AVIG-
NON, which Braque saw in Picasso's stu-
dio in the winter of 1907. In this painting
Picasso had achieved a radical synthesis of
African primitivism and Cézannesque
form that had taken him as well to the
threshold of Cubism. Sensing their paral-
lel interests, the two artists in 1909 began
an intensive, five-year collaboration that
brought the new Cubist style to fruition.
They worked, Braque later said, "like
mountaineers roped together."[1] As co-
inventor of what soon proved to be the
most influential aesthetic of the early
twentieth century, Braque found himself at
the head of the European avant-garde. He
remained there for the next thirty years,
his influence as a leader of the Modernist
movement exceeded only by that of Picasso
and Matisse.

Braque and Picasso's Cubist collabo-
ration ended with the outbreak of World
War I, when Braque was called to military
service. Wounded in battle, he recuperated
slowly and resumed painting only in 1917.
In his subsequent still lifes and figure
pieces he gradually abandoned the taut
geometry of his early Cubist researches in
favor of more relaxed, ample, and sensual
designs, varying and enriching his initial
discoveries as he experimented endlessly
with color, texture, and the disposition of
objects in space.

Between 1930 and '36 Braque
painted a series of still lifes—the
1933 PINK TABLECLOTH among them—
in which he temporarily abandoned his
complex spatial structures of the previous
decade for flatter, sparer, and more
abstracted compositions. The curvilinear
impulses that had become increasingly evi-
dent in Braque's work of the 1920s now
triumphed, transformed into decorative
surface patterns of sweeping arcs and lazily
looping lines. Reduced to shadowy, two-
dimensional diagrams, their forms often
distorted or overwhelmed by the free-

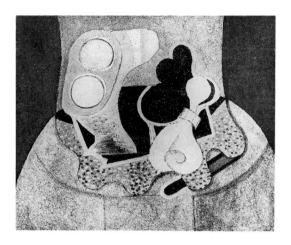

Fig. 44. Georges Braque, studies for a still life, present location unknown.

Fig. 45. Georges Braque, STILL LIFE, present location unknown.

flowing linear patterns, the objects in Braque's still lifes of the early '30s "virtually lost not only their value as such . . . but even their right to a material existence."[2] This abstracting process is readily apparent in the Norfolk painting, where several of the objects placed upon a table are nonetheless still recognizable: a bowl of fruit, glass goblet, sheet of music and a pipe whose rounded stem and the shadow it casts are witty, illusionistic digressions in an otherwise thoroughly flattened space. Less easily identified are the lobed form to the left of the goblet and the flaccid, pendulous shape—a mandolin, perhaps, or a carafe—in front of it.

More important to Braque than the objects he painted were the affiliations —both formal and poetic—that bound them together. "Let us forget things," he counseled the viewer, "and consider only the relationships between them":[3]

> Don't forget that you also have to paint what there is between the apple and the plate . . . this 'in-between' is no less important than what they call the 'object.' In fact, it is the relationship between objects themselves, and with the 'in-between,' which constitutes the subject matter.[4]

As he worked to reveal these relationships, Braque sought "that particular temperature at which objects become malleable"[5]

and begin to mimic and merge with one another, that moment when they disclose the deeper, poetic truths that lie unseen within and between them. Among the hidden attractions that Braque sensed between objects and that he accentuated in paint were congruences he called "rhymes." The playful poetry of the Norfolk still life is conveyed not only through its gay palette of pink, purple, and red—lively hues typical of Braque's work at the time—but through a sequence of witty rhymes. The large, meandering line in the right foreground, for example, is echoed in miniature in the snaky decoration on the goblet; the toothy pattern of the tablecloth's zigzagging edge is repeated on the wall behind. The sandy surface lends a stuccolike quality to the painting, a textural trick the artist surely learned during his early years as a house painter.

A sheet of pencil studies by Braque formerly with the Galerie Maeght may represent his initial thoughts on the Norfolk composition (fig. 44).[6] There also exists a preliminary study in oil (fig. 45).[7]

NOTES:
1. Quoted in *G. Braque,* Tate Gallery, London, 1956, p. 10.
2. D. Cooper, *Braque: The Great Years,* Chicago, 1972, p. 68.
3. Quoted in *G. Braque* (note 1), p. 14.
4. Quoted in Cooper (note 2), p. 51.

GEORGES ROUAULT

5. Quoted in *G. Braque* (note 1), p. 45.
6. Dimensions and present location unknown. See J. Cassou, *French Drawings of the Twentieth Century,* New York, 1955, no. 94.
7. Dimensions and present location unknown. See H. Ede, "Georges Braque," *Cahiers d'Art,* 8 (1933), no pag.

45. HEAD OF CHRIST *(Le Christ Flagellé)*

Oil on paper, mounted on canvas, 39″ × 25¼″
Signed upper left: *G. Rouault*

COLLECTIONS:
Galerie de France, Paris; St. Georges Gallery, London, 1930; sale, Hôtel Drouot, Paris, April 12, 1933; Weyhe Gallery, New York, 1935; Walter P. Chrysler, Jr.; Chrysler Museum, Norfolk, 1971.

EXHIBITIONS:
Choate Exhibition, Wallingford, Connecticut, Jan. 17—Feb. 13, 1936; Palm Beach, 1936, no. 43; Chicago, 1937, no. 38; Exposition Universelle, Paris, summer 1937; Detroit, 1937, no. 42; *Art in Our Time,* Museum of Modern Art, New York, 1939, no. 121; *Origins of Modern Art,* Arts Club of Chicago, April 1940, no. 33; *Georges Rouault,* Institute of Modern Art, Boston, Phillips Memorial Gallery, Washington, D.C., and San Francisco Museum of Art, Nov. 1940—March 1941, no. 3; Richmond, 1941, no. 241; *Paintings from Private Collections,* Museum of Modern Art, New York, May 31—Sept. 5, 1955, no. 130; Portland, 1956–57, no. 89; Provincetown, 1958, no. 53; *The World of Art in 1910,* Isaac Delgado Museum of Art, New Orleans, Nov. 15—Dec. 31, 1960, no. 85; Provincetown-Ottawa, 1962; Nashville, 1977, no. 51; *Fifty Years of French Painting: The Emergence of Modern Art,* Birmingham Museum of Art, Birmingham, Alabama, Feb. 1—March 30, 1980, no. 28; *Georges Rouault,* Josef-Haubrich-Kunsthalle, Cologne, March 11—May 8, 1983, no. 7.

REFERENCES:
R. Cogniat, *Georges Rouault,* Paris, 1938, no. 10; *L'Art Aujourd'hui,* spring 1938, pl. 7; C. Zervos, *Histoire de l'Art Contemporain,* Paris, 1938, p. 142; L. Venturi, *Georges Rouault,* New York, 1940, p. 73, pl. 18; R. Wilenski, *Modern French Painting,* New York, 1940, pl. 72; J. Soby, *Georges Rouault,* exhib. cat., Museum of Modern Art, New York, 1945, p. 15; L. Venturi, *Rouault,* Lausanne, 1959, pp. 44–46, ill.; P. Courthion, *Georges Rouault,* New York, n.d. (ca. 1961), pp. 458, 409, fig. 21; J. Kind, *Rouault,* New York, 1969, pp. 18–19, no. 12, pl. 12; H. Janson, *History of Art,* New York, 1973, pp. 521–522, fig. 779; S. Scholl, *Death and the Humanities,* Lewisburg, 1984, pp. 143, 146, fig. 27; D. Cleaver, *Art. An Introduction,* New York, 1985, pp. 362–363, fig. 19–7; D. and S. Preble, *Artforms,* New York, 1985, p. 348, fig. 393.

Rouault was a solitary genius. In the paintings of his early maturity—chief among them the 1905 HEAD OF CHRIST—he stood apart from his fellow artists of the early-twentieth-century School of Paris. While his contemporaries were devoting themselves overwhelmingly to secular subject matter, Rouault, a devout Catholic, produced intensely emotional religious

images and genre pictures that elucidated the timeless Christian themes of sin and salvation. He has been called the most important devotional painter of this century, "the monk of modern art." His blunt and brutal Expressionist style also found few parallels in the French art of his day. For genuine stylistic correspondences one must look instead to the German Expressionists of *Die Brücke*.

Rouault was the son of a Paris cabinetmaker. He spent much of his childhood with his maternal grandfather, a cultured, art-loving man from whom he inherited a love of Rembrandt and Daumier. At fourteen Rouault was apprenticed to the stained glass maker Hirsch. Of Hirsch's studio, he later wrote, "my work consisted in supervising the firing, and in sorting the little pieces of glass that fell out of the windows they brought us to repair. This latter task inspired me with an enduring passion for old stained glass."[1] In the paintings he later created Rouault was clearly influenced by the structure and hues of medieval glass windows, by their broad, flat fields of glowing, translucent color and thick, leaded contours.

In 1890 Rouault decided to become a painter and enrolled in the Ecole des Beaux-Arts. There he studied briefly under Elie Delaunay and in 1892 began a six-year association with the great Symbolist painter Gustave Moreau. Under Moreau's sympathetic tutelage Rouault perfected his powers as a colorist and crystallized his interest in religious subject matter. With one of his early Moreau shop efforts —THE INFANT JESUS AMONG THE DOCTORS (Musée d'Unterlinden, Colmar) —he won the *Prix Chenavard* in 1894.

Around 1900 Rouault discovered the works of Ernest Hello and Léon Bloy, two of the most important Catholic writers of later-nineteenth-century France. The painter met Bloy in 1904 and became, for a time, his intimate friend. Under Bloy's influence Rouault produced over the next decade his first great series of paintings. These dark and despairing images of prostitutes, clowns, judges, and the head of Christ directly reflected Bloy's tragic vision of mankind's spiritual corruption. The ferocious power of these violently

painted pictures reached an expressive climax in 1905–06 in such central masterpieces as the Norfolk HEAD OF CHRIST and PROSTITUTE AT HER Mirror (Musée National d'Art Moderne, Paris). The paintings of this period, which Rouault exhibited alongside the Fauves at the 1905 Salon d'Automne and showed regularly between 1905 and '12 at the Salon des Indépendants, scandalized the public and dismayed even Bloy, who in time denounced them as "the most atrocious and avenging caricatures."[2]

In his writings Bloy often focused on Christ's human sufferings, on the physical agonies of his Passion and death on the cross. He viewed these torments as a metaphor for God's eternal anguish over the sins of man. Though unworthy of Christ's sacrifice, man could expunge his sin, Bloy contended, and sanctify his own suffering through the vicarious experience of Christ's pain. In his 1886 novel *Le Désespéré*, Bloy had his Christ character explain this view:

> I have created you, beloved vermin, in my thrice sacred resemblance, and you have responded by betraying me. Thus, instead of punishing you, I have punished myself. It was not enough that you resembled me. I, the Impassible, felt a great desire to make myself like you, so that you would become my equals. Therefore, I have made myself vermin in your image.[3]

It is easy enough to imagine the suffering savior in the Norfolk icon making such a declaration. Here the Man of Sorrows —his great, pain-filled eyes seemingly melting into tears—bears anguished witness to the sins and cruelty of humankind. The heavy black contours that lash his face "are used as a virtual flagellation of the surface," wrote James Thrall Soby, "a direct translation of the artist's emotion before the subject."[4] "You paint," André Suarès once said to Rouault, "as one exorcises."[5]

NOTES:
1. Quoted in Soby, 1945, p. 6.
2. Quoted in W. Dryness, *Rouault: A Vision of Suffer-*

ing and Salvation. 1971, Grand Rapids, Michigan, p. 42.

3. Quoted in Dryness (note 2), p. 188.

4. Soby, 1945, p. 15.

5. Translated from A. Suarès, "Gustave Moreau," *L'Art et les Artistes.* 20 (April 1926), p. 218.

PLATE 1 *EUSTACHE LE SUEUR*

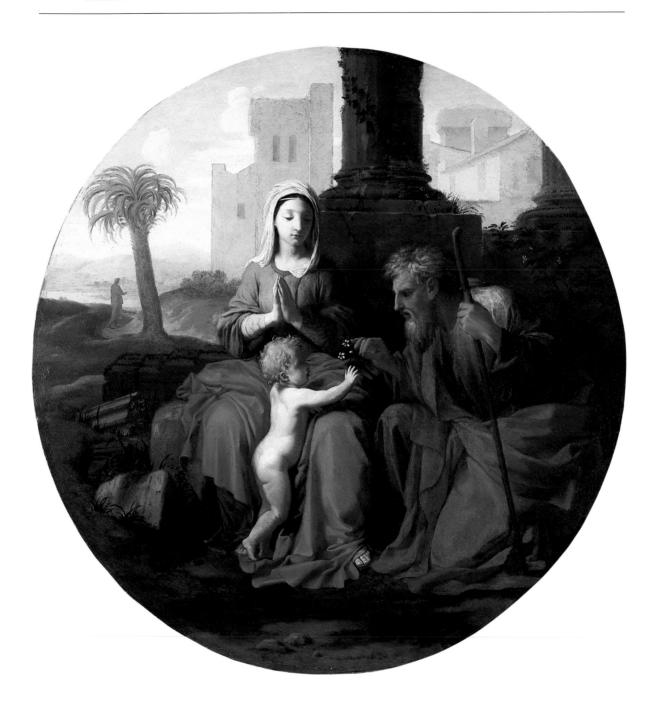

VIRGIN AND CHILD WITH ST. JOSEPH

MADONNA AND CHILD

PLATE 3 *PIERRE PATEL THE ELDER*

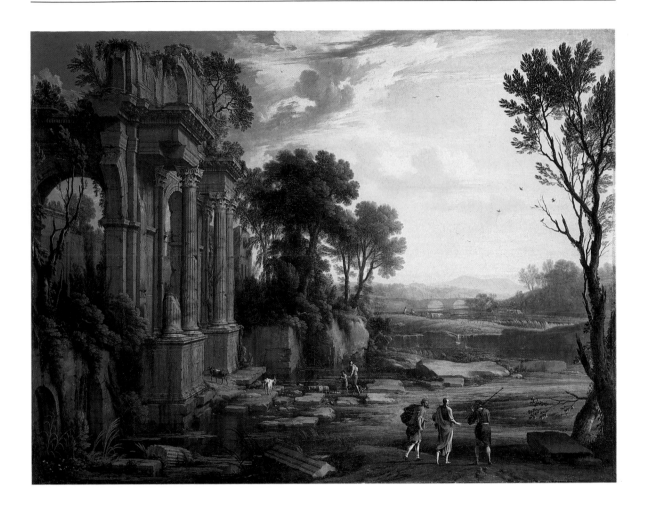

LANDSCAPE WITH JOURNEY TO EMMAUS

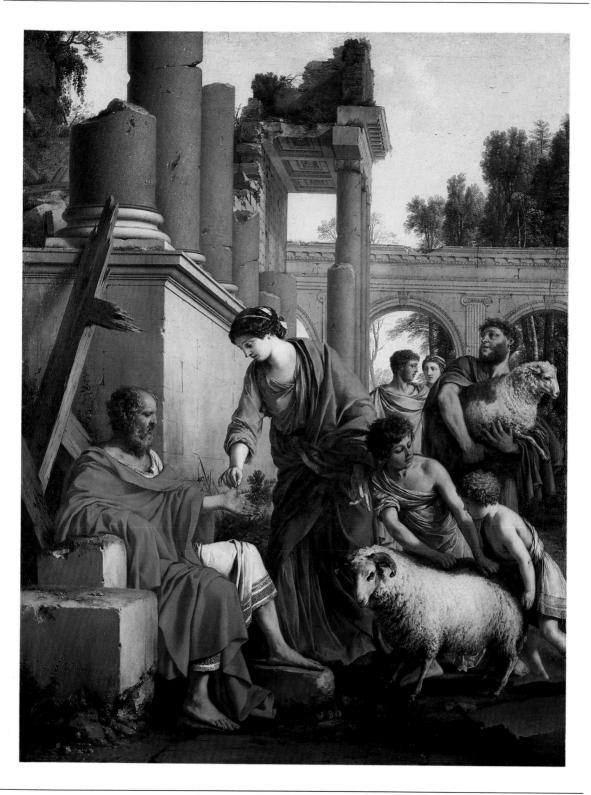

JOB RESTORED TO PROSPERITY

PLATE 5 *GEORGES DE LA TOUR*

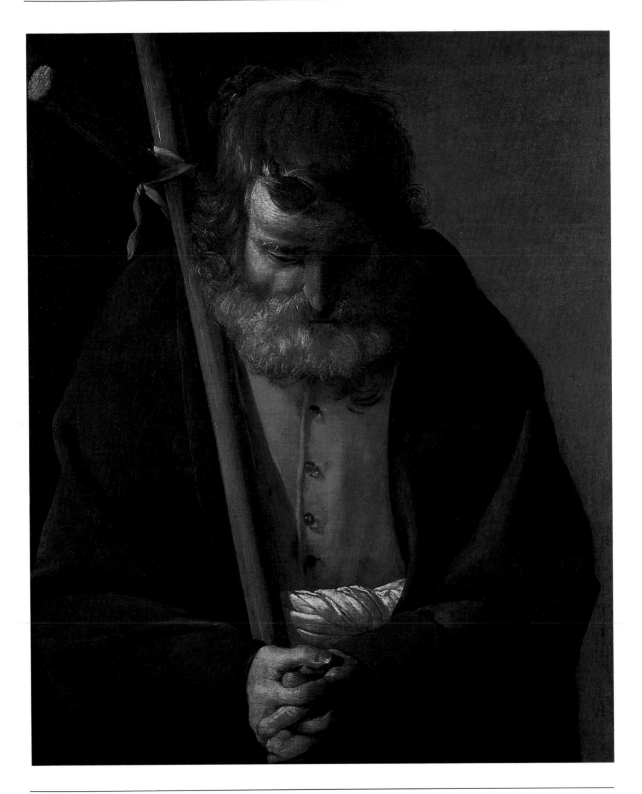

SAINT PHILIP

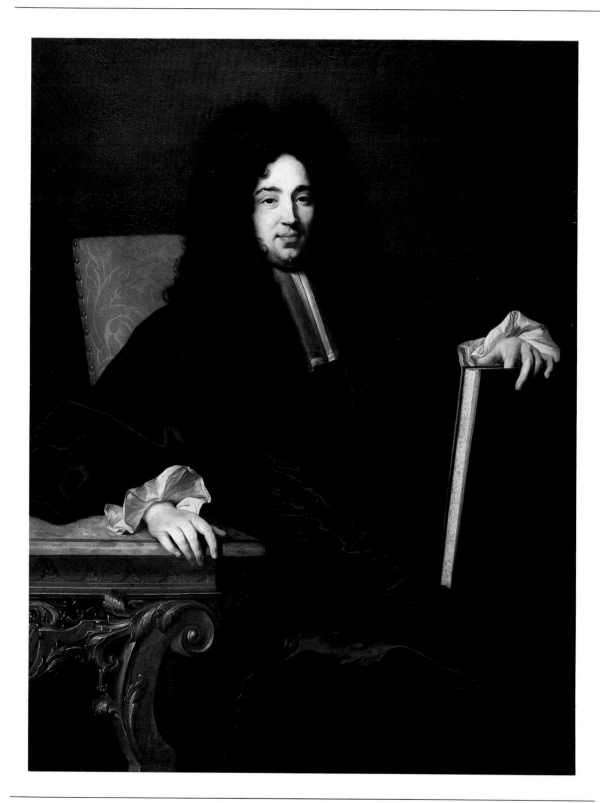

PORTRAIT OF A GENTLEMAN

PLATE 7 *CHARLES-ANTOINE COYPEL*

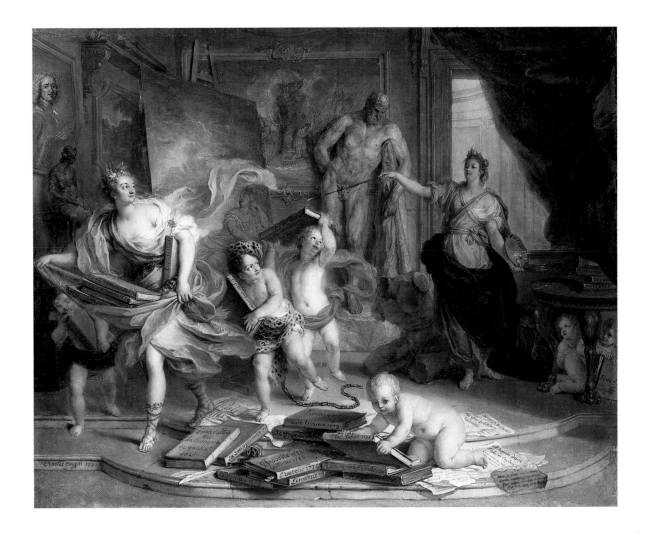

PAINTING EJECTING THALIA

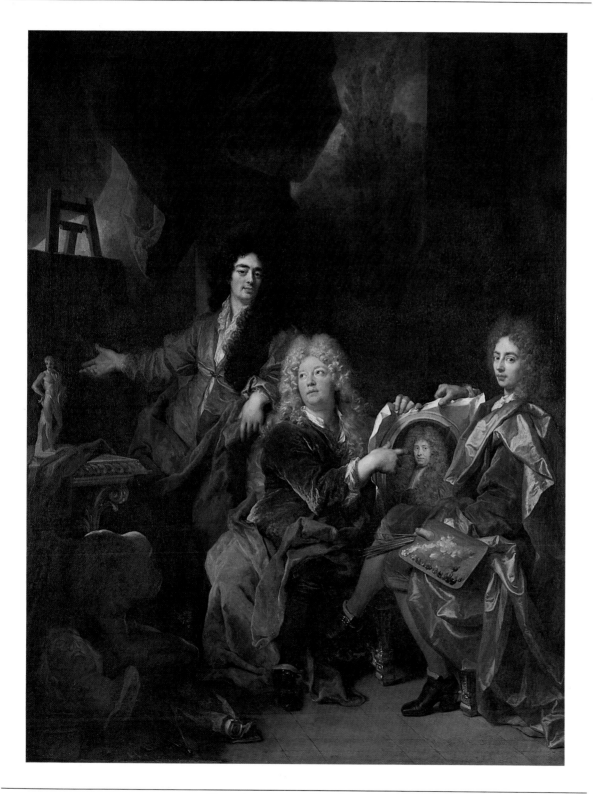

THE ARTIST IN HIS STUDIO

PLATE 9 *JEAN-FRANÇOIS DE TROY*

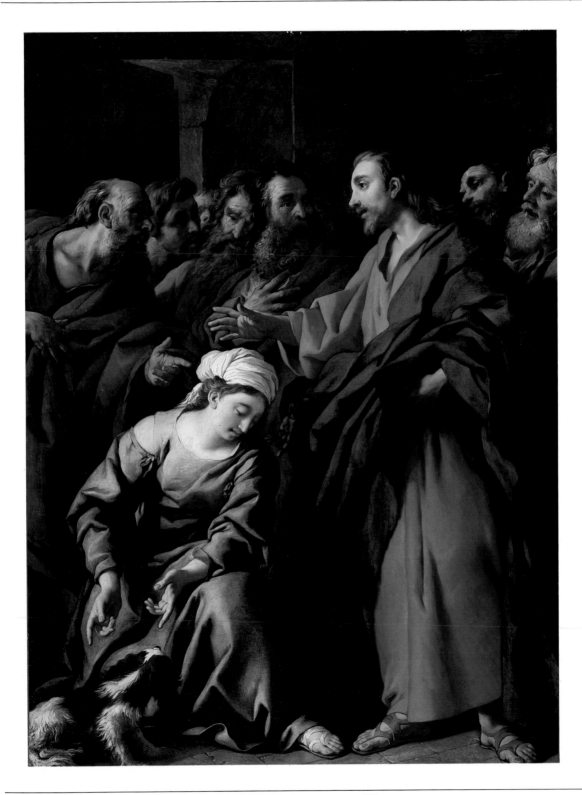

CHRIST AND THE CANAANITE WOMAN

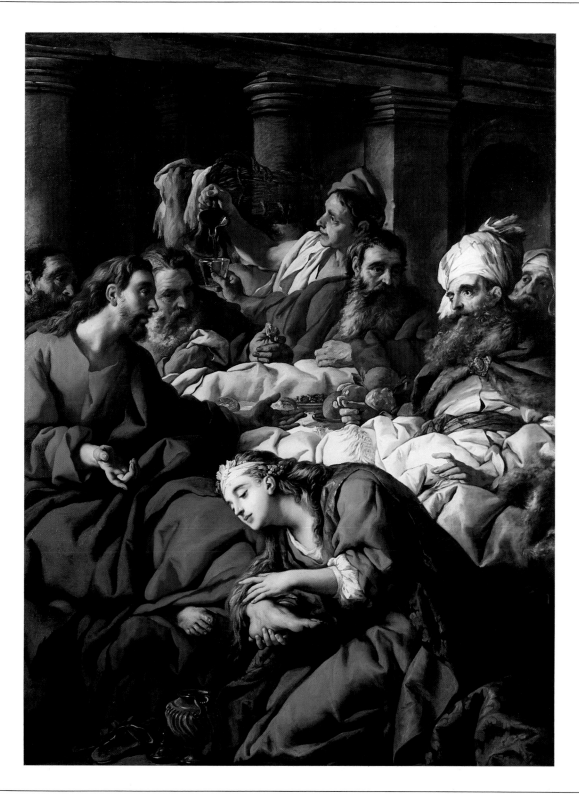

CHRIST IN THE HOUSE OF SIMON

PLATE 11 *LOUIS TOCQUÉ*

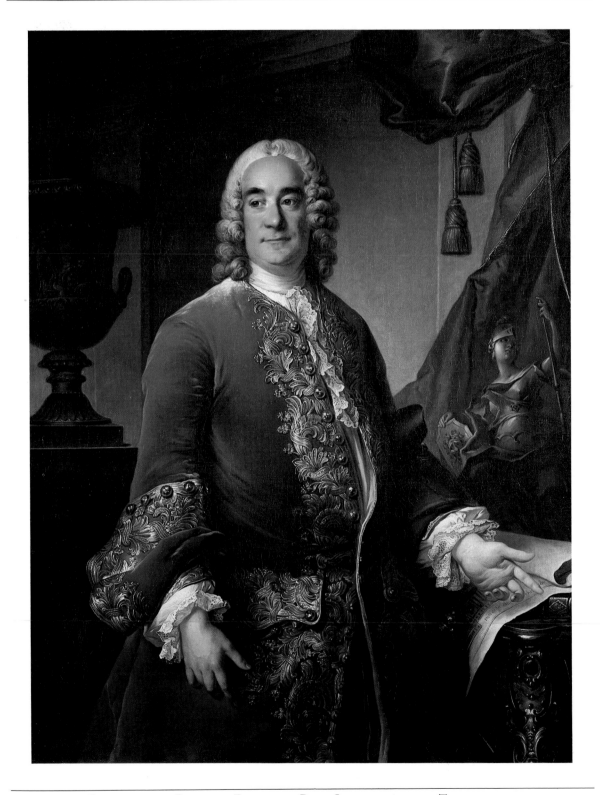

PORTRAIT OF CHARLES-FRANÇOIS-PAUL LENORMANT DE TOURNEHEM

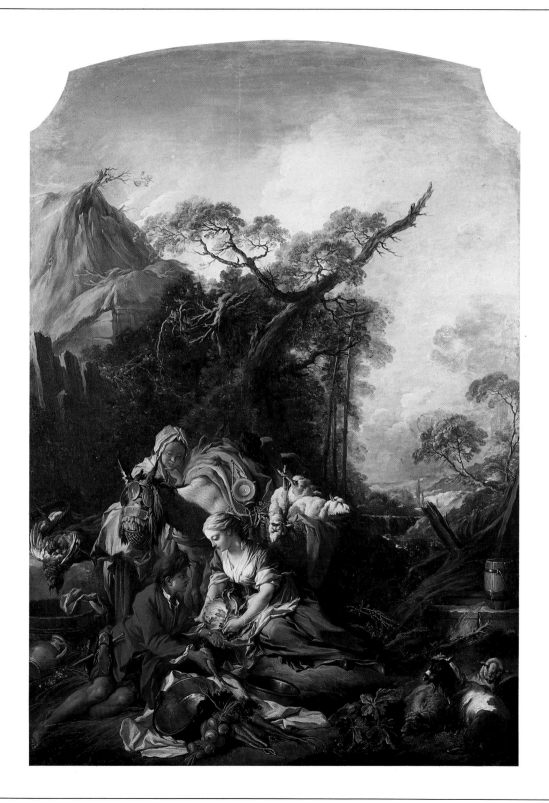

PASTORALE: THE VEGETABLE VENDOR

PLATE 13 *JEAN-BAPTISTE-SIMÉON CHARDIN*

BASKET OF PLUMS

LANDSCAPE WITH A TEMPLE

PLATE 15 *JEAN-BAPTISTE GREUZE*

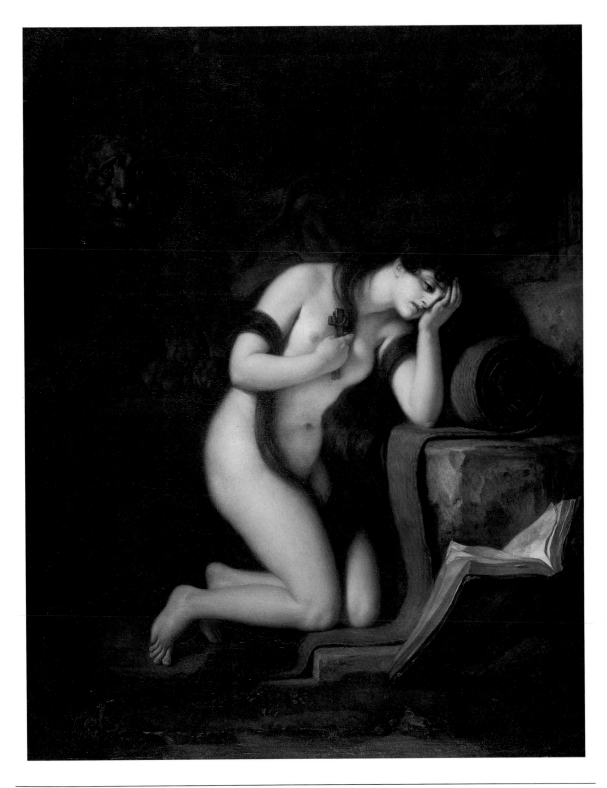

SAINT MARY OF EGYPT

ACIS AND GALATEA

PLATE 17 *JEAN-AUGUSTE-DOMINIQUE INGRES*

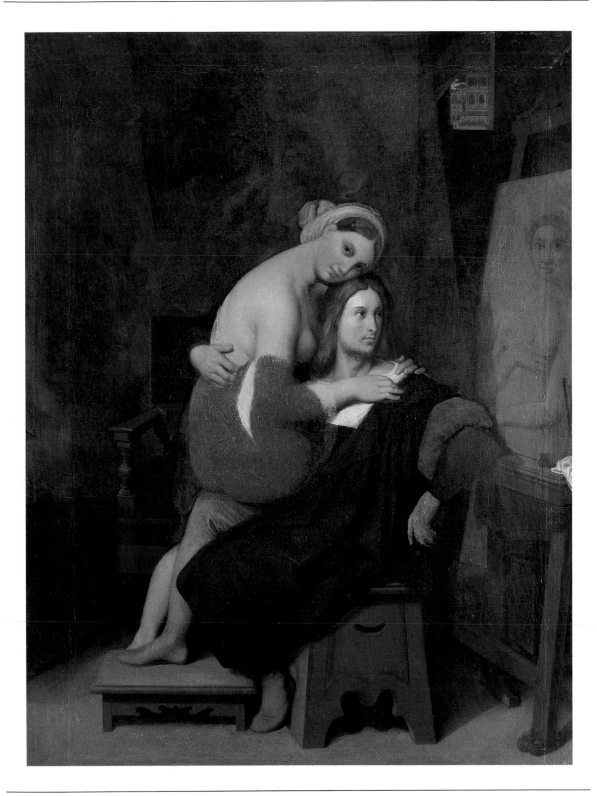

RAPHAEL AND THE FORNARINA

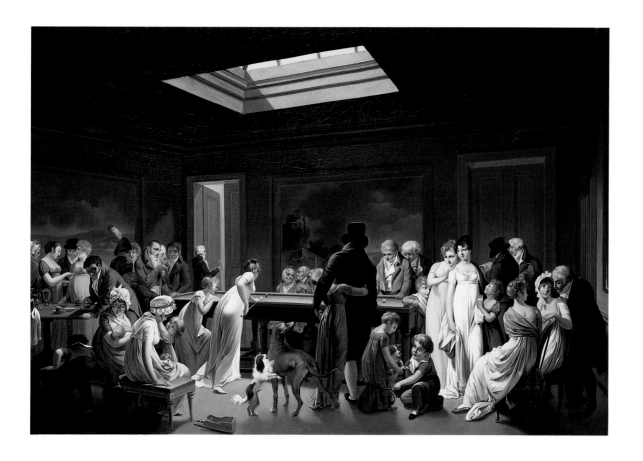

THE BILLIARD PLAYERS

PLATE 19　　　　　　　　　　　　　　*JEAN-LOUIS-ANDRÉ-THÉODORE GÉRICAULT*

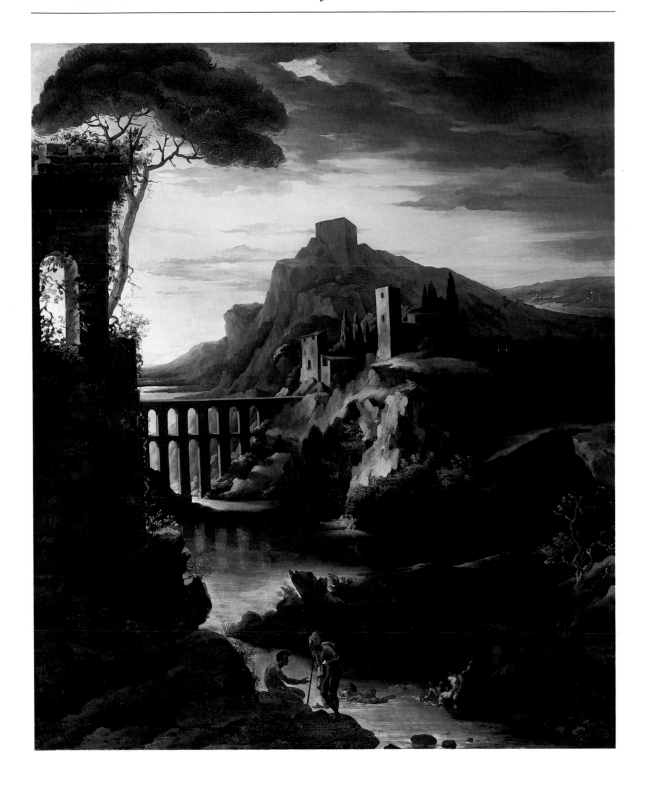

LANDSCAPE WITH AQUEDUCT

ARAB HORSEMAN GIVING A SIGNAL

PLATE 21 *MARC-GABRIEL-CHARLES GLEYRE*

THE BATH

ORESTES PURSUED BY THE FURIES

PLATE 23 *JEAN-BAPTISTE-CAMILLE COROT*

LANDSCAPE IN A THUNDERSTORM

CLEARING IN THE FOREST OF FONTAINEBLEAU

PLATE 25 *NARCISSE VIRGILE DIAZ DE LA PEÑA*

YOUNG GIRL WITH HER DOG

THE EXCURSION OF THE HAREM

PLATE 27 *CHARLES-EMILE JACQUE*

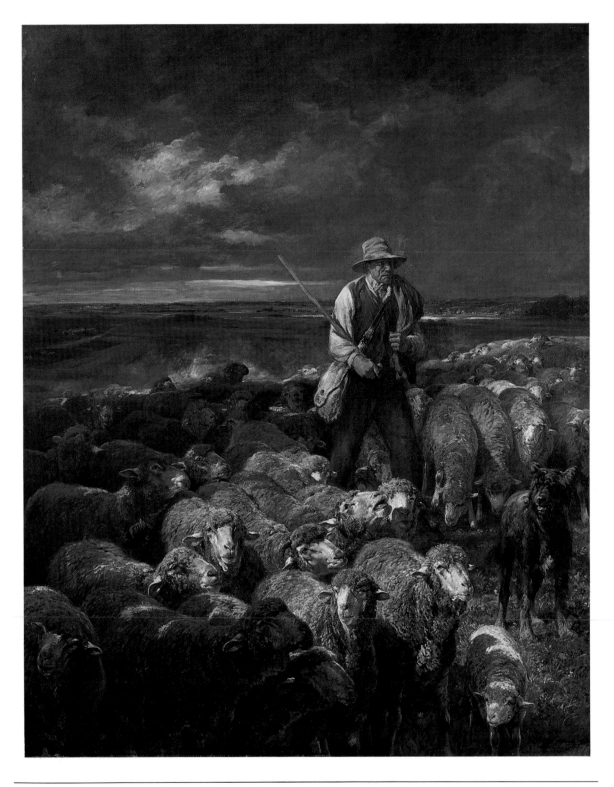

SHEPHERD AND HIS FLOCK

BABY'S SLUMBER

PLATE 29 *THOMAS COUTURE*

PIERROT THE POLITICIAN

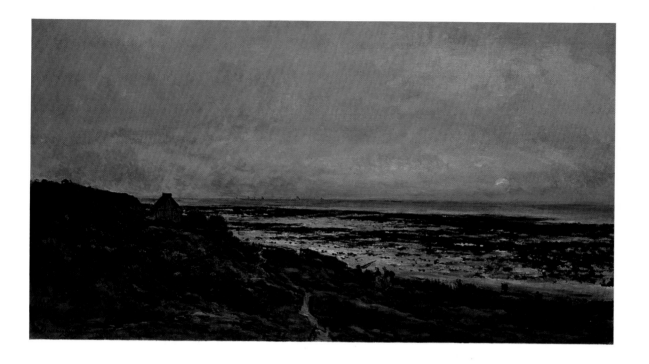

BEACH AT VILLERVILLE-SUR-MER AT SUNSET

PLATE 31 *EDOUARD MANET*

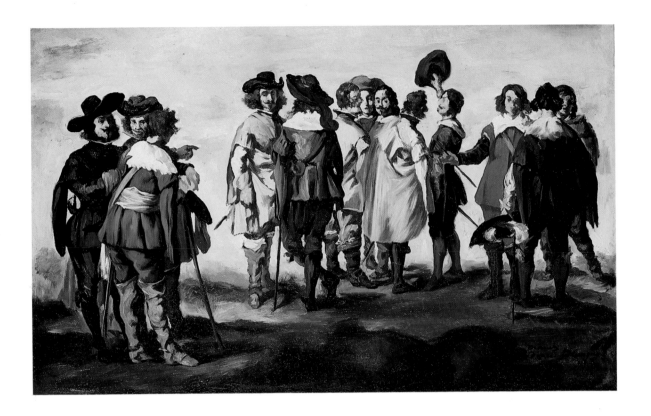

THE LITTLE CAVALIERS

BATHER AND ROCKS

PLATE 33 *CAMILLE PISSARRO*

THE MAIDSERVANT

PORTRAIT OF LÉON MAÎTRE

PLATE 35 *EUGÈNE-LOUIS BOUDIN*

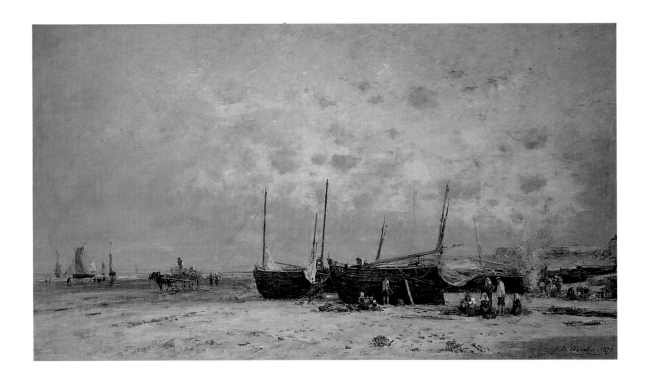

BEACHED BOATS AT BERCK

THE ARTISTS' WIVES

PLATE 37 *ALFRED SISLEY*

APPLE TREES IN FLOWER

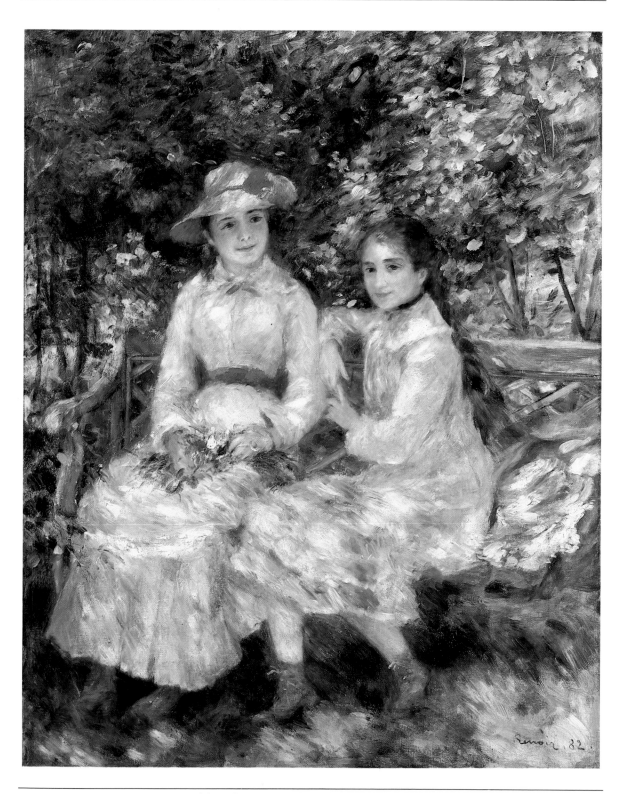

THE DAUGHTERS OF DURAND-RUEL

PLATE 39 HILAIRE-GERMAIN-EDGAR DEGAS

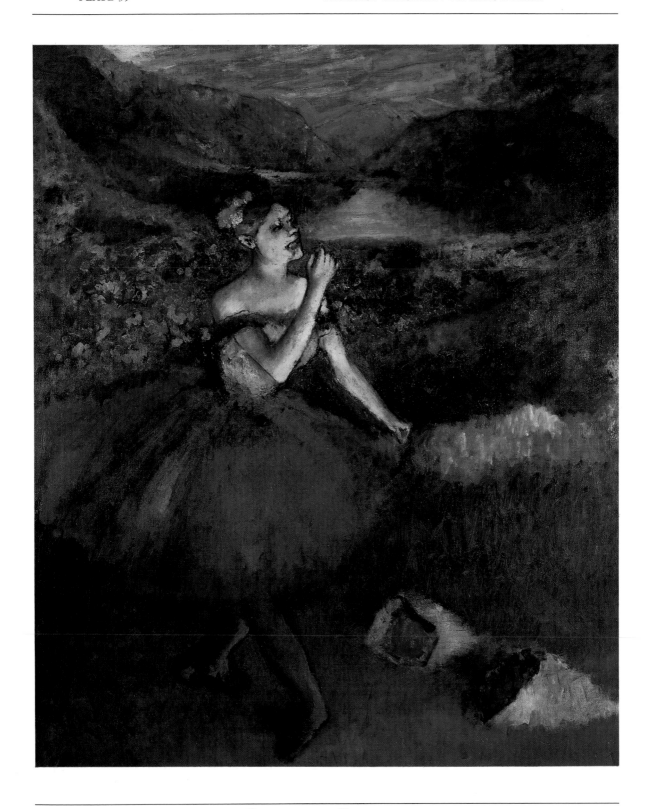

DANCER WITH BOUQUETS

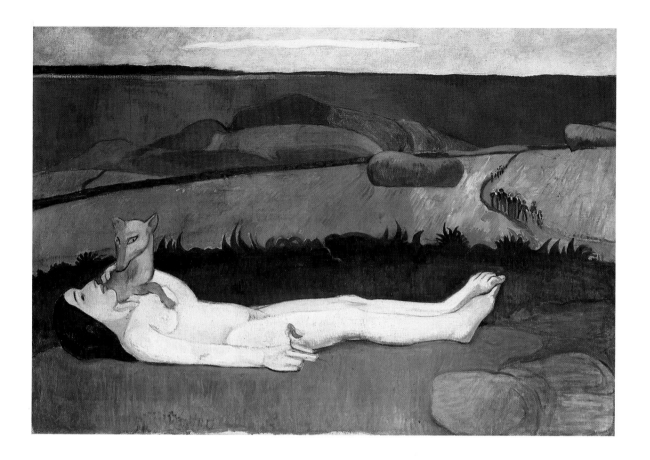

THE LOSS OF VIRGINITY

PLATE 41 *JOHAN BARTHOLD JONGKIND*

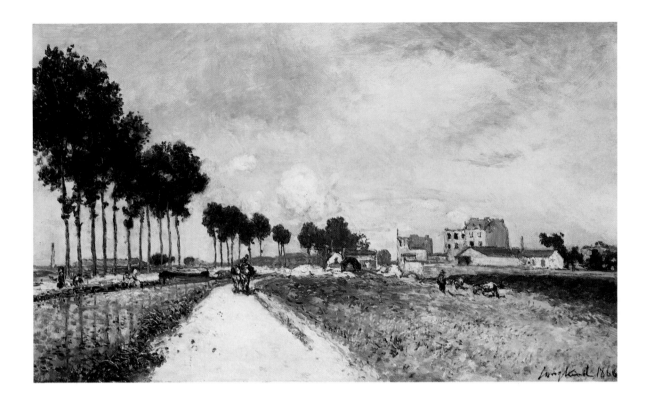

ALONG THE OURCQ

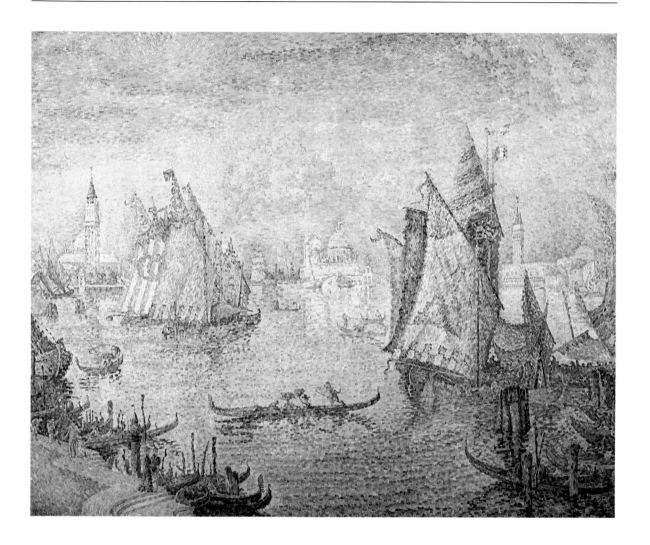

THE LAGOON OF ST. MARK, VENICE

PLATE 43 HENRI MATISSE

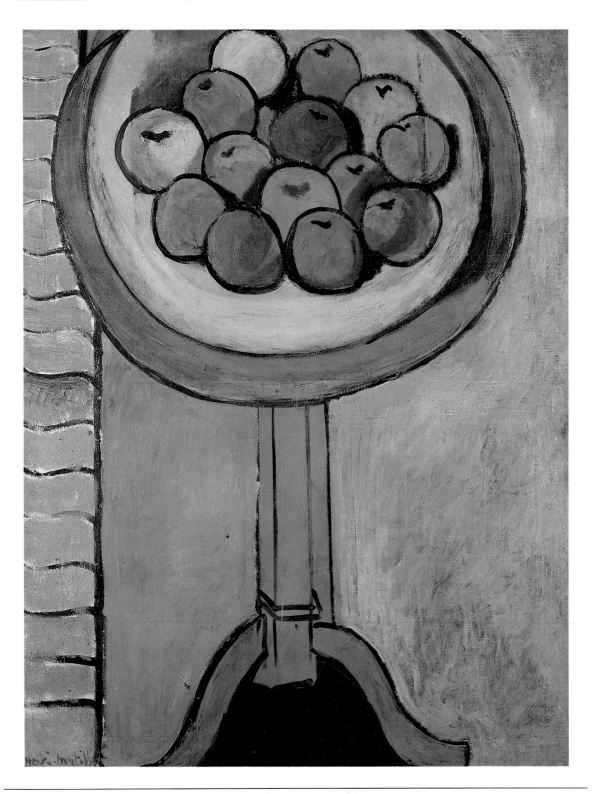

BOWL OF APPLES ON A TABLE

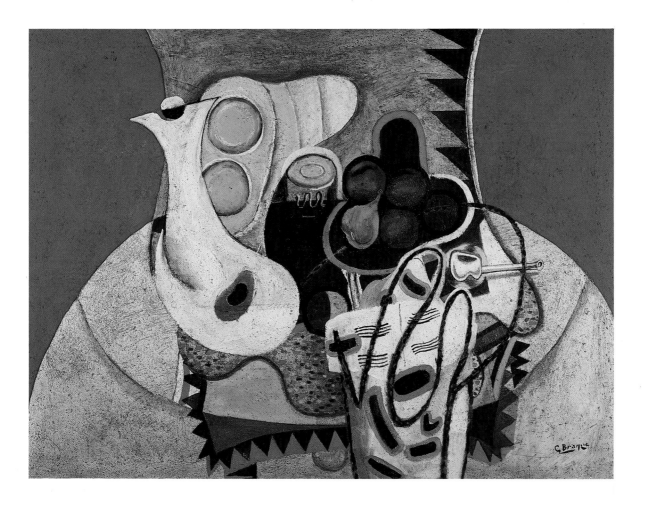

THE PINK TABLECLOTH

HEAD OF CHRIST

Artist's name, *catalogue/plate number;* page numbers